MANESSIER

MANESSIER

by J. P. HODIN

Praeger Publishers
New York · Washington

BOOKS THAT MATTER

Published in the United States of America in 1972
by Praeger Publishers, Inc., 111 Fourth Avenue,
New York, N.Y. 10003

Library of Congress Catalog Card Number : 71-172994

Permission to reproduce any of the
paintings in this book must be obtained
from the Galerie de France, Paris.

Printed in Switzerland

This copy is part of the American standard edition.
There also exists an American limited edition of 75 copies,
containing *Boule de Neige I*, an original
lithograph signed by the artist.

CONTENTS

ACKNOWLEDGEMENTS

My gratitude is due, above all, to the artist and his wife, Mme Thérèse Manessier, for so untiringly giving me all the necessary information without which it would have been impossible to fulfil my task, also for Mr Manessier's patience in showing me many a painting early and late in his studios in Paris and at Emancé, as well as introducing me to the workshops for stained glass windows at Chartres and for tapestry at Houx. The directors of the Galerie de France, particularly Mme Myriam Prévot-Douatte, not only favourably received my suggestion for writing a monograph on the artist but assisted me in many ways in compiling the documentation. Of great value to me was the unfailing help of my wife Pamela in checking the manuscript. I offer her my sincere thanks.

J. P. H.

INTRODUCTION

In his art Alfred Manessier embodies what is called *abstraction lyrique*, but 'lyrical abstraction' is a misnomer, partly because it only indicates one stylistic element, or rather the spiritual climate which, in one way or another, made a number of painters participate at the same time in a movement both of mind and technique and partly because the notion of 'lyrical' is too restrictive to cover the range and the depth of expression with which it is concerned. Nevertheless, it does indicate two essential factors in the unfolding of abstract painting, which made it necessary for a special term to be introduced.[1] On the one hand these factors, or instances, are the connection with tradition, or more specifically with that particular trend of the painterly tradition, the elements of which could be used and developed in the pursuit of the new artistic aims and the development of the expressive means which constitute the style of this group of painters.

On the other hand it is the affiliation to nature, its structures and textures, its moods, its effects of coldness and warmth, light and darkness, of the seasons, of the very rhythms of life, rather than to constructive elements derived from science and technology which, although emphasised in our age, nevertheless represent only one side of reality, the man-made side, the face of our mechanised civilization, time-bound as it is and rational, set against the feeling of eternity, the perpetual, of organic growth. In short it is the spiritual against the material-

[1] The term Impressionist Abstraction suggested by Marcel Brion (*Art Abstrait*, Albin Michel, Paris 1956) is also misleading because it only takes into consideration the influence of the late work of Monet, or Seurat or Bonnard and others on the style of this group, leaving out the new constructive elements and the different mentality.

istic, the evolutionary, or rather unchanging aspect of creation, against the dynamics of progress.

Having indicated this we must leave the group as such, that is, Jean Bazaine and Maurice Estève, Charles Lapicque and Gustave Singier, Alfred Manessier, Jean Bertholle, Jean le Moal and Gischia, and focus our attention on each individuality, for it is this which finally determined their work, their standards as artists, the particular direction of their minds, the combination of tradition and invention, of spirit and technique, in the forming of their personalities.

The present study is devoted to Manessier the painter. I emphasise this because Manessier, especially during the last two decades, has devoted much of his time and energy to monumental works, to the revival of the stained glass technique in its modern use, and to tapestry. He has also designed costumes and décor for the theatre, vestments for priests, patterns for enamel work and has illustrated books. He has produced outstanding work in these fields which will be dealt with in due time in special studies. My concern here is with the painter, and this book offers a study of the man behind the work, his background, his mind, his temperament, in which I have traced the development of his art from its first beginnings to the present day, in its formal, thematic and technical aspects. I have examined what part nature, the impact of various landscapes and natural forms in the wholeness of their presence, has played in the formation of his imagery, and also investigated the question of how and why religious concepts influenced the trend of his art, making his painting the vehicle of a spiritual interrogation, a means of communication for a creed both humanist and divine, queried again and again by the artist and continually approached anew.

For Manessier is a mystical religious painter, although one has to use these terms with discrimination. He is, according to the words of Werner Schmalenbach, 'after Georges Rouault the only great painter of Christian Art in our age', and Marcel Brion says of him that he is 'without any doubt the greatest religious painter within abstractionism'. The extent to which he is possessed by the religious spirit in art is of considerable importance in our time. The two poles in his approach to painting—and he is above all a painter, not a theologian, not a

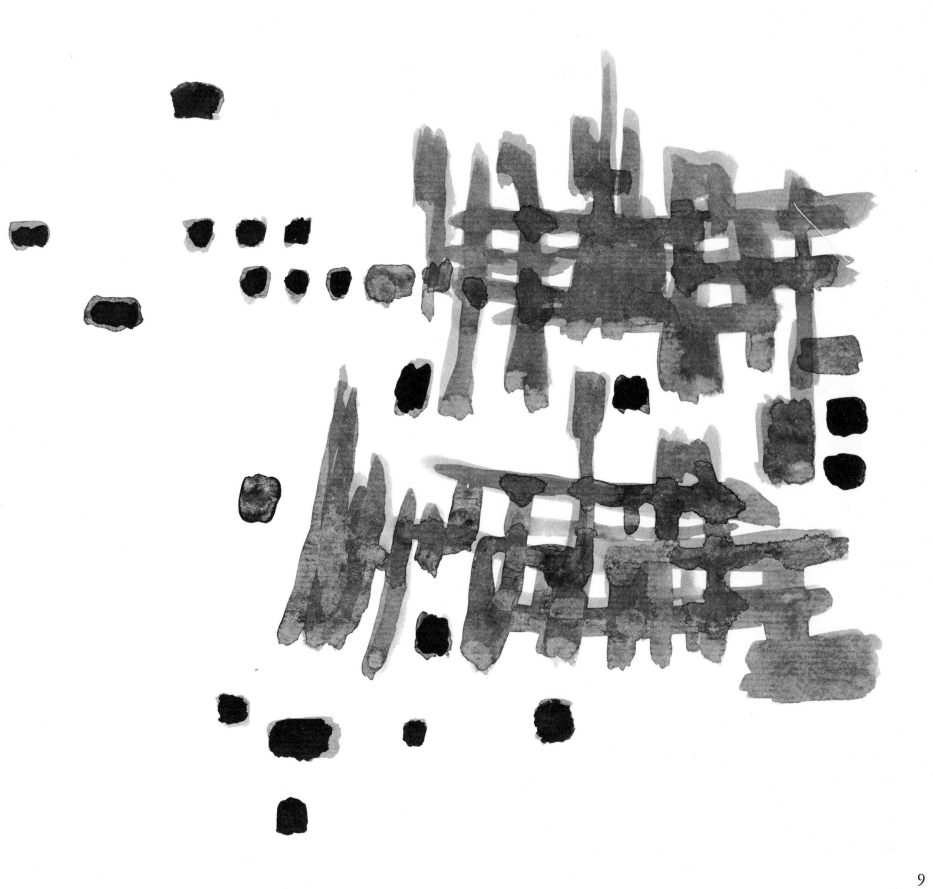

philosopher; a painter deeply concerned with the poetry of life and nature and the eternal message of love, suffering and redemption—are those meditated upon and also investigated in contemporary religious philosophy in the works of Pierre Teilhard de Chardin in *The Divine Milieu* and *Hymn of the Universe* and also *The Place of Man in Nature*. All this moves Alfred Manessier to the depth of his being. Before us a great vision unfolds and a genuine human attitude. It is humanity in its spiritual aspirations, its anxieties and its despair, its humility and purity. And all this is expressed as it were in an 'abstract' manner! It is exactly in this that the particular fascination of Manessier's work lies, the root of his impact, the secret source of his genius as a painter. It is for us to analyze the problem which is contained therein, for does not the term 'abstract' exclude all allusion to any 'reality', be it transcendant or touchable? This is what led Léon Dégand, the advocate of pure or absolute abstraction, to criticise lyrical abstractionism as a halfway measure, thus rejecting a genuine form of expression only because it could not be adapted to the Procrustean bed of an extremist doctrine.[1]

[1] See Michel Ragon, *L'Aventure de l'Art Abstrait*, Paris, 1956.

PART ONE

1 THE BEGINNINGS

No painter can be judged by the works of his early periods. Such pictures may express his desire to become a painter and even reveal to a certain degree his inherent talent, but what establishes the art of his maturity is the complex result of the creative urge in his personality, the crystallization, in fact, of this personality in the expression of its response to the world, both material and spiritual. That is why we can speak of the creation of the world as an unending process. For every single artist the world is to be rediscovered, and in witnessing the world in a work of art the beholder, too, experiences a new world through the mediation of the artist and his faculty for giving it life and form. Art is a widening of our perception.

Alfred Manessier was born on 5 December 1911, in Saint-Ouen, a little industrial village near Abbeville in the province of Picardy in Northern France. In this flat country on both sides of the River Somme which, beyond Abbeville, opens up into an estuary leading to the English Channel, he discovered, when he was about twelve years old, his inclination to become a painter. Le Crotoy in particular, on the right shore of this estuary, being the landscape of his childhood, became, at various times in his life, the object of his nostalgia. It was a nostalgia for the sea, for the exhilarating experience of sharing the life of the fishermen in their boats, the quest for solitude and the search for truth; it was his love of these men, their fishing tackle, their way of living and working, their relationship to time and tide, the high skies and the unique sensation of light in the North. And as light has become for Manessier one of the main excitements in his career, he

has tried, over and over again, to express it through colour harmonies and contrasts, thus repeating and reliving this first strong sensation of his youth, the light of Le Crotoy, the chiaroscuro of its patterns—the sands, the pebbles, the glittering or misty horizon, the banks and the sea grass swaying in the wind. We have to go back as far as these early years to realize what a hold this scene gained upon the artist's psyche. Yet, it was not until much later that he was able to express it satisfactorily. Recalling once his earliest times as an artist, Manessier spoke of Matignon, a painter whom he called one of the two freest people he had ever known. The other one was his maternal grandfather. 'He was a rope-maker, extravagant and a poet. The ropes made him thirsty and he drank like a sponge. When he was thirty-five he decided never to work any more. He poached in the streams, living on a little smuggling. Matignon had a small camp stool, a pipe, Wellington boots, checked trousers, and a chauffeur's jacket and cap. He was often seen at Le Crotoy on the Somme: he combed the harbour, the landscapes: 60 to 70 sketches a month. I have sometimes thought that the good-humoured Corot resembled him. One day—I was twelve years old—my mother had taken him across the fields to show him some of my water colours. Matignon encouraged me. At the age of fifteen I was sitting three yards from him at Le Crotoy. I had a camp stool, a pipe, Wellington boots, etc. I covered the port, the landscapes. In oil, already! Taciturn: not a word was spoken. At sixteen I had some success with some tolerably good figurative paintings and seascapes. I had a very complicated signature. I believed that this was "done". To-day Le Crotoy is buried under six feet of sand. It is terrible not to be able to find one's childhood places any more. Only the sky has remained faithful to me.

Was it in that epoch that my mother's godfather offered me a biography of Rembrandt? The book closed, I cry out that even though I work myself to death, I want to live like that man. ...'[1]

Besides Rembrandt there was another experience which was somewhat disturbing. The young Manessier saw the first illustration of a Cubist picture by

[1] Jean Clay, *Alfred Manessier, Ma Vérité de Peintre*, in *Réalités*, No. 202, Paris, November 1962.

Picasso. This was a most decisive event. So from the very beginning we find in Manessier's make-up, on the one hand tradition, and on the other the quest for a renewal of art within the context of our age.

In Paris Manessier spent his most receptive hours in the Louvre copying first of all Rembrandt, then Tintoretto, Titian, Rubens, and Renoir. He spent each day from 9 am to 2 pm in the Louvre, which he called 'My best school', and afterwards until 6 pm he attended the architects' classes—'that was sufficient'. At 8 o'clock in the evening he would work in the Ateliers of the Montparnasse. And he finished his evening at the *Association des Ecrivains et Artistes Révolutionnaires* (A.E.A.R.). Manessier copied, apart from Rembrandt's *Bathsheba at Her Toilet*, Tintoretto's *Suzanne at the Bath*, Renoir's *The Nymphs* (then in the Louvre, now in the Jeu de Paume). He made several free studies after a nude of Cézanne. This certainly improved his technique as a painter and his grasp of the laws of composition. But why these painters rather than others? And why did Manessier study architecture as a main subject instead of painting? There is a self-portrait done in Amiens in 1928, the face seen in a dramatic lighting from the right, a frontal view of a young man, serious, determined. Only the light reveals the potentiality of his mind, which he is unable yet to express directly, some inner restlessness perhaps, a curiosity beyond the ordinary. There was an artistic trend in the family of the Manessiers, art was always in evidence, although on a modest plane. His father and his uncle before him had attended the *Ecole des Beaux Arts* at Abbeville, and his grandfather Manessier, who was a stonemason, had carved sculptures for buildings in the town to be placed at the sides of porches or above doors and windows. To draw was natural in the family and the little boy was greatly impressed by the beautiful head of a lion which had been hung in the place of honour in the grocery store and bar run by his grandmother in Pont-Rémy, a small village not far from Abbeville. His father gave the young man permission to go to Paris on condition that he studied architecture, which was a safer occupation than that of a painter. It was not until his father, then a wholesale wine merchant in Amiens, suddenly died, that he was able to make the change-over.

We can easily detect in the artists whose work Manessier copied in the Louvre a common denominator. It is a concern with colour and light: their predominance over the structural or linear element. It is this quality which also determines the difference between the Florentine school of painting and the Venetian school which so attracted the lyrical side of Manessier's temperament. And that this temperament, this character, was to develop beyond the lyrical into the deeper layers of experience can be seen in the overwhelming love which Manessier developed for Rembrandt from his early childhood, and which remained unabated throughout his life. There we also encounter that experience of light which is not natural light alone but the light which has conquered darkness, darkness being the womb from which that light issues in a transcendental as well as a religious sense. It was that light that had to be expressed in his painting.

Sitting one day with Manessier in his house at Emancé, in the autumn of 1966, under the copy of Rembrandt's *Bathsheba at her Toilet* on which he started to work immediately after arriving in Paris, he said: 'What Rembrandt taught me essentially when I explored his work was the sense of plastic achievement and its place in the world. Success or lack of success has no say in his work. Rembrandt did not worry about this. His painting has a permanent presence. I can say of myself that the incidents which I have to pass through in my life have no moral effect on me either. If a painter is not ready to live like Rembrandt, whatever the circumstances, he does not count. I believe strongly in that. This strength in facing the world, this strength in facing the material requirements, is decisive. The same is true of Renoir. His striving for a rejuvenation of the spirit independent of his physical decline, the victory of the spirit, that is decisive. Rembrandt, Renoir, Cézanne, Matisse, in all these painters the spirit was very young. Certain young painters nowadays turn when they reach the age of 40 to new occupations. How can a painter ever envisage a change of occupation? In the young generation of today there is a certain greed, a haste, an urge for publicity. My rhythm is slow. I am absolutely never in a hurry. I can live very well like this. My patience is without limits. I do not aim at success and it often astonished me that I had the success which is attributed to me....'

2 CUBISM AND SURREALISM

In the thirties the art life of Paris was dominated by two major trends. There was Cubism in all its richness and maturity as developed mainly by Picasso, Braque, by Gleizes, Metzinger and their school, with its new concept of space, its compositional and spiritual character, and its iconography, and there was the Surrealism of Breton and Max Ernst with its shock methods, its own ideology and imagery, its frenzy tempered by psychoanalysis and its emphasis on dreamlike a-logical realism. From the painterly point of view Manessier was more attracted by the new constructive aspects and manner of representation developed by the Cubists, although a strong undertone of Surrealism is also detectable — in fact the two intermingle in the works which he then produced and which were exhibited at the three Salons des Indépendants between 1933 and 1935 and later. Picasso impressed himself most decisively on the young painter's mind, and in the line of succession from Cézanne to Picasso he experienced the new branching-out of the French tradition. The Cubism to which he adhered was not the strong rectangular kind which dominated the analytical phase but rather the later curvilinear and enriched type which ensured a greater freedom of composition and concept. This is typical of Manessier. For as with Picasso, the tendency of his development has been to go beyond every phase of his art when once he has explored it to its depths, without becoming sterile or doctrinaire — as was the case with the school of Cubism. Manessier's break-through to lyrical abstraction, and not to a purely geometrical and rational concept of it, is the expression of a basic predilection, a predilection for a poetical metaphor emphasising the poetical quality of both

motif and colour. This is one of the characteristics of his talent as a painter and one of the elements of the organic and consequent development of his art. That he himself was an artist with a budding vision of his own can be seen in certain compositions of 1935 and 1936. A free linear design is employed in what we can now easily recognize, when looking back from our art-historical standpoint, as a graph of the still youthful personality of the painter who, two decades later, was to become the leading figure of the lyrical abstractionism which then dominated the scene. We have only to think of the composition *Marine Gods*, a large painting of 1935 which in its earthen colour scheme and its anthropomorphic, elongated and angulated forms attempts to present a mythical image with a tinge of Surrealism. All the same, this painting has its roots in the experiences and sensations of Manessier's youth — the sea, its horizon and the depth of space here rendered in a Cubist manner by planes, used as compositional elements holding together the whole scene with its clearly defined above (the atmosphere) and below (the dotted area, the earth) and the biomorphic shapes within. The metamorphosis of natural forms used for the purpose of a symbolic representation is taken from the vocabulary of Cubist morphology and reveals fine tone values and a convincing constructive faculty. Manessier has painted a number of such compositions, of which many have been destroyed during the war and which on the whole consist of figures, proto-symbolic figures in a landscape and Cubist still-lifes. The conception was in general a dynamic one, as in *Marine Gods*, heightened to a more Surrealist pitch in compositions such as *The Lunatics* of 1938 and *The Last Horse* with their obvious Picasso–de Chirico–Max Ernst inspired imagination, speaking, however, of an inner restlessness and even a certain despair. There is definitely a pessimistic strain in Manessier's mind which only later could be controlled, dominated and sublimated by his faith, so that an enlightened critic once called him a tragic optimist, indicating a permanent inner struggle for a balance of mind which has over and over again to be re-established. These *Lunatics*, which were shown to the public in the exhibition *Jeunes Peintres de Tradition Française* at the Galerie Braun in 1941, must be considered as the climax of this Cubist-Surrealist adventure. A still–life with fish, and an upright picture

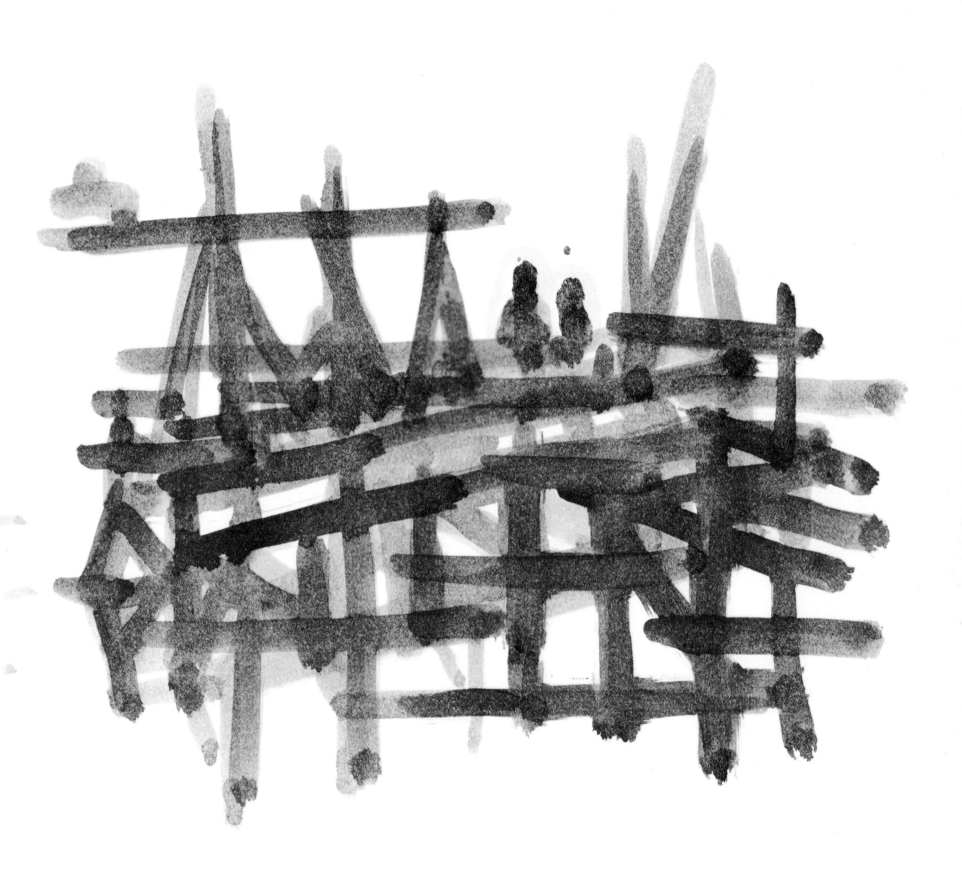

of a standing figure without head, both of 1935, must also be included here. Whereas the three lunatic figures, in their birdlike or frightening lemur-like shapes, are phantoms screaming from the entire picture surface —in the dancing triangles, squares, rhomboids and electric lines of lightning— in *Woman and Child* of 1941–2 we can recognise a return to a quieter and more stylised figuration. Here is the peace and security of motherhood. The child with a halo stands firmly on a chequered ground, with its arms outstretched, looking upwards at the mother, and a bird sits on the ground in front, also looking upwards — all portrayed with the accuracy of an old Dutch master. Here again there is an element of Surrealist parentage, for Surrealism used a photographic Naturalism to enable it convincingly to represent the vague states of dreams.

3 WAR AND THE OCCUPATION

The years 1942 to 1944 indicate the end of the pre-war influences, both as to their iconography and their style. Having described this first phase of modernism in Manessier's work which followed the early Impressionist paintings, we have now to occupy ourselves with three important facts in the artist's life which all happened within the decade beginning in 1935. Stylistic, spiritual and historical, they all had their impact on his art. The first is the meeting with Roger Bissière (1888–1964), a most decisive event in his development as a painter. In 1935, when Manessier became his pupil, Roger Bissière was a man of 47 and Professor of fresco painting at the Académie Ranson, 7, rue Joseph Bara, where he taught from 1925 to 1938. There gathered round him a group of young artists on whom he had a happy influence. Besides Manessier, they included Jean le Moal and Jean Bertholle. Closely associated with them was Malfray, who taught sculpture and who had Stahly and Etienne Martin as his pupils.

What role did Bissière play in the development of the French School of non-figurative painting? After his venture into Cubism, through his friendship with Braque which started in 1922, he turned away from it in 1937 'feeling that it was outdated', as he himself wrote.[1] Bissière was an honest, even scrupulous, and lonely artist struggling for a personal and meaningful style, and it was these characteristics that attracted the young to him. Through a tortuous spiritual crisis in which he meditated on the problems of art as apparent in the works of

[1] Michel Seuphor, *A Dictionary of Abstract Painting*, London, 1958.

21

modern masters, as of those of the past —he published in *L'Esprit Nouveau* studies on Ingres, Corot, Seurat and others— he realised that his very aim as an artist was to humanise Cubism and to tie it up with the French seventeenth-century tradition. Into his often severe constructions, subtle colour values are worked to communicate a poetical message. Seen historically, his position is a transitional and therefore difficult one. However, it was this very quality which was to prove the fertilising agency in his contact with the young artists who were grouped around him at the Académie Ranson between 1935 and 1938.

In 1939, Bissière retired into the country, to the province of Lot, and during the war he stopped painting altogether. A troublesome eye complaint endangered his sight. When, in 1940–1, Manessier, forced by circumstances, settled in Benauge near Boissierettes where Bissière was living, he worked for his old friend as a farm hand and woodcutter to provide for the needs of his family.

In 1941, recalled suddenly by Jean Bazaine who was trying to form a group with the aim of working in the organisation *Jeune France,* Manessier returned to Paris. On the day of his arrival he found his canvases at the Exhibition *Jeunes Peintres de Tradition Française*, organised by Bazaine in the Galerie Braun. They were shown in company with pictures by Bazaine, Beaudin, Bertholle, Borès, Estève, Gischia, Lapicque, Lautrec, Le Moal, Pignon, Singier, Walch and others. With this exhibition the non-figurative movement was born in France. It must be pointed out that most of the exhibiting artists did not know Bissière.

After a short visit to Paris in 1946, where he became acquainted with the living painting of the day, Bissière returned to Lot and began to paint again. It was after his re-entry into the circle of artists that Bissière freed himself completely from figuration. And even if it may sound strange it was in this epoch that a strong influence arising from the trend of the young artists made itself felt in his work. Manessier introduced him to Drouin. During and shortly after the war, some of the outstanding talents of France, those who were most characteristic of this epoch, were assembled in the Drouin Gallery at the Place Vendôme.

Manessier and his friends saw Klee for the first time at Drouin's. During the German Occupation Klee circulated beneath the surface, so to speak. He became

the symbol of that art which was called 'degenerate' and was condemned by Hitler. There is a freedom of fantasy in Klee which is not at all in accord with Manessier's taste and ambition. But Klee certainly succeeded in enriching the sensibilities of Manessier and his friends during the Occupation. Through the process which he called 'interiorisation', not abstraction, Manessier arrived step by step in 1945 at non-figuration (*Salve Regina*) (8).

An explanation for this process may be found in a statement by Picasso: 'From the point of view of art there are no concrete or abstract forms, but only forms which are more or less convincing.' To this Picasso added 12 years later: 'There is no abstract art. You must always start with something. Afterwards you can remove all traces of reality. There is no danger then, anyway, because the idea of the object will have left an indelible mark. It is what started the artist off, excited his ideas, and stirred his emotions. Ideas and emotions will in the end be prisoners in his work. Whatever they do, they cannot escape from the picture. They form an integral part of it, even when their presence is no longer discernible. Whether he likes it or not, man is the instrument of nature. It forces on him its character and appearance.'[1]

The sudden death of Manessier's father in March 1936 was not only a great personal loss, it radically changed the course of his further studies. Architecture was abandoned, his determination to become a painter proving unshakable. In 1936–7 we find him in Amiens, where he had previously attended the Lycée and the Ecole des Beaux-Arts. Now he had to liquidate his father's business after his death. Two whole years passed thus with only one brief exception. Manessier took part at the Paris World Exhibition of 1937, where he collaborated in the realisation of an enormous composition on a machine theme for the Pavilion of the French Railways and Transport. The chief planners for the decorations were the painters Delaunay and Aublet. As one of a group consisting of Bertholle,

[1] Quoted from statements by Picasso, 1923 and 1935, in Alfred H. Barr, *Picasso, Fifty Years of his Art*, The Museum of Modern Art, New York 1946.

Bissière, Estève, Le Moal and others, Manessier worked on four large murals for the Pavilion.

In 1937 and 1938 he showed some of his paintings in the so-called *Témoignages* exhibition at the little Galerie Breteau in the rue des Canettes in Paris, to be followed in the same year by another grouped under the title *Matières et Formes,* at the Galerie Michaud in Lyons. The former was the first exhibition in which Manessier took part. Twelve painters in all were represented —these included Bertholle, Charlotte Henschel, Le Moal and Wacquer besides Manessier— and three sculptors, among them Etienne Martin and Stahly. Poetry, music (Pierre Barbaud) and the crafts were also represented. Gaston Diehl, realising the *élan* in this group of young people, encouraged them. In *Marianne* of 1 June 1938 we read:

'In a curious shop in the rue des Canettes, painters, sculptors, poets, musicians and craftsmen presented a varied and rich ensemble.

It is the multiple effort of a group of young people who have understood the Cubist and Surrealist lesson, the incontestable grandeur of a Picasso, and what has now become a search for a new means of expressing all the passionate intensity of being.

Some of them already affirm a bold penetration into the symbolic. Such are the paintings and the designs for stained glass windows by Bertholle, the pictorial researches of de Beyer, Le Moal, Thomas, Manessier, Varbanesco, who more often than not stand aloof from all figuration in order to retain only a concentrated formal dream.'

On the occasion of the Lyons showing, Gaston Diehl spoke of 'spiritualisation':

'The rebirth of such "spiritualisation", which is clearly manifested among the artists of *Témoignage,* as among the group formed more recently, *Les Réverbères,* this desire which comes close to mysticism, shows the extent of a longing which is beginning to dawn across the world.'

In October 1938 Alfred Manessier married Thérèse Simonnet, also a painter. The young couple settled in a sculpture workshop in 4, rue Franquet in Paris 15e.[1]

Almost a year later the war broke out. Manessier was called up, and had the good fortune to be sent as a technical draughtsman to the Ministry of War in Paris. There followed the tragic phase of France's defeat and the bleak years of Occupation. At first during the Occupation he could not paint at all; later, he could work only under great stress. In his study stood a strange, even comical sculpture of his depicting Don Quixote on horseback with shield and spear, all made from an old washing machine. It summed up his feelings at the time. But, whereas the Knight of La Mancha rode out into the world to conquer his ideals, he, the painter, who was prevented from painting was waging a war against circumstances which were beyond his control. And all the broken hopes and the melancholy which it entailed!

On 3 August 1940, his son Jean Baptiste was born in Cahors. Manessier was able to rejoin his wife and his mother only four days before.[2] They settled in Benauge, as already mentioned. There they stayed in a farmhouse from October 1940 until May 1941, when they returned to Paris. In this seclusion, surrounded by the peace of the countryside, where no Occupation troops were present, where one could walk for miles without encountering any enemy or stranger, the humiliation felt by every Frenchman could be sublimated into a work which perhaps had the promise of surviving the débâcle. But did the artist aspire to that? Not directly. He just had to oppose the dark night that had descended upon France with a belief in something everlasting in life, in art, in the spirit.

In his capacity as artist, he was thus not only unable to work amid estranged surroundings, but was also battling against his inner scruples. By 1942 his work as a painter had become quite secondary. What filled his time now was dictated by the needs of his family and the task of re-educating the youth of France, preparing them for the day of liberation. That is why Manessier agreed to

[1] Between 1935 and 1938 Manessier had lived in Montparnasse, 117, rue Notre-Dame-des-Champs, Paris 6e. He remained in the rue Franquet until 1939. In July 1939 he moved to 203, rue de Vaugirard, which is still his Paris residence.

[2] Manessier has two children. His daughter Christine was born on 13 April 1945 in Paris.

participate in monitoring the teaching of painting in *Jeune France*, an organisation founded for the purpose of a re-organisation, a re-orientation of youth. Manessier worked there for two years and so made his living. He is not fond of teaching but he felt it to be his duty to assist as far as possible in this moral effort, the aim of which was to defend authentic and proven values in an epoch in which art was debased. In many fields of intellectual life those men who then taught in *Jeune France* were to become most influential in the revival of France's cultural life after the war. It was the painter Bazaine who brought Manessier into this circle. And there was Jean Vilar, the future creator of the *Théâtre National Populaire*, and Clavé, the director of *La Roulotte*, Jean Dessailly, André Clement, as well as Schaefer, who taught music, the writer Apert and others with Flamand, the present director of *Editions du Seuil*, as the leading personality.

At practically the same time and on the initiative of Gaston Diehl, Manessier and some friends decided to prepare clandestinely an exhibition of the work of painters, sculptors and engravers, which could be held in the future when times were better. The meetings took place on the first floor of a little restaurant in rue du Pont-Neuf, just opposite the rue Christine. Many friendships were cemented there. In the year of the liberation an event took place which was to be the first *Salon de Mai*. This Salon influenced young people a great deal during the following twenty-five years. Manessier took on the duties of a member of the committee, from which position he retired some twelve years after its foundation.

4 THE LIGHT OF SOLIGNY

It was not until 1943 that Manessier again took up painting as a full-time occupation. The meaning of life was at stake. He told me one day that in September 1943, curiosity made him visit the headquarters of the Trappists, *La Grande Trappe de Soligny*, in the province of Orne. (He painted the scene *La Grande Trappe de Soligny* that same month.) The visit impressed itself unforgettably on his mind. It was during the Occupation; he stayed for three days, and when he left he was a changed man.

The Trappist régime is the most penitential that has ever had any permanence in the Western Church. The rules are severe, the hours of worship and church services are long, but directly related to the natural rhythm of day and night and to the changes of the seasons. It was this severity and the ties with nature which impressed themselves deeply on Manessier. Asceticism seemed to him to be the only remedy against the misery of the time, against all the inner helplessness and perplexity, against the depression so evident everywhere. The artist felt the need to reach the bottom of the pit to enable him to clarify his ideas about life and death, about his art and its aims.

'The Armistice signed, I had a little house in a lost corner of Normandy, in Le Bignon, near Mortagne'[1] so Manessier himself recollects, 'and it was there that

[1] In the province of Perche, where Thérèse Manessier's family was living at the time of their arrival. Etienne Martin and his family joined them there later on.

for me everything really started. First of all, I felt myself submerged in a thousand elementary joys : I was miraculously alive. While all the pre-war values were collapsing in the ruins, I was discovering the perennial marvel of a tree, a flower. Moreover, I was cut off from the atmosphere of Montparnasse, delivered up to my own forces : my painting had been liberated at one blow, it had become less rigid, filled with effusion and love. It was also at Mortagne that I encountered God. ...'

There, in effect, one morning in 1943, among those rich vales of the Perche, Alfred Manessier came for the first time to know his Truth, his road to Damascus, the greatest upheaval of his life. Invited to spend several days at Mortagne, the young poet Camille Bourniquel told him one evening, in the glimmer of the candlelight, with all the solemnity of his age, that he would be going the next day to make a retreat at the grand Trappist monastery of Soligny, which was some 18 kilometres away. 'There was a long silence', so Bourniquel recounted, 'and then Manessier spoke : "Would you mind if I came with you ? I have always wanted to. ..." We set off at dawn through the drowned autumn countryside. I remember that the cows trailed with them a little cloud of mist.'

After four hours of walking, they arrived at the window in the entrance gate. 'We are not receiving visitors', said the monk on duty. They both prepared to turn back when there was a telephone call from the Father in charge of hospitality, enquiring about their occupations. 'He is a poet and I am a painter', answered Manessier. 'Open to them.' Astonished, the monk who was in attendance at the turnstile pressed a button. 'We had fallen right into the Middle Ages. Some monks in leggings and gaiters were feeding pigs.' 'I was ill at ease', recalled Manessier, 'like a tourist. I hated pretending to retreat.'

That evening, however, with Bourniquel, he was present in the gallery at the *Salve Regina*, in the total darkness of the chapel, only pierced by the red light of the Holy Sacrament. The monks arrived one after the other, in silence. The bells rang. 'It was the moment when nature was appeased. The leaves became calm. I saw in my mind songs rising and falling. If I could succeed in grasping this inner light, this rhythm, this meaning, I thought, I could do more than render a

visible image of it, I could give its essence. ...' This, in fact he tried and achieved two years later in his first 'abstract' painting, which derived its name from this incantation: *Salve Regina* (8). It was not an easy achievement. Before that he had endeavoured to render religious themes in a figurative manner. He suffered

a great deal in his attempts. They were inconclusive. He produced a first version of *Salve Regina*, but it had not the breath of life and he destroyed it. For him abstraction was not to be an aesthetic quest. But the belief that there was a possibility of attaining a sacred emotion in this way remained with him as a firm

conviction. To be able to express the cosmic appeasement in Nature together with the liturgical theme of the *Salve*, that could even resolve the seemingly insoluble problem of art and religion. And he achieved it in this magnificent composition.

'I felt profoundly the cosmic link between that sacred chanting and the world of nature all around, which thrust itself into the silence of the twilight. The hours took on an unwonted beauty. These men who sang were perhaps a little out of touch with the world but there was truth in their relationship with nature. Listening to them I felt how much our lay world needed to rediscover the sense of the sacred. The monk in charge of hospitality had assigned to me an excellent fellow, an old monk with weak sight, Father Guy, a labourer, a worker, rough in speech, with the vocabulary of a carpenter and no theology. Yet within three days he had brought me into contact with unknown truths, he had turned my values upside down. I sneered: "But it is sufficient just to look at the lamentable state of your church! A horror...." He remained silent. "And art! Let us speak of that: if I were a Christian I would be obliged to abandon painting or produce things like the church of the Saint-Sulpice." He was on the rack. He did not know how to reply.... It all happened like that, in the silences, the imponderables. He knew nothing of painting. Nothing could bring us closer. And at the same time, there was, deep down, as it were, a truth which, little by little, passed from him to me. That man had love; I felt complete trust in him. And, as always, I advanced without too much reflection.... Without doubt, there had long existed in my innermost depths a secret world of metaphysical anguish. Yes, how true is that saying: "You would not seek me if you had not found me...." I had been gathered up with ready compliance. It is quite wonderful: to enter without breakages, without renunciation. ... And it was not an ephemeral enlightenment: if the presence of the Faith had not existed in me organically, I am certain that during the past twenty years I would have thrown everything overboard. ...'

On the morning of the third day, before leaving La Trappe, the painter and the poet took Communion together at the six o'clock mass. The die was cast.

Manessier had found the answer and a meaning to his life, but not the end of his anxieties.

'Yes, but all the way to the cross the agony of Christ was unceasing. The Night on the Mount of Olives is a night of anguish. "And his sweat was as it were great drops of blood falling down to the ground." It was the anguish of human death. Death of the body and death of the spirit. An atrocious death, but real. Christ did not hide his human weakness. One can be Christian and know the anguish twenty-four hours out of the twenty-four, and nevertheless fall again and again on the Road to Calvary. For me, Christianity has, above all, given a meaning to that anguish, a meaning to that suffering. It has centred things... but that does not change a man, that only gives him the direction for his journey... he starts from the point to which he goes. ... Christianity, you see, is also a way of rejoining the others; a response for all. Something which goes beyond us and unites us at the same time. The idea of the mystic Body of the Church is a beautiful one. When one has stripped it of all the superfluous trappings that encumber it, what remains is the essential. ...'

The essential! And it was that too which made Manessier search for a form of expression which was humble enough to reach it. 'If we had', he said, 'the evangelical purity of the Primitives, if we could look at nature with all the innocence of love, then perhaps we could depict the sacred as they did. But we are men of this century; broken, exploded. Whether we want it or not, there appears on the canvas a falsehood which is inherent in our society. On coming out of La Trappe, I wanted to express what I had experienced in three sacred figures placed round a table. It was false, almost intolerable. Then I thought that in rejecting figuration I might more easily express what I felt. ...'[1]

It was Father Guy, the simple worker who had made the artist realise his true vocation. And, as Manessier put it to me, it came not directly through his words but through his person. No intellectual dialogue took place between them. All the questions which Manessier had asked himself over and over again in his

[1] Jean Clay, *Alfred Manessier, Ma Vérité de Peintre*.

lonely wanderings, in his fierce and solitary inner struggles, as to whether the problems of art and religion could ever be reconciled in our age; whether one could be a true Christian without a breach with the artistic vocation, whether the message of Christ could be transmitted to the beholders by way of art, seemed to have received an answer. What Manessier had experienced was a sudden enlightenment, an opening up of secret reserves, an unfolding of capabilities of which he had been unaware. In 1942 there was no sign at all that the Church might envisage such a position, it was in fact unthinkable. The Catholic Church of the last century and modern art — what could they have in common? And then suddenly this unexpected meeting and this clarity about his calling, this certainty that such a way was feasible!

What he had demanded of himself as an artist was to try to express what he had to say as simply as possible in a statement as natural as possible — it was a wish, a longing, without any definition, any outline, and suddenly there was this absolute change. When he left La Trappe he had a creed, he knew.

How can we classify the pictures which he had produced before? What was their message? What was the inner tension out of which they had grown, and which they attempted to transmit? *Robot Magician* of 1937, using for its Cubist stylisation a subject matter dictated by the mechanical processes of our time, or *The Great Staircase* with its Surrealist connotations — where did they lead? Nowhere. What message had the guitar player, *The Musician* of 1938, with his mysterious flag, to give? There were eyes depicted everywhere in these paintings. What did they see? What did such compositions reveal? That a young painter had studied Picasso, or Braque or Max Ernst or de Chirico? Not only that. An oblong composition of 1941 depicts a forest in the centre and mountains and stars in the sky and a guitar, symbolizing man's urge and ability to give expression to nature's poetry, man's ingenuity in inventing such lovely forms as musical instruments (it is not only 'the guitar' used by the Cubists); it is man listening to what the night and the forest and the stars have to tell him, the tale of Creation.[1]

[1] The title was *Composition*; the picture was destroyed.

And there is *Man with the Branch* (1) of 1942. We sense the poet in Manessier who tries to sing of wounded man, of simple man plunged into the middle of an international catastrophe, the war. In the same year he also painted the *Apocalypse*.

But now something fundamental was added. Poetry was reinforced with truth, the truth of a creed, of an eternal knowledge. He could not continue to add similar works to his humorous Don Quixote or to the sculptures of a female figure. They were Cubist idols, negroid idols of 1942. There is also a head and

33

shoulders of 1943 in a Cubist style, there are some sculptures in wood on a bench, reminiscent of Totem figures, then a mother and child motif, a head... He could not add to these exercises in form and material. He had to turn his back on them and probe his inner self.

Before we proceed, let us pause here a moment to glance at the *Family Portrait* of 1943.[1] It still retains the somewhat summary manner of Cubism. The artist, palette in hand, stands in front of his easel and there is a mother and child (his wife and son) and his own mother (who, since the death of her husband, has lived in her son's household), and there are the symbols of homeliness: the coffee pot on the stove and the drawn curtains which allow only a faint view of the landscape outside, thus enclosing the warm interior.

All this is not to say that a painting of Manessier's would from now on be valid and valuable only if it carried a message, that is, a literary, a religious message. Not at all. What is true, however, is that the artist suddenly discovered a spiritual centre, a focus of the mind, an inner fire which was to nourish everything he did from then onwards and still does, whether he depicts a religious or a natural theme, whether he produces a painting, a stained-glass window or a tapestry. The works painted in 1943 and after, particularly those reflecting the scenery of Le Bignon, reach already that spiritual intensity which was unthinkable in his work before, although the dominating mood is dark and dictated by outward circumstances. The old cottage in which Manessier lived and worked most of his time from 1942 to 1946 had thick walls, with little windows letting the light in only dimly during the day. Manessier tried to work in the yard. But his first paintings of this period were produced in artificial light. During the Occupation no electricity was available, only paraffin lamps and flickering candles. So the night had full sway when the sun was set, and it was this and the concept of 'the light which shines in the darkness' which were behind such pictures as *Man with a Lamp*, of 1943, with its geometric character, its strong structure as well as its fluorescent mysticism. And there is a composition *Le Bignon* from the same year

[1] Exhibited in the same year in the Galerie de France: *Twelve Painters of Today*.

in which we can already detect the mature Manessier and his personal style, in the lyricism of colour, as well as in the power of transposing natural forms into forms with a supernatural significance.

The Young Milkmaid, painted in 1943, is still characterised by a near-Cubist style, but the colour is divided into the small planes which now began to dominate, the reds and pinks and cold blues; background and figures receive the same treatment as compositional elements of equal importance. And there is *Le Bignon at Night* (5) of 1945, which in its stylisation speaks of the artist's inner need of 'interiorisation', of an element of emotion, which otherwise is alien to the Cubist concept. The opening up of the building, thus offering to the eye both its inside and outside, is still a Cubist device, but in the case of Manessier also a spiritual one, as his later work will prove.

The Old Calvary in the Snow of 1944, painted in cold blue and grey tones, is an attempt to produce a complete image of suffering, the essence of suffering, so to speak, an attempt which ends in a dualistic form. There is the crucifix, the image of Christ on the Cross in all its recognisability, superimposed on a wintry landscape, with trees covered with snow and leading deep into a space which is broken up and left undefined, with branches like sharp thorns (the first thorns in Manessier's work) suggesting the symbolic connotation: winter—thorns—suffering—the sacrifice of love.

Between 16 and 20 September, 1943, Manessier painted his first *St Veronica's Napkin*. He repeated it in 1945, and later on about 15 times. These pictures mark a stage of painting where figuration and abstraction meet, as it were, on a fleeting surface, in a spiritual space, where at one moment the artist, believing himself to have caught the eternal face, sees it fading away—it always escapes man—leaving him alone with his idea. Before, however, we enter into the problem of abstraction as interiorisation, we have to consider these compositions where Cubism, with its space structure, and religious theory were combined in a proto-figurative manner, studded, as it were, with elements which lead us onward to that style of painting which was achieved by Manessier in his pursuit of the freedom of expression and of absolute artistic values. Here form, colour and subject matter

become one, but on a different stylistic plane. A few words which I found in one of the artist's albums from his early years[1] may elucidate both his struggle and his new aims.

Speaking of themes for his paintings, he demands that they occupy him so intensely that he can try his hand at them again and again. These, and only these, would be themes worth-while exploring, themes by which he is obsessed. The aim of an artist is to saturate them with an accumulation of human feelings as complete as possible, including adversities and complexities — suffering, anguish, joy, to be expressed exclusively in signs and colours. He must abstain definitely from all allegory and from the anecdotal, to reach the essential. What he aims at is the very essence of suffering or of joy. No resort to figuration is permitted. The canvas in itself must be an object. Emotion must enter in one way or another. There are risks, 'my risks and my dangers'. To gain greater clarity in the development of these then radical ideas in his approach to painting, he explains to himself that this goal is not to portray a man in his state of suffering, but suffering itself; an attempt to translate this through the use of equivalent signs and colours. The painting will thus penetrate deeper, the artist will be 'inside', he will pass through that inside, to go beyond the subject and reach action. Wrestling with this idea he underlines the words 'No excuses! No pretensions.' There is the necessity for a new pictorial language which will fortify expression. 'I am still searching for it.'

Here words are used to express the way in which one reality is replaced by another, the reality of creation with the reality of signs and colours. Kandinsky spoke of spiritualisation. What Manessier is concerned with is interiorisation. There is a difference. Interiorisation is the attempt to express something which is an inner experience, not an attempt on the part of the will or an intellectual attitude. Interiorisation aims at the incarnation of the spiritual in the very flesh of matter.

[1] Up to 1940.

5 THE PERIOD OF TRANSITION

With the *Man with the Branch* (1) of 1942, Manessier reached the utmost simplification in his figurative style. Cubist constructive elements, Fauvist delineation and emphasis on colour and a humble human message: that man is vulnerable. There is no symbolic meaning in it, just this statement. The warm colouring defines, as it were, 'the musical key' of this composition. *The Pilgrims of Emmaus* (11) of 1944, which was exhibited at the *Salon d'Automne*,[1] sets Manessier's art on quite a different plane. There is a Cubist flat space and a Cubist breaking-up of surfaces, but not to the same extent as in analytical Cubism, i.e. to the point of the breaking-up of the objects. These remain clearly recognisable: the oval table; the two disciples on the left and on the right of it, and at the top of the table Christ majestically dominating the whole scene. Behind him the space opens up, vibrating with light, while the base of the composition remains firm and static. All this, however, seems to be of secondary significance when compared with the colour. The colour, with its innate tendency to destroy form when used in its own right, is here strong: hot reds and cold blues and few accents of green, the centre remaining radiant and golden. It is the colour which, in this picture, goes far beyond the Cubist conception. There is only one other French painter one can think of in this connection — Jacques Villon, whose style is determined by the balance of Cubist measure and luminous colour. Whereas in Villon's work colour remains a purely aesthetic element, in Manessier's it is expressive. Stylistically this picture is to be seen as a stage in Manessier's progress towards a

[1] Manessier was regularly represented at the *Salon d'Automne* from 1942 until 1949.

composition such as *Salve Regina* (8) of 1945. Here figuration disappears altogether and the Roman Catholic antiphon, beginning with the words *Salve Regina* recited after Divine Office from Trinity Sunday to Advent, is given expression in pure forms of colours with a Gothic uplift and harmonies as refined as the feeling dictated by the thanksgiving to, and invocation of, the Mother of God. Even if one does not know the title, the picture strikes one as an image of organ pipes in the process, as it were, of changing into music itself, into a sequence of tones transformed into colour: ice cold and cool blue and green values, composed vertically, rising and descending tones, hot red accents and brown and orange and yellow cadences with sensitive horizontal intervals, dark and fathomless. Manessier is a great master of colour. That is his most personal contribution, as is also his rich, formal inventiveness and his sense of musical harmony in arranging and re-arranging large and small forms, balancing cold and warm, mastering the orchestration of strong colours and tonal values, thus reaching combinations of a rare subtlety. That is why his art is acknowledged as a new peak of achievement in the unfolding of modern French painting. In it the luminosity of Impressionist painting is combined with the vitality and ardour of Fauvism, thus uniting power and subtlety. In 1945 Manessier painted the picture *Face of Pity*, still in the same style as *The Pilgrims of Emmaus*. The figuration, in a vertical movement, is just recognisable, the stylisation is accentuated (one is tempted to speak of crystallisation rather than stylisation) and the same is true of a picture such as Manessier's second *St Veronica's Napkin* of 1945, painted spontaneously with broad brush strokes from a strong feeling of agitation, and also *Christ and St Veronica* of 1946. There on a pale greyish-blue-mauve background two heads and shoulders confront each other, subdivided through vertical and horizontal coloured outlines into areas of warm, radiant tones —red and orange and mauve— and a third squarish area in the middle, the first indication of the miraculous imprint, a *Holy Face*. Camille Bourniquel wrote at this time: 'Alfred Manessier is like one of those Medieval artisans who received visits from great Biblical figures in his studio.'[1]

38 [1] Camille Bourniquel, *Trois Peintres*, Galerie René Drouin, Paris, 1946.

Manessier's work from these years is not, however, confined to pictures of religious themes. He always had recourse to nature, could never work without contact with it and apart from compositions such as *Christ at the Column, Christ and the Peasant, Salve Regina, Christ and St Veronica, St Veronica's Napkin, Annun-*

ciation, Water, Salt and Oil, etc., there are *October Evening, Breton Sunday, The Little Harbour, Blazing Light, The Bay* and *Port Navalo*. Some of these paintings were shown in the exhibition which Manessier shared with Le Moal and Singier at the Galerie René Drouin in 1946. Other paintings of country scenes from these years are *The Pink Village* and *Country House in Normandy*, dreamy poetic images of Proustian quality, memories woven into reality which in this way begin to live a super-real life; objectivity penetrated by and changed through a subjective response which is the essence of Manessier's inwardness. For Manessier nature and religion are the two poles between which art oscillates. It is life and spirit. Life, the miracle of Being, the *élan vital* and its manifold manifestations, and the spirit of the Christian mysteries, the humanisation of life through the sacrifice of God's own Son.

'I start painting', says Manessier, 'when I feel a very close coincidence between the scene that I have before my eyes and my inner state. That relationship releases a creative joy which I long for and need to express. Let us say, very generally, that if I am disturbed and I see a tree in tormented shapes, my canvas, even though abstract, will be peopled with each of the features of that tree in which I have recognised my anguish. I wander continually from the inner world to the outer world. To translate those relationships which exist around me, joy, the love of two beings for each other, prayer, I must turn to reality, read in light, songs, trees, stones, that joy, that love which dwells in me. In this way the world takes on its meaning. The fact that there is harmony between the inner world and the outer world proves that the laws go beyond us and include us. The Liturgy of the Church informs us of this ambivalence. Easter coincides with Spring, with the rebirth of the earth; a sentiment of religious exaltation finds response in the verdant spectacle of re-awakened nature, restored to life. This is the vital point of my painting: if I can express Easter, at the same time as a spiritual joy and as pantheistic rebirth, I have won. The Christian must not withdraw from the forces of nature. That is to cut man from his roots. For example, I have long dreamed of painting a great harvest linked to the idea of an exultation, a glorifica-

tion. I am waiting. I am not yet ready. It must be in conjunction with a personal event which may happen —or not— I know not when.'[1]

Besides Easter there is Christmas, the Nativity, which coincides with the festivity of the return of the light, 'for it is after the Solstice when Christ was born in the flesh with the new sun transforming the season of cold winter and vouchsafing to mortal men a healing dawn, commanding the nights to decrease at his coming with advancing day'.[2]

And so all Manessier's great liturgical compositions — Christmas, Easter, Epiphany —the cycle from the birth of Christ, to His Passion, Death and Resurrection— have their equivalents in natural happenings.

In these early years when he was striving after a personal style, he explained his aims in the following words: 'More and more I wish to express man's inner prayer. My subject matters are the religious and cosmic impressions of man when confronted with the world. In every way my paintings seek to be the testimony of a thing lived from the heart and not the imitation of a thing seen through the eyes.'[3]

Why did Manessier, the painter, have to pass through Cubism and Surrealism to arrive at his own style, and why has his style become non-figurative? What necessity determined both his way and manner of expression?

When speaking about all this in November 1966, he said to me:

'There is a spiritual climate which determines the style of the centuries. In every epoch there is, as it were, a leading thought like an arrow which influences all the activities of man. Consequently both the artist and the scientist are hit by the same arrow. Those who do not want to take notice of it, those who resist naively, and we may call them the "naivists", are somewhat beside the point. One is left with no choice as to the style of one's time. What prevents one from choosing

1 Jean Clay, *Alfred Manessier, Ma Vérité de Peintre*.
2 Paulinus of Nola, *Poema*, quoted from Alan W. Watts, *Myth and Ritual in Christianity*, London, 1953.
3 René Huyghe, *La Peinture actuelle*, éditions Pierre Tisné, Paris, 1941.

differently is the truth that we are part of a whole —science, art, philosophy— in every age. The arrow, that is a thing which advances. ...

The beginning of my abstract painting was an interrogation. The further I penetrated into non-figuration, the more I approached the inwardness of things. Non-figuration thus represents a historical fact; it is an approach which actualizes the present moment, it is a definite concept in this present moment of painting. Painting, again, is a movement which changes incessantly. What is active and what has actuality in the present time is non-figurative. Painting cannot but be non-figurative nowadays, otherwise it would be sentimental or historical. Abstract painting is an action, it is an act. I paint as nature acts, I employ the same process as nature does. It is nature which passes through men and is transformed in man. The artist is the very place of the transfiguration, of all the mutations, and in saying this I mean the artist who does not make himself a mere mirror of nature. The old masters had intensity in their representation. The same is required of us. On the plane of pure painting it remains the same. Abstraction, that is the consequence of a certain cultural development; behind it is a historical dialectic process of long standing. It is to be seen as a dialogue of painters, of generations of painters in the pursuit of greater refinement, greater clarity, in one word, the fulfilment of painting.'

6 THE FRENCH TRADITION

Within the history of Modern French Painting, the group of artists who broke through to abstraction in the mid-forties did in fact establish abstract art in France. Before this there was only the figure of Delaunay, whose Orphism, still considered by Apollinaire as Cubism, was unable single-handed to establish a new style. Abstract art had its roots outside France, in Russian non-objective art, in Suprematism and Constructivism, in the Dutch de Stijl movement, in the German Bauhaus (Kandinsky). Isolated figures, working early in an abstract manner in Paris, as, for example, Kupka, were not French. The lyrical abstractionists represent a genuine trend within the unfolding of abstract art in France. It is to be seen as an organic development of the French tradition in painting. The emphasis here is on painting, *la belle peinture, la belle matière*, the uninterrupted line which goes right back to Philippe de Champaigne, in whose spirit both Braque and Manessier proceeded. No less than in the beginning of Cubism and Fauvism, the works of the painters other than Manessier who took part in the elaboration of this French abstractionism—Bazaine, Bertholle, Estève, Gischia, Lapicque, Le Moal, Pignon and Singier were very much akin. Of course they discussed their aims and ambitions, but as a group they were only loosely knit. Having matured under the harsh conditions of the war and the Occupation, each of them in fact remained solitary; they had not, like the Surrealists or the Cubists, and before them the Symbolists, Impressionists and Fauvists, their permanent Montparnasse or St Germain cafés where they hammered out their theories. They visited each other, but they worked in isolation, and so it remained. In this sense

43

they were marked as a group by the war. And although it is true that at that time the subtle, often mystical and even humorous art of Klee penetrated into the French consciousness, it is also true that as painters Manessier and some of his friends stand nearer to Bonnard.

What they aimed at was, above all, the purification of the art of painting. The formal side of painting did not suppress the expressive side; form and expression were one. Art remained a human communication. It was for Manessier the communication of beauty, of joy in the manifold shapes of creation and, above all, in the light which reveals it. The whole passion of the group, and it was always a passion for painting, was concentrated on colour, and colour means for Manessier 'light'.[1] Speaking of faith which is the secret source nourishing his art, Manessier once said to me: 'I do not believe in the religious picture. It is man who must be religious. I make a difference between the subject and the object. In Corot there is a Christian light beyond compare. It is for me more valuable than all the paintings of religious themes without the light of Corot.' Quite rightly Bourniquel observed: 'Manessier is a mystic through the intensity of his temperament and the authority of his palette.'[2]

Lyrical abstractionism, having been established as the particular French contribution to abstract art, thus fulfils the spirit of French tradition. Such a statement, however, must not be interpreted in a nationalistic spirit. Manessier himself would never accept such a narrow interpretation: 'That I am called a painter in the French tradition honours me but also makes me feel embarrassed. For me the meaning of these terms is opposed to any nationalism. French painters have always been open to impressions from other countries. I copied Rembrandt in my youth, Rubens, Titian, Tintoretto. They are not French. To be sensitive to influences means an enlargement, an expansion of the consciousness of the world. To forget this enlargement of the world's consciousness

[1] Werner Schmalenbach, Alfred Manessier, Preface to the Catalogue of the Exhibition in the Kestner Gesellschaft, Hannover, December 1958–January 1959.
[2] Camille Bourniquel, *Trois Peintres*.

45

would impoverish one. It is a gift. But it is also important not to forget the fact that every place has its own essential individuality.' He spoke of the 'personalisation' of places. Enlarging on the great traditions of single countries, he gave Chartres Cathedral and the pyramids as examples. 'Pyramids are unthinkable in France. They have their own aesthetic laws and to isolate such a form from the country of its origin is impossible. They are dependent on the radiation of the place they occupy. A tree can grow in a certain ground only and not in another. This is what tradition means for me. A great tradition is to make entirely new things but they must have their roots, roots which condition the object by its place.'

Manessier has his own ideas about *influences*. French artists on the whole work consciously or even unconsciously on the evolution of French art. They discuss problems, they learn from each other, they build up a leadership and a style. In other countries, which cannot pride themselves on any contribution to the modern movement, countries which always remain dependent, artists are attacked for 'borrowing'. As if any artist could only draw inspiration from himself the way a spider spins his thread.

The importance of Picasso for Manessier, for instance, was limited to his Cubist period. But what an impact it was! It flung him, in his early youth, out of his provincial isolation into complete bewilderment. Grow wings or be shattered! It was in Amiens, in 1928 —he was then seventeen— that he saw in the library an art review with some Picasso reproductions from the Cubist period. The name was unknown to him, even by 1928, but we have the consider that the French provinces suffered from a gross lack of information. Manessier was staggered, but his friends only laughed. He suddenly felt quite alone amidst all this laughter, for it unmasked to him stupidity before the unknown. 'In spite of myself', he said to me, 'I was attracted by these paintings, without understanding them.'

'Influences', Manessier exclaimed, 'are always present if an artist is sensitive. It may be unpleasant, for it means a fight against the influences which one is forced to resist. Influences — that is a dialogue with, and also an opposition to

another personality. It is a fight which enriches one. What is at stake is oneself. Rembrandt was my first idol when I arrived in Paris. For six whole months I copied the Bathsheba painting. What human quality is in it, and what intimacy! Later, in the Hague, I was more moved by Rembrandt's drawings than by his paintings. There is no aesthetic idea in his work, his art stems directly from life; it gives again what in his humanity he received from it. There is absolutely no lie. His feeling is deep, his drawing traces his human emotion. You can follow, as it were, the thought of his line as it formulated itself in his soul. What an undertaking! Tintoretto has moved me less in the human way, but has fascinated me nevertheless. His art was more "official". Renoir again: when I copied him, that meant the liberation of my technique. ... It was painted in an easy manner, carmine was flowing as freely as feeling. The way that Renoir attacked his subject amused me a great deal. But only on the plane of technique. ...' Speaking about Lapicque Manessier recalled the Exhibition *Young Painters of the French Tradition*: 'We had not the same horizon, we knew each other only vaguely, but it was a collective effort, our thoughts arose from a common basis. The most influential man then was Lapicque. He was in fact the animator in the sense that he brought into our discussions a new restlessness beyond Cubism. One had to begin anew, from zero; all was broken up again, dissipated. In those days one had to be strong to stick to one's painting. There was no market, no dealer, no money. It was the same for all of us. We burned chairs to make a fire. We began in a way as a community with certain affinities but later on each of us reached his own autonomy. We worked with the utmost consistency within the framework of our own disposition.'

Lapicque's influence on Manessier made itself felt between 1942 and 1944. His Impressionism had a certain transparency of form as its characteristic. Manessier was susceptible to this. But this transparency soon provoked a certain dissatisfaction in him which he had to overcome. He continued his investigations in other directions to resolve the contradiction which he felt inherent in it. A picture, he reasoned, has the character of a wall; he therefore had to find the wall again.

PART TWO

7 FIVE LANDSCAPES

That phenomena from the interior and exterior world alternate in Manessier's work has already been established. 'I am a peasant', the artist said to me one day, 'attached to my roots. I live with the seasons and I am entirely dependent on light. I draw a great deal from nature.' And in adding the words 'I am not an intellectual', he clearly wished to convey that his non-figurative trend was not chosen or decided upon at random but that it stemmed from an inner necessity. He spoke simply and unpretentiously as always: 'It is good to have firm foundations.'

To what extent do the formal elements of landscape, its structure, its rhythm, its light, penetrate into his non-figuration, and in what way are they reflected in the religious themes which he painted either at the same time or afterwards? In *Landscape for Easter Day* (16), of 1949 the two sides of his art are contained even in the title of the picture.

In the manifold and refined development of Manessier's non-figurative style there are also, apart from the landscapes which he 'experienced' at various times, definite turning points where style and concept have changed, where new enriched visions were born to unfold slowly until they blossomed. Always receptive, inwardly alert, the artist ventures further, to sing new praises to creation and to the Gospel which is to him man's compass in life.

Each of the landscapes which confronted the artist offered him a new sensation, a new light, new tensions, new formal elements which entered his art. Manessier became attached to these places and found over and over again that the same

pictorial problem, placed in a different environment, became quite another problem for him. Feeling the coherence in all things, being conscious of and sensitive to the variety which life's scenery offers, he feels that all things are always new, untouched by previous experience, and that they become symbolic when connected in his mind with religious motifs. Thus, having painted many pictures with the theme of night *Le Bignon at Night* (5), 1945, *Longwy at Night* (24), 1951, *Nocturnal Reflection* I (28) *Nocturnal Reflection* II (26), 1952, *Per Amica Silentiae Lunae* (of Le Crotoy) (48), 1954, *The Night* (65), 1956, *Night at Le Mas* (83), 1959, *A Night of the Epiphany*, 1966, *Nocturnal Forces*, 1966, to mention only a few — he could sit down one afternoon in the winter of 1966 and say dreamily: 'I would love to paint another night, that very night of Good Friday in Palestine. ...'

The years 1942 to 1944 were an important turning point marking the end of pre-war influences. The Surrealist adventure was a short-lived one. Addressing Dorival, Manessier declared: 'For me, the nightmare of the war liquidated Surrealism.' And significantly he added, referring to a wider frame of similar affiliations: 'I have always suffered from the deformation that I imposed on the human figure. It was the truth of Rouault, of Picasso and many others, but it was not my truth. It was a caricature of what I intended to portray. Expressionism, the communication of an inner feeling, of suffering, by an individual grimacing, I have practised it, but that has become unbearable to me and very superificial. I have given it up.'[1]

I remembered the words he had said to me: 'I have a compass in my work but the way has always to be discovered.'

Thus, experiencing a kind of irreverence, revolt, arrogance or even blasphemy in any sort of deformation, Manessier, the religious man, aimed in non-figurative art at expressing a state of pure spirituality. What he manifests in his balance of

[1] Bernard Dorival, *Manessier, Artisan Religieux*, in *L'Œil*, No. 10, Paris, October 1955.

53

colour, composition, line and chiaroscuro is unquestionably a classical element, the classical element in French tradition.

I have also mentioned how during these years (1942–4) Manessier introduced certain Cubist and also Fauvist elements to meet his inner needs. What were those needs? These he himself explained in 1955: 'For myself, I make paintings that respond to my thirst for harmony and unity, to that re-ascent towards "myself" reconstructed step-by-step, towards that world lost from grace; but that painting is very far from the general public; because the public live in a materialistic world and no longer encounter in themselves that need. ...' And he added: 'To-day's man seems no longer to need us. But without tiring one must whisper to him that a world of harmony and love does exist — or rather, prove it to him. ... Artistic creation demands two conditions. First of all one must not say: "I will", for the exteriorisation of inner states demands a kind of abandonment of self; next, one must possess a great deal of love; this alone will allow us to carry our subject to its complete fulfilment, i.e. to the stage where it becomes so far humanised as to acquire a general importance.'[1]

With the *Pilgrims of Emmaus* (11), of 1944 and similar pictures from that time, the period of proto-Cubist figuration has come to an end and Manessier's first stage in non-figuration begun. It lasted until 1948. Manessier clearly explained what non-figuration meant for him. And Michel Seuphor declared:
'Non-representational art seems to me to give the modern painter the best chance of reaching his personal reality, of becoming aware again of what is essential to him. Only when he has understood this and made it his starting point can an artist eventually regain balance and revitalise even the external reality of the world. If man is indeed a hierarchy of values, then his outward appearance is merely a transparent envelope if void of spiritual content.'[2]

It was in this period up to 1948 that such important pictures as *Salve Regina* (8), 1945, *The Sunken Cathedral*, 1946, *The Construction of the Ark*, 1946, *Salome*, 1946,

[1] Bernard Dorival, *Manessier, Artisan Religieux*.
[2] Michel Seuphor, *A Dictionary of Abstract Painting*.

St George in Combat (9), 1947, *The Ascent to Les Bréseux*, No. 1 (13), 1947, *The St Matthew Passion*, (12), 1948, (for the refectory of the Dominican Monastery in Paris, in rue de la Glacière) were painted.

a Le Crotoy

In 1948 Manessier returned for the first time after the war to Le Crotoy, his childhood paradise. He had not seen it since 1939.

As the titles of the pictures from Le Crotoy themselves indicate, the forms, the colouring, the chiaroscuro of the paintings are derived from the Somme landscape. These, both oils and watercolours, were produced in a first series in 1948–9: *Flood Tide in the Somme Bay* (20), 1949, *The Harbour, Le Crotoy*, 1949, *The Quays*, etc. A second series followed in 1953–5: *The End of the Jetty* (41), 1953, *Rising Tide* (42), 1953, *Dead Water* (44), *Low Tide, Barges* (46), 1954, *Northern Spring*, 1954, *Northern Harbour*, 1955, (45), *The Little Harbour*, 1955, etc.[1]

It was only then, and not in his earliest pictures, that the true face of Le Crotoy emerged in his work. On these sands of the Northern coast, contemplating the ebb and flow of the tides, the sky and the waves, the flight of the birds and the strange shapes of the debris left behind by the water, Manessier conceived all the paintings which established his name.

There is no deliberate or formal use of abstracted shapes neither do we encounter here an inventiveness of a purely rational kind, nor are the variations conceived as values in themselves. A relationship to some objective phenomena is always traceable. That the picture after it has been finished begins a life of its own, displaying its own virtues—this is what gives it validity. One example may elucidate this procedure. Between 1950 and 1952 Manessier painted a whole series of pictures entitled *Winter*. He once caught sight, through the window of his Paris studio, of his children playing in the yard below. Heavy snow had fallen the night before, covering certain surfaces and leaving others as dark shapes embedded in the whiteness. The children wore red triangular woollen hoods and played with coloured balloons. Out of these elements Manessier composed his

[1] In the case of the Le Crotoy landscapes the titles of the pictures are quite obviously related to the subject matter. Often, however, paintings are provided with titles long after they are finished. Any of his paintings may change considerably during his work and Manessier's principle is: 'I always allow the painting to take command of me. It is always the painting itself which directs me.' Sometimres again a title is decided upon in advance, for instance *Gethsemane* (25), 1951.

pictures. For the spectator details of the scene just described are quite irrelevant. What counts is the beauty and the impact of the paintings. The atmosphere of a sunny, gay, crisp winter landscape is caught in them. In the case of the Le Crotoy landscapes it is the shapes of barges in the water enclosed by the harbour (*Barges*), or the strange formations created by the receding water (*Low Tide*), with elements based on the delineation of the shores, of the shape of pebbles, of shells, the fishermen's gear, the atmosphere of the seascape, etc., which determine the abstract language with its vocabulary, its grammar and its syntax.

Here it is important to underline once more the painterly and spiritual angle from which Manessier observes nature in order to transform it into art, i.e. into a human statement. At home in Le Crotoy Manessier amused himself in collecting on his walks various natural objects. Manessier once spoke about them to Bernard Dorival when the latter visited him there: 'If I collect them it is not because I believe in *l'art brut*. *L'art brut* — that is an act of love on the part of Creation, it is not an artistic creation. These pebbles are beautiful, but they are not works of art. They are objects for meditation. They have a suggestive power. Art is not collecting these things, it is seeing the equivalence between this sky and those shells, it is demonstrating those equivalents.'[1]

It is Manessier's poetical conception which enables him to produce these gems of painting, in which the colours shine like jewels. His colour scheme at that period oscillated between various nuances of blue, of amethyst, with occasional strong accents of blood red. He harmonized the violet shades with purple ones, the rubies with sapphires, thus achieving airiness and transparency within a firm structure, for which he often employed a deep velvety black. There is, in fact, always the contrast between black and white, securing the coherence of the picture, and there are subtle transitional passages between them in fine tone values, or passages between primary colours and tone values, of which he is a great master. Manessier achieved in Le Crotoy such subtle harmonies that he must be ranked among the finest French colourists after the Impressionists. In the words of

[1] Bernard Dorival, *Manessier, Artisan Religieux.*

58

Dorival, 'His nuances and half tones were most delicate, the pearly greys, the pale beiges, merged into the pinks, the blues paled into lilac, the yellows died away or became golden, creamy whites made their appearance.'[1]

During the years 1946 and 1947 Manessier seems to have preferred a certain lyrical restraint, the quality as it were of chamber music. It was only afterwards that the colours grew in intensity and even in purity, without ever becoming provocative or obtrusive.

Looking back on this period, Manessier remembered the difficulties he encountered when searching for his style, his own language. In the beginning the works were too geometrical, even dry. The dryness was not deliberate, it was a manifestation of his uncertainty. He also had difficulties with the design — it all remained too static for his taste. The *écriture* then was somewhat systematic. All this involved him in new research, aimed at attaining full liberty of expression, at achieving a balance of the elements which make up the picture. There were whole series of water colours and oils from the time of *Flood Tide in the Somme Bay* which were then abandoned.

Manessier spoke to me one day of having taken great pains to master the craft of painting. '*J'ai beaucoup de mal à maîtriser le côté artisan*. An abyss yawns between the craftsman, who is firm and confident, and the artist, who is humble before his task. That is really what matters: to keep each thing in its place. When everything is harmonised, painting is at its highest.' For the abstract painter another difficulty arises. 'There is no fixed language. Any fixed language would lie. We have always to renew our mode of expression. Nevertheless — there is a unity in my work.'

By about 1949 it is evident that Manessier is seeking to enlarge the scope of his expressive powers, to give them greater fullness and strength. The outlines in his paintings become more precise, more vigorous, accompanying the intensification of the colour, and he increases the size of his canvases. But even here the purely artistic and spiritual qualities are the guiding principles. 'I am very

[1] Bernard Dorival, *Manessier, Artisan Religieux.*

particular in deciding about the size of my pictures. Each subject matter, each statement, requires its particular physical presence. A still-life motif asks for more discretion. For religious themes I feel the need for a more monumental expression, for a landscape again this may become too large. The physical presence of a religious theme is conditioned by its sacramental message, the idea which it represents, the use for which it is destined. All this is important.'

By this time Manessier occupied a place in his generation which, as Camille Bourniquel wrote, was 'truly exceptional. It is rare for an artist to gain his position from the very start and succeed, from his first works, in imposing his personal vision and his own demands'.[1] That this was made possible was only the consequence of a truly honest and modest attempt to honour French tradition.

In a letter to Dorival in 1943 he wrote: 'On my return from the war, out of, as it were, a most profound impulse in me which was related to a need to restore my heritage to its rightful place. ... I clearly perceived, in a moment of despair for the future of French painting, how essential it was to widen one's love rather than to continue to tear oneself to pieces and to undermine oneself — and then suddenly, without my knowledge, extremes came together. What seemed to me irreconcilably opposed —Bonnard, Picasso, for example— found to be complementary. I stress the inner and subterranean character of this work. It has all unfolded since the war, as an outcome of those events.'

Among the religious motifs which were produced at that time, are *The Light of Epiphany*, a sovereign evocation of night, the mystery and beauty and message he unveiled step by step in many paintings devoted to this theme. There is also *The St Matthew Passion*, (12) which took shape in his imagination when he was listening to Bach's composition of the same name. Imprinted as it were on a strong carmine background, moderated here and there by orange and pink tones, there are the hieroglyphics of the evangelist, in a sensitive and economically applied pattern of lines, suggesting iron bars and cruel crosses with squarish or oblong thickenings, creating balance and tension, evoking faces and bodies on

[1] Camille Bourniquel, *Trois Peintres*.

that pulsating ground which speaks of blood and redemption. In the verticals —strong verticals which seem to rise and fall— and the horizontals of this painting, Manessier created an architecture which corresponds to the spiritual content of its narrative. Thus, the personal architecture of Manessier's work evolves slowly, leading him on in his determination to reveal his doctrine as did the masters of Byzantine, or Romanesque, or Gothic Art. It is of the utmost significance in his case that *Salve Regina* (8) was built up in the same way as *Flood Tide in the Somme Bay* (20) and that this picture in turn announces the style of the paintings which were based on the landscape of Holland. There is *Angelus Domini Nuntiavit Mariae* (10) of 1947 with its base in green and red, dark blue and luminous blue with brown and pale pink accents, with a design suggesting a rising rhythm (there are linear elements in the design resembling ladders and steps), evoking also the sensation of the sound of bells, that is to say the colour equivalents corresponding to them and their vibrations, all designed in the basic shape of a *mirador* or watchtower. How closely-knit the evolution of Manessier's pictorial language is can be seen from the fact that the same principle of composition applied here makes its appearance also in the stained glass windows for Bréseux.

When Manessier exhibited in the gallery of Jeanne Bucher in 1949 all the paintings were on the theme of Easter. Similarly, a later exhibition, that in the Phillips Collection in Washington, 1964, was also devoted to the same recurrent theme in Manessier's work. But the style of these later pictures was determined by his journey to Spain, with the impact which the Spanish landscape, as well as the work of Goya and El Greco made on the artist. The paintings entitled *Homage to Goya* (97) and *Garden of Olives or Homage to El Greco* (102), were included in this series. There is also a *Homage to Miguel de Unamuno* (104), the great Catholic Philosopher of Spain whose works carry a religious message for our time, just as, in France, do those of Léon Bloy, Jacques Maritain, Pierre Teilhard de Chardin, Gabriel Marcel, and Manessier's friend Emmanuel Mounier, whose critical attitude in his essay *Feu la Chrétienté*,[1] analysing modern society in its relationship

[1] In *Œuvres de Mounier*, 3 vols., 1944–50, Editions du Seuil, Paris, 1962.

to Christianity, is of particular interest to us. It is Manessier's own creed and confession.

In the same year of 1949 and accompanying the exhibition at the Jeanne Bucher Gallery, Manessier's first portfolio of seven lithographs, also on the theme of Easter, appeared. This portfolio had enabled Manessier to master this branch of the graphic arts. He studied the technique of lithography very thoroughly. To him it was a means not merely of reproduction but of creative expression, a means in its own right, like painting. Seen from this angle, Manessier produced original works of a strong impact and technical novelty.[1] Another important collection of eleven lithographs illustrates, if one might so describe it, three Spiritual Canticles of St John of the Cross, published in 1958 with the translation into French by Father Cyprian of the seventeenth century.[2] In 1962 there followed the lithographs for a poem by Charles Péguy, written as a tribute on the early death of a young friend, (*La Présentation de la Beauce à Notre-Dame de Chartres*).

The book containing the poem by Charles Péguy has 64 pages and is entirely printed by lithography, including the text which is handwritten by Manessier himself. The illustrations alternate with pages of text. The general colours of the book express la Beauce, the ripe fields and country flowers: yellows, blues, reds, etc. Certain of the more dramatic motifs are in red, indigo and yellow. The book ends on the theme of 'hope', with clear yellows, reds and blues.

Manessier employs stone as well as zinc plates for his lithographs and never uses more than five colours. Whereas the seven lithographs on the theme of Easter were printed in the Atelier Pons, the St John and also the Charles Péguy series were printed in the Ateliers of the brothers Mourlot, both in Paris.

In 1958 Manessier also painted a picture *Homage to the Holy Poet, St John of the Cross* (73),[3] which became the property of Charles Laughton, the English actor

[1] In one of the albums which contained notes, sketches of compositions, photographs of works and personal photographs, I found pages of notes concerning the printing of lithographs, its techniques, the phases of the various procedures, culminating in his emphasis on freedom. 'Do not take a course of lithographic technique!' It is through experimentation that Manessier developed his own style.

[2] In 1971 the lithographs on the themes of The Spiritual Canticles of St John of the Cross served as models for twelve large tapestries.

[3] To Manessier St John of the Cross was at least as much a poet as a saint. Hence the title.

63

and friend of the artist. Laughton loved this painting as it made him think of the death of King Lear. He suggested some time later[1] that Manessier should come and watch the performance at Stratford-on-Avon. The painter was very moved by the intensity of his acting.

The painting *In the Flame which Consumes* (72) of 1957 again shows how richly inspired and profoundly shaken Manessier was by this Spanish poet and saint. The idea of the painting is based on the interior fire, which lights up the night and destroys its bearer. It has a jewel-like quality, expressive of redemption and ultimate joy, inner peace and illumination as the outcome of suffering.

Other religious themes painted in this period, apart from the *Evening Litanies* (37) of 1951–2 and *Nocturnal Reflection* I and II, already mentioned, were *The Passion of our Lord Jesus Christ* (32), *Barrabas* (29) and *Lord, Shall We Strike with the Sword?* (36),[2] *Hallelujah* (34) of 1952 (two versions) in its explosively gay colouring,[3] and Manessier's first *Crown of Thorns* (35), all painted in 1952 and exhibited in the Galerie de France (December 1952–5 January 1953).

In 1954 he followed it with a further *Crown of Thorns* (40), a dynamic composition, both in design and in colour, and expressive of a religious and artistic power that is quite extraordinary. This masterpiece won Manessier the great international prize for contemporary painting at the Carnegie Institute in Pittsburgh.

One of the paintings of this period deserves special comment. It is *Longwy at Night* (24) of 1951, the picture of an industrial landscape in Lorraine inspired by the iron furnaces working at night. 'It was at that time', Manessier told me, 'that I stopped breaking up forms, planes and light, a procedure which made me suffer more and more and which might have had its origin in the influence of Lapicque. After a long period of struggle to introduce large colour surfaces, I felt that I had found myself.' The background of *Longwy at Night* is orange, the mood nocturnal. The interior of the islands which form the composition is divided and subdivided geometrically with long horizontal passages which join them

[1] November 1959.
[2] The question of the disciples at the moment when Jesus was arrested.
[3] Altogether Manessier made seven or eight paintings on this theme.

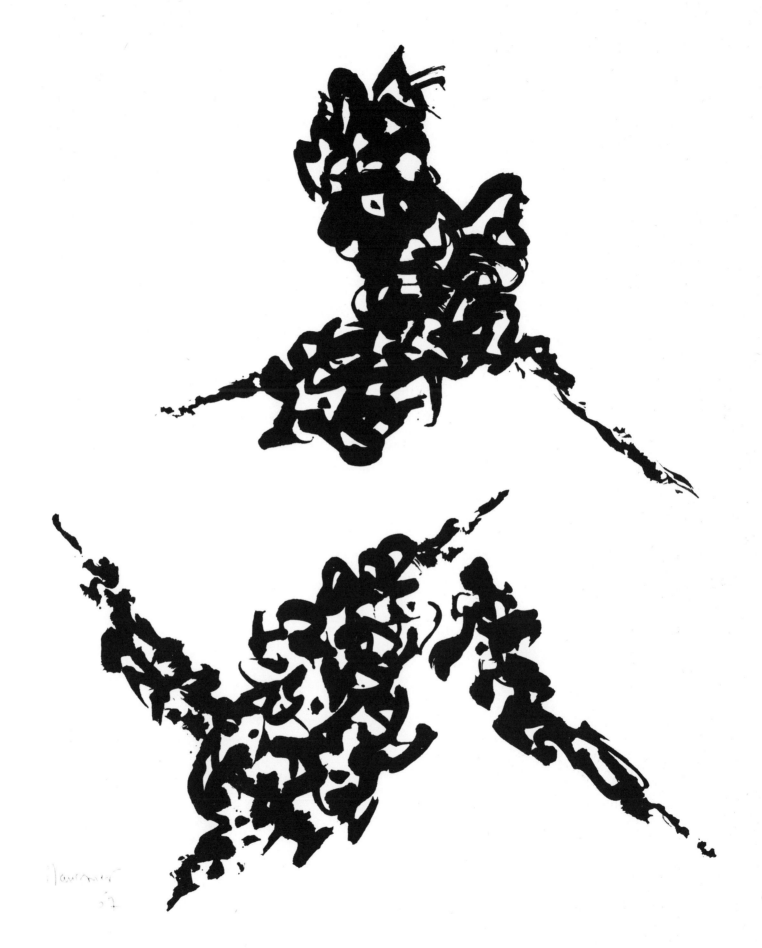

65

together like gangways; brilliant colours on a greyish base, rather lyrical in its conception, redeeming so to speak the primary hellish aspect. This painting in its composition of 'islands' was anticipated in pictures such as *Landscape for Easter Day* (16) (in orange and greys) of 1949 and *Forms at Dawn* of 1951, and seems a variation of them. In its final form, however, it indicates a new change of *écriture* and from *Longwy at Night* (24) many paintings of the period that followed are formally derived. Compare, for instance, *Gethsemane* (25) of 1951 with its elements of Eastern calligraphy, or the humorous *In the Pasture* of 1954, representing forms with the 'landscape' inside them, or, again *Nocturnal Reflection* II (26) of 1952, with its vertical rising rhythm. Another vertical rising composition is *Evening Litanies* (37) of 1952, with its elongated shapes and strong contrasts and the chalice form, introducing the symbol of the libation. *Per Amica Silentiae Lunae* (48), on the other hand, a title derived from a poem by Vergil, is directly connected, in its clarity and lyrical peace, with the elements of the Le Crotoy landscapes, as for instance in *Dead Water* (44) with its ivory base and its islands in grey studded with fine blues, ochres, pale greens and black as its dominating colours.

b Holland

The paintings in which Manessier distilled his experience of Holland, the impact which the Dutch landscape made on him, are certainly one the culminating achievements of his career. Never before, not even in Le Crotoy, had he developed such an inventiveness, had he combined such a variety of forms. In both landscapes, that of Le Crotoy and of Holland, the Northerner felt at home; both meant a step forward in the unfolding of his art. At an early stage his non-figurative style tended towards a rather formal character and there was the risk that it might become encased and rigid. 'Painting', he once said to me, 'has a tendency to close up or to open up. There is a need for *éclatement*, for eruption, for renewal.' And it was Le Crotoy and, afterwards, Holland which provided him with this sensation. Holland deepened his love for Rembrandt. In Rotterdam he saw an exhibition of Rembrandt drawings, in Amsterdam he admired the perfection in the art of Vermeer, in Haarlem the late pictures of Frans Hals. And, being a volatile artist, subject to depressions and outbursts of creativeness, he learned here the great lesson that an artist need not despair. There was the case of Frans Hals. He lacked freedom of expression, his art remained on the surface nearly all his life, but towards the end of it, particularly in his great group portraits of the Regents and Governors of Charities, he reached that triumphant liberation which made him a very human and great painter. To Manessier, Frans Hals is synonymous with the virtue of hope.

The Dutch paintings of Manessier himself reveal an intense *joie de vivre*. They are an outburst of painterly vitality quite unique in his – *œuvre*.

Ell de Wilde, with whom Manessier connects his artistic experiences of the Dutch landscape, wrote of him:

'Manessier comes to Holland in February 1955. He stays there eight days but those eight days are as good as a year. What he had searched for in those last years, in the region of the Somme, found its fulfilment in Holland: the light, noble as the flash of silver, colour strong and deep, the atmosphere modulating the fine shades of colour, the horizon where the houses and the trees unite in a

living harmony, the country below, flat and straight, patterned like a chess board. That is the image of Holland which so impresses itself on Manessier as he walks along a canal cutting the snow-covered countryside, enraptured with it. He measures the intensity of the light and the living colour of the reeds in the snow; a sunrise in the wintry brilliance reveals to him a world of poetry. He sees Amsterdam in the rhythm of its luminous façades: Rembrandt, Vermeer, Frans Hals. ...

All that he observes finds an echo in his enchanted spirit: in the vast dimensions of the Dutch countryside, he goes through a profound and inevitable emotion from which the new image emerges at last clear and distinct. His desire for expression takes on a new vitality: his encounter with Holland is for him an inner liberation. In a letter he wrote to me on his return to Paris, he says: "I am conscious of a great development, a Dutch melody which has been dormant in me for a very long time."

First of all he makes small sketches in which he translates fragmentary impressions. Little by little, his memories and his experiences crystallize into a series of definite images: he produces bigger pictures; the colour is deep and yet clear, the light intense, the form confined within its outlines, the brushwork free.'

For a year he works on the theme of Holland. There is no hesitation: the tension of the evolving shapes remains with him until the picture is finished.

A new way has opened in the art of Manessier.

De Wilde always realized about Manessier that 'in present-day painting, his art is a reality that one cannot deny';—that with him 'the inner picture and the memory of the exterior world observed are superimposed so that in the end they create together a synthesis which finds its expression in the picture'. He saw that 'nothing in his art has the tendency to become a system, and thus it avoids falling into an empty and meaningless mannerism'.

To Manessier, a man of the North as much by his origin as by the resolute and passionate character of his temperament, the North, with its chiaroscuro, appeals so strongly that he is able to apprehend things that do not easily yield themselves

up. Manessier, says de Wilde, 'is also a man of the North in his attitude to life. As a man as much as an artist, he looks for the road of inner liberty, by giving himself up to life. His art is not born of an aesthetic ideal, but is more of an inner experience. His singular predilection for Rembrandt springs from that attitude towards life and art; he loves Rembrandt not because of the manner in which he resolved the problems of form, but because of the way in which he understood life.'[1]

Again and again Manessier spoke to de Wilde about his attachment to Rembrandt:

'Rembrandt did not plan his life, nor, indeed, his art, in an ordered way; he allowed them to happen. His art has weaknesses, and, unlike the Italian masters of his century, whose desire to create an art that was divine, sublime, grand, came from a brilliant intelligence, Rembrandt came to discover in himself, by giving himself up to life, that independence, that richness, that inner freedom that triumphed in him; and from himself and from living, from that discovery of himself and of his importance as a man —all experienced through his particular trials— there comes an intensity, an effusion, a warmth, whatever it is that makes the heart bigger, more fraternal, more sensitive, more approachable, more merciful. That is Rembrandt's victory over life, over all kinds of miseries, over wretchedness and also over his own personal weaknesses. It is not a question, as with the Italian aesthetes, of Beauty and its cult, but simply of the cult of love — of charity, of the importance of the heart.'

Manessier's Dutch experience is part of his artistic search for a new form, a new expression of the Northern landscape. Here then they are, these images of Holland, emblems of the character of its landscape, of its essence. There is the *Northern Harbour* (45) of 1955, rectangular, almost purist or Protestant, or a homage to Mondrian's spirit, one might suggest. Shades of yellow, pale blues, greys, light mauves, with strong accents of black on an off-yellow ground. The following pictures were all painted in 1956. *Near Haarlem* (60), can be read as a

[1] Catalogue Manessier 1955–6, Holland, Galerie de France, Paris, 1956.

solemn text in dark blue Chinese lettering interrupted only by the light of a yellow triangle and a half-moon-shaped form resting upon a pale grey ground. But in *Dutch Harbour* the small forms are scattered gaily in a chatty way, reds and blues and pinks and ochres, with definite, dark, although soft delineations. One can smell the sea water, one can see the pennants fluttering in the wind, one can hear the ships' bows playing in the waves. In *Silvery Canals* (58) all this is heightened into a pale blue crystal clear laughter of completely relaxed happiness.

There is a picture of *The Wind and the Dunes* where, against a background of large, ribbon-like shapes in yellow, pink and orange, we find a composition of thin stripes, darker in accent, serving as elements of movement or lines of force, with a pale yellow winter sun adding its formal accent.

The shapes used in this painting are all well observed, they are the elements of the Dutch landscape, of its rhythm, of its movements, of its conglomeration of forms, meticulously annotated by the artist.

If *Snow-covered Polders* (50) emerges as a more static and severe variation of *The Wind and the Dunes*, then *Little Dutch Landscape* (59) seems a more intimate statement, like chamber music, in its fine tone values of pale blues, pale greens, and a few yellow accents (yellow appears in nearly all the Dutch paintings) superimposed on larger shapes of light and dark orange colour against a background of pink-mauve. *Festive Canal* (61), leads to *Festival in Zeeland* (52) with its slimmer and sharper shapes in dark colours against the background of yellow vertical ribbons embedded in grey. Here are the basic forms of canals, of small harbours, of windmills, of fishes and reeds, of boats and sails, of birds in flight and dancing waves, of fields and houses, of fishing nets, of the sun in a wintry sky shining on the whiteness of the snow in air pure and crisp, so that every outline appears well defined and clear. Large and small forms create refined harmonies.

One day, in the middle of winter, Manessier felt the spring approaching. He painted his *Call of Spring* (55). Strongly delineated green shapes contrast with an orange background, patches of water, triangular and irregular, mirror the blue sky, and the small forms in mauves, pale blues and pinks are the fields awakening to the call of the sun. How fertilely the artist's mind reacted under the impact of

70

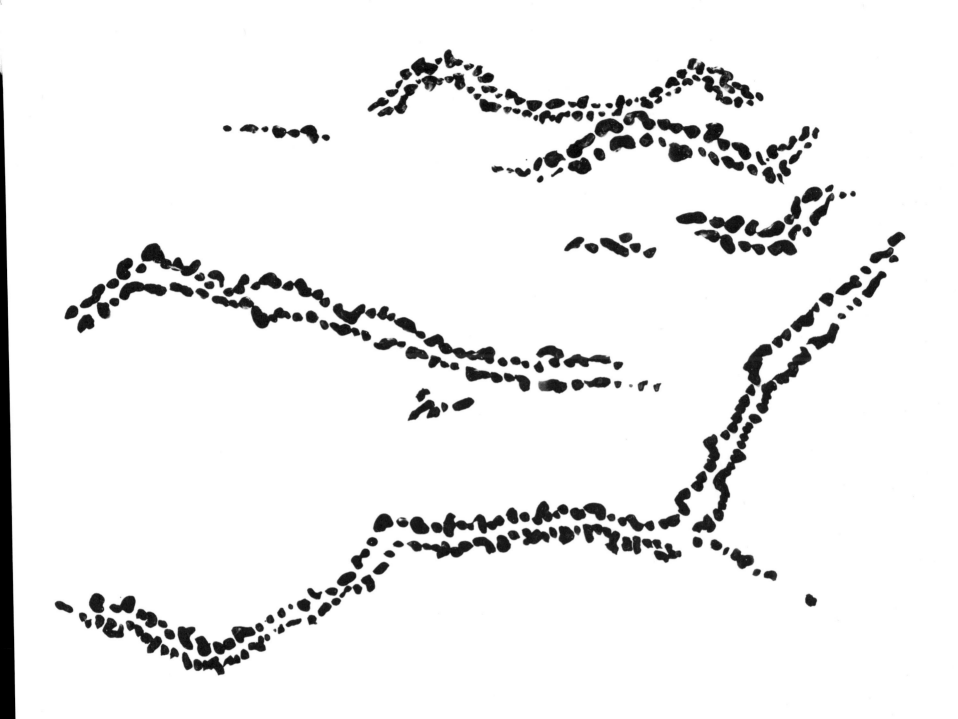

these experiences can be seen in a painting such as *The White Bush* (57). Here and
in *Homage to the Poet St John of the Cross* (73), of 1958, we have already a foretaste
of what Manessier was to develop in a later phase of his work, this time under the
impact of a Southern landscape and its dynamic quality : the landscape of Provence.

Holland was like a fanfare of joy in Manessier's orchestration. In *Requiem for*

71

November 1956 (64), on the other hand, he plumbs the depth of his tragic feeling.
(November 1956, the drama of the Hungarian uprising.) It was a sinister, depress-
ing episode which made Manessier cry in his helplessness. His great restlessness
is discernible in the nervous strokes and the agitation of the drawing. The
elements of the picture are composed as if they were a reminiscence of some land-
scape, but they resemble also a shattered crown of thorns rigidly conceived as if
made of iron, killing and murderous. There is a fiendish yellow confined to
narrow shapes, and stains of blood. And the darkness of an endless night and
the violence of despair.

Festive Canal (61) and *Requiem* (64) represent life's extremes; this is the wound
and blessing offered by existence to man. It is the essence of the tragic sense of
Being, expressed in pictorial language. *Requiem* — that was the rift in human
happiness, an anticlimax to optimism. In Manessier's work there followed a
series of religious themes: *In the Flame which Consumes* (72), of 1957, *The Sixth
Hour* (69) (on the cross), of 1957–8, *Homage to the Holy Poet, St John of the Cross* (73),
of 1958 and others. What he felt in the days of the Hungarian uprising he express-
ed in a conversation with Georges Charbonnier. Speaking of his *Requiem*, on
which he was then working, he said: 'It is certain that I was almost afraid of that
canvas. It was almost the canvas of despair. It cannot stop there. There's
nothing to be done: I cannot live with that thing under my eyes. The truth is I
must rescue it. And it is through painting that it can be saved, that it will be
saved. At least I hope so, otherwise it will be completely lost. ... Despair is
something in which I do not believe. It is cowardice. It is surrender. I do not
condemn any man for despairing, but it seems that in going beyond the transient,
beyond material things, despair is not possible. That is a reality which I contin-
ually touch in painting. Often my canvases pass through moments that are
almost despairing, but I have seen, I know by experience that they need not stay
that way. Out of despair hope can be born. ... That is something that I have
repeatedly lived through.'[1]

72 1 Georges Charbonnier, *Entretien avec Alfred Manessier*, in *Le Monologue du Peintre*, Paris, 1960.

c Provence

With the drawings, the pastels, the paintings and the washes on themes from Provence we notice such a violent irruption into the well-balanced style of Manessier's previous work that there might be justification for saying that a new painter was born in him. We are accustomed in our times to sudden changes in the style of contemporary artists. These are often dictated by mere intellect, by the cry for novelty, and achieved by means which shock the beholder. They are elaborated quite rationally and in a detached manner, leaving out entirely the human reaction in the artist, who thus becomes a mere producer of commodities, an adventurer. That, however, cannot be true of Manessier, a man with strong beliefs, a painter as ardent as he is honest and stubborn, a person who is proud as a craftsman but humble as an artist. What happened? We have known him as a painter imbued with a sense of calm, of harmony and even of classicism, an artist who, although anchored in post-Cubist art, rediscovered Nature as a primary source of inspiration, who re-established its validity in the face of the ever-increasing pressure of doctrinaire abstractionism. After his encounter with the South he appears to have become fascinated by violent movement, by torrential events. Shall we now call him an Expressionist? Yes, if by that we mean that such an unclassical form-language as that of Expressionism also corresponds in its own way to nature and that it is the new sensation which accounts for its existence. It is not the purely subjective Expressionism with its obligatory deformation which thus finds its way into Manessier's work, but it is the expression of a side of nature which is as valid as its opposite, as the contrast between a clear spring morning and a stormy winter night. Of course Manessier knew of the conjunction of opposites in his art, he knew the meaning of spring-Easter, and of winter-Christmas, he knew the peace of Le Crotoy and the tragic emotion of the *Requiem* — but here for the first time such a wide range of forces were released in him that a new style was born.

Manessier would not have dared to face the light of the South which attracted Van Gogh, Cézanne, Matisse, Bonnard and even Picasso, had it not been for his

73

friendship with Camille Bourniquel, which led him to embark on this adventure. But it was also something of a necessity. As he himself says: 'Only the attraction of friendship and the need to relax after the excessively rainy month of August 1958, brought me there.' There were two stays, one in 1958, brought about, as it were, by accident, and one several months later, in 1959, planned with the object of pursuing his research into the fascinating new landscape, particularly its dynamics, and of recording its movements in innumerable drawings. And there is another important novelty in this development. Whereas, before, his drawings, for instance those produced in Le Crotoy, were rough sketches, simple annotations, here they acquire a different character. 'He finds an immediate interpretation for the violent attraction he feels towards the stony hills which surround Aups and Moissac-Bellevue, towards the Verdon and its torrential tributaries, and the harsh barrenness of the vegetation', says Bourniquel. Apart from many hundreds of quick annotations and sketches, there are drawings, made with a pen, and washes executed with a sensitive brush, following with fascination the movements of the stone formations, of water flowing, of its whirls, of vegetation growing, of folds in the earth and trails on the ground, of roots and branches, patterns of dots and lines, of dense accumulations of forms and the ebbing away of tensions.

'For the first time in my career,' he said to me, 'I drew. At this moment my drawing was on the same level as my painting. Previously it was colour which dominated. In contact with this landscape drawing began to live beneath my hand. It was no longer mere drawing, it was a synthesis.' It was a completely new departure when he asked his gallery to exhibit his drawings and pastels together with his paintings and washes. He himself wrote in the preface to the catalogue, which he dedicated to his friends Camille Bourniquel and Elvire Jan: 'I am astonished at the exuberance of all these drawings which appear on these walls like major objects, "works in themselves", since this mode of expression has usually been for me no more than notes and rough drafts, modestly tidied away into boxes, once they have transmitted their substance to the painting which they have for a moment supported.'

This new phenomenon is, incontestably, the outcome of a clash with the *Midi* which since its beginning has taken on the character of a revelation. ...

'I had scarcely arrived when I was seized by the frenzy of a work all the more novel to me because it was nothing more than drawing: instantaneous lines, supple, lively, full of light and space, rhythms which swept over me in waves, from all sides, compelling me to follow solemnly that life intense as a tragedy of the inner life, the nerves of the hand poised like a needle over a record.'[1]

Bourniquel himself recollects from this time:

'He was out walking as early as seven o'clock in the morning. He walked in the woods, stopped before some moss, a flower, the bark of a tree, a rock: he drew it all, minutely. Before coming he had imagined a Midi à la Dufy. Once there, he discovered the inner secrets of the landscape. On the last day he laid out on the ground forty or fifty water colours: "I have seen the priming of a new art. ..."

Stony hills, torrential tributaries of the Verdon, old abbeys, consumed by the sun, the parched look of the olive trees, of the vegetation, of the bark — I in my turn walked in those landscapes of greens, reds and greys, in order to understand better this upheaval in the art of Manessier, which had made him see, he said, his great themes, "set down and, above all, drawn differently", as Jean Clay put it.'

Manessier himself described the experience:

'What an impact! I had always suffered from my awkwardness in drawing. And there, at the sight of those wild hills, I felt that it had loosened up, that it had become liberated. ...'[2]

'I have been sensitive to the harmonies, to the rhythms, to the play of the various levels of the landscape, even more than to the colours, to the light', Manessier told Bourniquel. 'I have had the impression of finding myself before a rhythmic combination of outlines, a counterpoint, like listening to a work of music. Architecture of a tragic dryness, in which the water itself plays an active role:

[1] Album, *Lavis de Haute-Provence*, Galerie de France, 1959.
[2] Jean Clay, *Alfred Manessier, Ma Vérité de Peintre.*

75

it marks out the reliefs, the curves of different levels, it hollows the stone and restricts the planes.'[1]

Apart from the drawings and washes, more than twenty paintings were then created on the Provençal theme and exhibited in 1959. Rich in colouring, dynamic, these paintings represent a new phase in Manessier's work. 'For me', he once said, 'painting is a continual patient advance, a stripping down, with absolute faith that in the end a miracle will happen.'[2]

The formal quality of the Provençal landscapes also found its way into religious themes such as the *Dedication to St Mary Magdalen* (76/77) of 1959, of which there are two versions. In this work the artist, using the forms and rhythms of the Provençal landscape, tried to render both the mystical experience and his idea of the inner life of St Mary Magdalen as related in the Gospel. He had seen a reliquary in the church of Sainte Baume and, as he himself said: 'In that canvas I rediscovered also the ardent side, the "flame" which is associated for me with the person of the Saint.' Other paintings of this genre on which Manessier worked between 1959 and 1962 are the monumental triptych and predella of *The Image* (92/93) (of the holy face), *Resurrection* (91), *The Earth's Offering* (96) *Darkness, Et Gloriam Vide Resurgentis* (89), of 1961, *Large Holy Face, The Fire* and *The Buried Summer*. They are determined by the same vocabulary of form. One day Jacques Lassaigne who saw this large collection in Manessier's studio suggested that it should be presented at the Venice Biennale. Manessier received there in 1962 the international prize for painting.

On the occasion of the Venice Biennale Jacques Lassaigne wrote: 'As has already happened several times in Manessier's very rich career, a kind of pause, of meditation and inner transposition has enabled him to transform the powerful impressions which he had received in the countryside of Haute-Provence in 1959 into new means of evoking and glorifying secret presences. Eight large vertical paintings of a full and profound harmony of colour, together with dark earthly

[1] From *XX^e Siècle*, No. 15, Paris (Christmas 1960).
[2] Jean Clay, *Alfred Manessier, Ma Vérité de Peintre*.

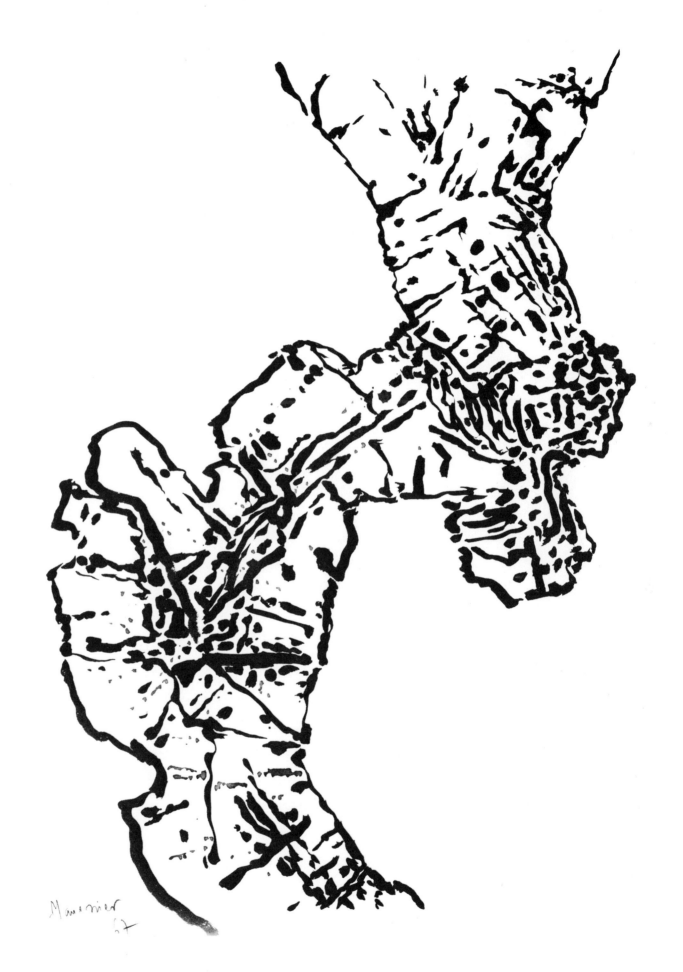

Manessier
57

77

visions, are arranged around a central triptych whose inspiration is more directly perceptible. They are like the progress of the soul through an increasingly exalted light, going from a familiar accompanying of things to a majestic orchestration of vibrant tonalities and pure rhythms. An intimate adherence to self-effacement — are there today other ways of approaching the mysteries of sacredness?' These works are to him 'evidence of the sincerity of a complete commitment and of a remarkably honest and frank technique in the service of the expression of a man's emotions and convictions. ... Manessier's art is proof of one of the lasting elements of this great current of emotional colourism which has flooded French painting during the past fifteen years. From the point of departure of the impression received by the artist the vision ripens, develops and varies according to a rhythm which is similar to that of the seasons. It is less a matter of capturing the successive moments of a natural scene than of translating a thought into its accomplishment. For the vision precedes what it is finally attached to. It is a mode of existing and already has its dominant colours. It may be compared to a grille which suddenly finds itself enclosing that which exists beyond it. The painter keeps merely the visible trace, the arabesque, the reflection of what is dying. It seems that space and light are absorbed by things. The painting is offered like an overturned mirror, a sky in which all that is most colourful and lively on earth is reflected. This art does not stop, nor does it accept any limitation or end. It consists more of fragments or pieces of nature, of landscapes, cadences, rhythms which connect these fragments, and finally gives them meaning, for they are evidence of the architecture of the world.'[1]

And Giuseppe Marchiori, after having spoken of the blue in which Manessier composed his large paintings for the French Pavilion at the Venice Biennale, the colour of the sky and of eternity which changed the central room in which they were displayed into an azure chapel, a blue which radiates a secret and an inner life, which reflects the dialogue between darkness and light, revealing Manessier's spirituality and his quality as a mystic, argues that Manessier is also a man of the

78 [1] Jacques Lassaigne, *Manessier*, in *Cimaise*, Paris, September–October 1962.

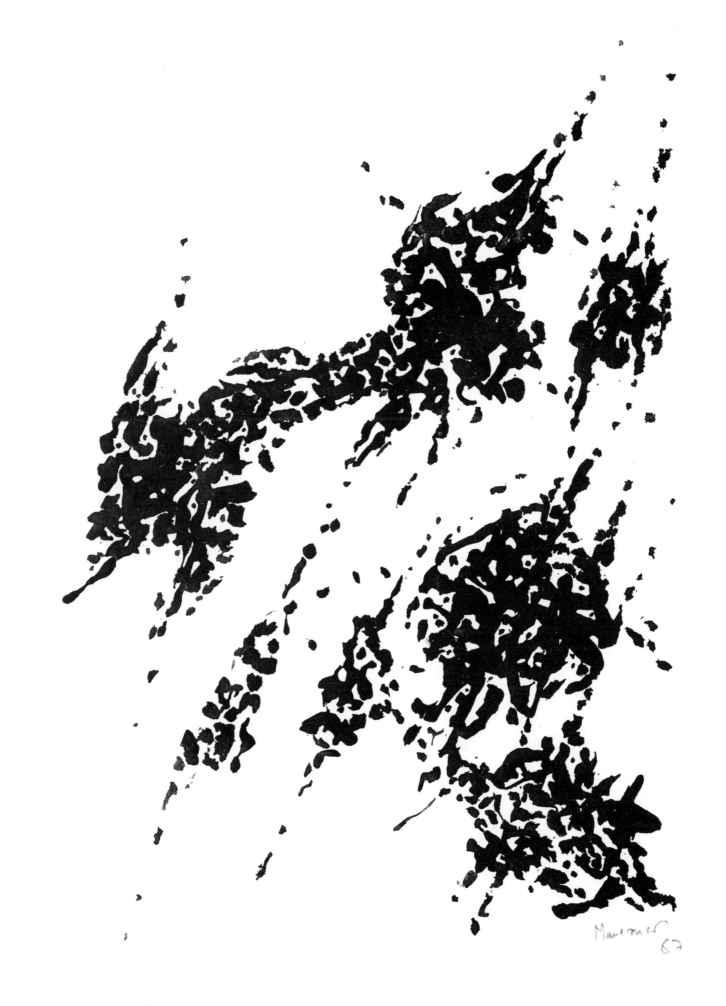

79

earth, a man nourished by age-old wisdom, a French painter whose work 'might have been born out of the contemplation of the stained-glass windows of Chartres and the water colours of Cézanne.... Manessier is, in fact, together with Bazaine, the most outstanding representative of that generation which can be defined as "post-Matisse" or even "post-Braque".'[1]

Manessier's dynamic style from this Provençal period continues in the series of pictures which was later based on the Spanish landscape. These, however, with the exception of the nocturnal motifs, are painted in a higher key.

 [1] Giuseppe Marchiori, *Spiritualité de Manessier*, in *XXᵉ Siècle*, No. 20, Paris (Christmas 1962).

d Spain

Spain, the country of Goya, of Greco, of St John of the Cross, holds a great attraction for Manessier. He has visited it six times in all. At Easter, 1962, he went to Madrid; at the end of August 1963 to Valencia, to stay for the first time in the Ermita de Luchente; in May 1965 he went again to Valencia, and during the following winter he returned to the Ermita for close on three weeks immediately after Christmas. Another visit followed lasting from September to October 1966 and Manessier went to Luchente again after his journey to Canada in 1969.

'Madrid and Goya — what transports of liberty! What hymns to liberty! In Madrid, in fact, it takes on a power such as I have never felt before.' So Manessier exclaimed when asked about his experience of Spain.[1]

Goya's pictures at the Prado, the visits to the Church of St Antoine de la Florida where he is buried, these provided the high-lights during Manessier's first visit to Spain. The freedom of artistic creation, the absolute honesty with which a great artist depicts the world which surrounds him are ultimately the expression of his love for it. 'In a work', Manessier said on another occasion, 'whatever it may be, I must feel the force of the love which has given it life, as the most profound human love gives life to the child. There is more hatred in a bunch of flowers from Bouguereau than in Goya's most horrifying etching.'[2]

When he speaks of the freedom of an artist, particularly of Goya's type, the thought in Manessier's mind includes also the great suffering, the loneliness, the truthfulness to oneself. Manessier's admiration for Goya found its expression in the painting, *Homage to Goya* (97) of 1964, which in its structure is based on that of the Spanish landscape. In his verve, in his love for the artist in whose spirit he experienced a *force bouleversante*, a revolutionary power, and under his influence, he found that his drawing was changing. 'I believe that it was Goya who took me by the arm. ...'

[1] Manessier in *Connaissance des Arts*, No. 174, Paris, August 1966.
[2] Jean Clay, *Alfred Manessier, Ma Vérité de Peintre*.

It might be of interest to mention that, although Manessier painted a picture, *Garden of Olives or Homage to Greco* (102) in 1963, which in some way reflects the rhythm and spirit in Greco's art, Greco stamped himself less on his mind than did Goya. But what Spain meant to him on the whole entered into his *Homage to Miguel de Unamuno* (104) as Don Alfonso Roig named the picture. Father Don Alfonso was a young priest in a little parish, in the province of Valencia. There an old friend bequeathed to him a hermitage built, as it were, in the spirit of Le Corbusier, but two centuries earlier, in a place where a great battle had taken place between the Moors and the Spaniards. From it there is a splendid view of some hundred kilometres, bounded by mountains. Father Roig transformed the wine cellars, which lie between a square walled garden, planted with almond trees, and the square main building, into two studios, and, having kept up a lively correspondence with numerous artists, among them Manessier, he would invite them to come and paint there. Of this man, who had a remarkable interest in the living arts, and who visited France, Switzerland, Germany and Austria to see exhibitions and to study new architectural construction, Jacques Lassaigne wrote: 'His extraordinary, methodical curiosity has made him today one of the most discerning connoisseurs of modern religious architecture and living art. Each time he returns to Spain, he increases the number of articles, lectures, works, praising Le Corbusier, Kandinsky, Picasso, Miró and the younger artists, indefatigably fighting prejudices and false ideas, defending just and generous causes. He has become the intimate friend of Père Régamey, Nina Kandinsky, Manessier, Vieira da Silva, of the great Swiss architects, of the monks of Taizé. ...'[1]

In the company of this man Manessier became conscious of the particular spirit of this place and it was thus that he conceived his Spanish pictures, 'here where the silence of nature, the peace and perfection, allowed the most secret voices to be heard'. (Lassaigne).

[1] See Catalogue of the Manessier Exhibition at the Galerie de France, June–September 1966.

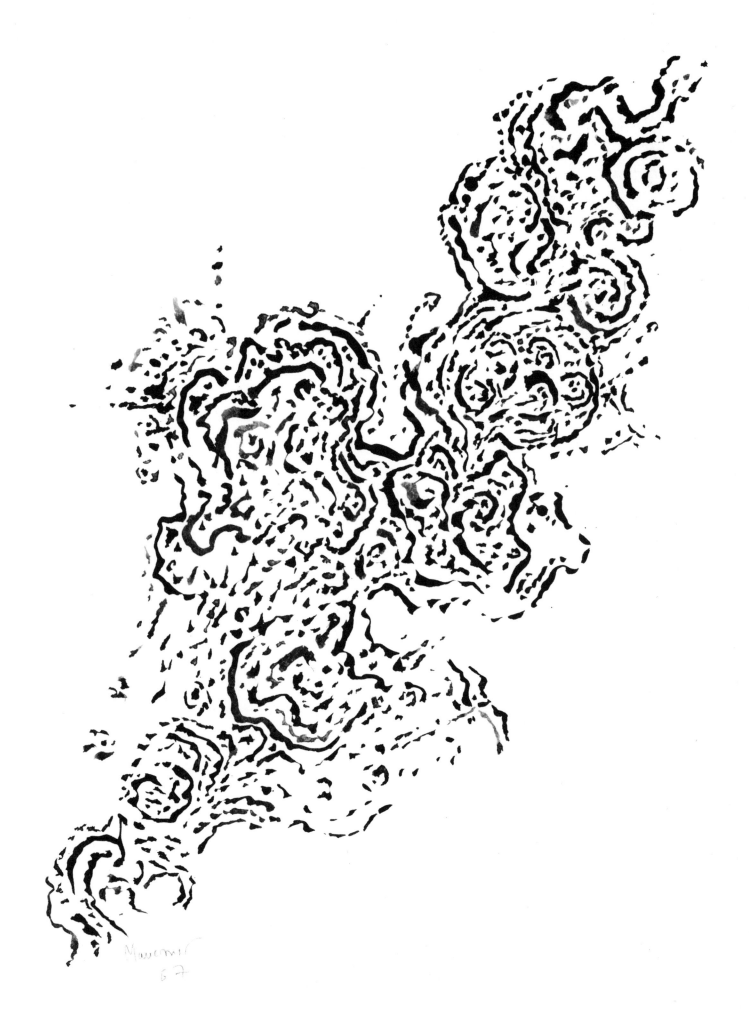

83

It was not with the purpose of verifying some romantic concept of Spain that Manessier came in the spring of 1963 to spend a few days in the Ermita de Luchente, and also, on that occasion, to visit Catalonia, the Levant and Castile, 'having no other guide nor light but the glowing lamp of his heart', as Don Alfonso wrote of him. Impressions from these journeys lie behind such pictures as *El Tajo in a Storm* of 1963, or *Parched Soil* of 1965. Afterwards he felt the need to return there in different seasons, and he was particularly sensitive to the winter light, whose clarity spiritualised all things. Thus there came into existence pictures such as *Spanish Soil*, (108) of 1964, *Winter Space, Wintry Structures* and *Premature Spring*, all of 1966.

Situated on the summit of a hill, about twenty kilometres from the sea, in the region of Valencia, the Ermita was built around a chapel. With its whitewashed walls, it has something of both the farm and the convent. Each room of the Ermita has a window through which one can catch sight of the chapel, the heart of this complex of rustic buildings. Chains of arid mountains form a back-drop, yet from all sides distant perspectives set a boundary to the immense space. The trees —olive, almond, carob— the vines, the thyme and the rosemary, soften with their simplicity the stony surface of the rough parched earth. In 1965 Manessier painted *The Vineyard* and *The Olive Grove*; in 1966 *Almond Tree* (three versions of this symphony in pink), and *The Road from the Vineyard*.

Here the lack of water creates a relationship between sky and earth which often reaches a dramatic intensity; here rain is a gift that must be awaited. Manessier lived the simple life of the men who strove to tame the natural hostility of that earth. Sharing their bread, he discovered the quality of their tenderness, of their love and their sacrifices. It is through the unity with their difficult life that he then approached the secret of their landscape, as Father Alfonso wrote.

This secret is one of light. At first it may seem harsh, and even oppressive. Penetrating deeper, Manessier came to know the infinite variety of its nuances, governed by the time of day and year. Tenderness is combined with force, gentleness with violence. Under the crushing sky, among the reds and ochres, his eyes discovered the subtlety of the pinks and greys, which gave him the key

to their harmony: *Grey Rocks* (106), *The Other Side of the Rocks, The White Rock, The Red Rocks*, all of 1966.

In the hours when earth and man again find freshness and rest, he observed their metamorphoses. Tension and serenity, sensual life and silent reflection: it is from the purest contrasts that light borrows its mystery, (*Early Morning* of 1965, *Early Morning Light* of 1966).

Manessier learned that, as Don Alfonso pointed out, in Spain the night is sometimes more alive than the day. The night, the perfect complement of a day that is often implacable, restores tempers and appeases the colours without destroying their luminosity so that the birth of a new day is unnoticed. As a result of his efforts to create and continuously to liberate his pictorial language, these landscapes and that light of Luchente bring about the beginnings of a new style. Already perceptible in the renewal that the paintings of Provence signified, carried further in the group of works presented at Venice and at his exhibition in Washington (*The Three Nails* of 1963, *The Sap* (99) of 1964, *The Depths of Darkness* (103) of 1963 and others) it truly flowered after 1963, in the period of Luchente.[1]

Night has always been among the themes which appealed strongly to Manessier. In Spain he painted several pictures on this theme: *Night at the Ermita* (107), *Nocturnal Forces, Night in the Vineyard, Night Bouquet*, all in 1966. Again he applied its tonality and structure to religious themes such as *A Night of the Epiphany*, of 1966. But even the pictures of the *Holy Face* (two versions) *Holy Face I* (100) and *Large Holy Face* (101), both of 1963, are nocturnal. 'Each time that I search deeply within I encounter that night celebrated by St John of the Cross in his *Trial by Night*. It is when I set out from my night that I succeed in illuminating things. Everything becomes clarified in the obscurity. In the night, it seems to me, there is a kind of central point. ...'[2] 'Night in the region of Valencia is astonishing', Manessier wrote in 1966. 'Everything remains coloured, luminous. ... I am speaking of a landscape put to death by the heat,

[1] See Don Alfonso Roig, in the Catalogue of the Exhibition at the Galerie de France, Paris, June–September 1966.
[2] Jean Clay, *Alfred Manessier, Ma Vérité de Peintre*.

which is born again of the night; of colour which is not lost, which lives again as pure colour. In the North the night is death. In Spain its meaning changes: it is a resurrection.'[1]

These Holy Faces of Manessier's, particularly the *Large Holy Face*, exhibited in Paris in 1966, are expressions of deep religious feeling, they are human in the tragic sense of Unamuno; they are on the verge between figuration and non-figuration, as we have already observed when speaking of the representations of St Veronica's Napkin. 'There is always a moment in them', Manessier said to me, 'which is like the blossoming of a new figuration. In nearly every period of my work, there is an upsurge, like a wave — the Holy Face, St Veronica's Napkin. It is like the surface of a water out of which a fish suddenly throws itself, into the light out of the depths, then the surface becomes smooth again.'

Don Alfonso observed that the Holy Faces were modelled as if with earth. This seems to correspond to the 'human' nature of Christ, the biblical symbol of man being of dust. But Christ in the terrible agonies of the Passion glorifies it finally with his immortal light.

Manessier admitted that it was so. 'It is strange', he said, 'but I really felt it so. I put on a palette an earthen colour and a blue. I thought of that mud. I have not told anyone.' He was moved that his friend had experienced it. It proved to him that his pictorial language came across, after all, with its message, that there was a direct communication.

Thinking back on his Spanish journeys he said to me in December 1966: 'I would like to make an exhibition of my drawings from Spain, similar to that I made of those from Provence. Throughout the years I have produced several thousand annotations. I shall now start to compose some religious themes based on my sensations from Spain. The style will remain the same as that of the works between 1964 and 1966, but the light has changed. And then those experiences of the Spanish nights! I shall attack again some old motifs such as *Salve Regina* or *The St Matthew Passion, The Passion of Our Lord Jesus Christ*, and all the Halleluiahs.

¹ Manessier in *Connaissance des Arts*.

I feel an urge to do so, as I did at the time when I prepared my paintings for Venice. I then worked for three years without a canvas leaving my studio. Now I will seclude myself again.'

Here, where figuration and non-figuration meet, the painter seems to be faced with a deeper problem than that of a part-figuration only. We can speak of part-figuration in the case of a canvas such as *The Three Nails*, where the nails of the Cross are clearly recognizable, embedded as they are in a highly dynamic colour pattern, amorphous but significant of a definite emotion. Significant, not symbolic. In the notion of the significant is tacitly contained what may be called the unconscious and subconscious mind of the artist. I have often heard Manessier speaking of unity. The unity of experience, its wholeness, the unity in the presentation of a work of art. We find this concept analyzed in depth-psychology. 'The creative process', says Erich Neumann, 'is synthetic, precisely in that the transpersonal, i.e., the eternal, and the personal, i.e., the ephemeral, merge, and something utterly unique happens: the enduring and eternally creative is actualized in the ephemeral creation. By comparison everything that is solely personal is perishable and insignificant; everything that is solely eternal is... inaccessible to us. ...

One of the fundamental facts of creative existence is that it produces something objectively significant for culture, but that at the same time these achievements always represent subjective phases of an individual development, of the individuation of the creative man. The psyche carries on its creative struggle "against the stream" of normal direct adaptation to the collectivity; but what began as compensation of the personal complex by the archetype leads to a continuous activation and animation of the archetypal world as a whole, which henceforth holds the creative man fast. One archetype leads to another, related one, so that the continuously renewed claims of the archetypal world can be satisfied only through continuous transformation of the personality and creative achievement.' Manessier, being a Christian, is involved in the perpetual process of giving shape and life to canonical forms. 'Such canonical forms are also grounded in archetypes; that is, even in its representative form, art is a symbolic expression of the

collective unconscious and, although it is essentially a representation of symbols close to consciousness, it has a decisive therapeutic function for the life of the group. For the fact that the symbol is consciously represented does not necessarily mean that it has been made fully conscious or that it has been dissolved through conscious assimilation.'[1] In creative man we find a preponderance of the archetypal in keeping with its creative nature. 'The most prevalent archetype of western civilization is the Passion of Jesus of Nazareth.'[2]

Let us now consider the abstract character of Manessier's formative will in the expression of his religious archetypes. It has its parallels in the history of art. S. Giedion concluded his research into the art of primitive peoples with the words: 'Art, indeed, began with abstraction.' Some of the more complex early abstractions 'arose from the need to give perceptible forms to the imperceptible'.[3] And Herbert Read has stated that a will to abstraction undoubtedly existed alongside a will to representation.[4] When we turn to the Catholic philosopher, Jacques Maritain, we find that art is defined as 'a kind of spiritual sensibility in contact with matter'. He also speaks of an 'Epiphany of creative intuition', i.e. a manifestation of the superhuman in art. 'Creative intuition', he says, 'is today, and has always been, and will ever be, the primary power of authentic renewal. Salvation in Art comes only through creative intuition.'[5] It is as if he had had Manessier's achievement in mind when he criticized the early mechanical abstract theories: 'The great mistake has been to put the instrumental and secondary before the principal and primary, and to search for an escape through the discovery of a new external approach and new technical revolutions, instead of passing first through the creative source, and thus taking a risk but having a chance of finding a real solution.'[6]

[1] Erich Neumann, *Art and the Creative Unconscious*, London, 1959.
[2] Herbert Read, *The Forms of Things Unknown*, London, 1960. See also Alan W. Watts, *Myth and Ritual in Christianity*, London, 1953.
[3] S. Giedion, *The Eternal Present*, Vol. I, *The Beginning of Art*, New York, 1962.
[4] Herbert Read, *The Origins of Form in Art*, London, 1965.
[5] Jacques Maritain, *Art and Scholasticism*, London, 1949.
[6] Jacques Maritain, *Creative Intuition in Art and Poetry*, London, 1954.

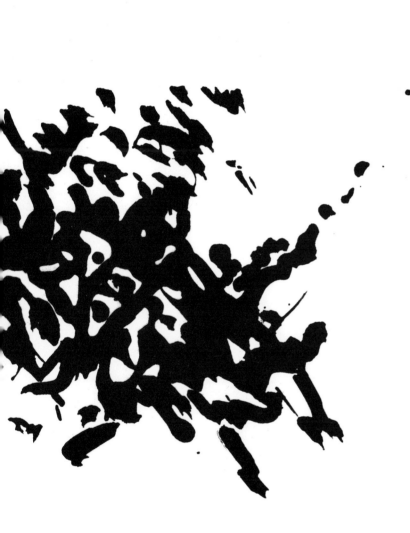
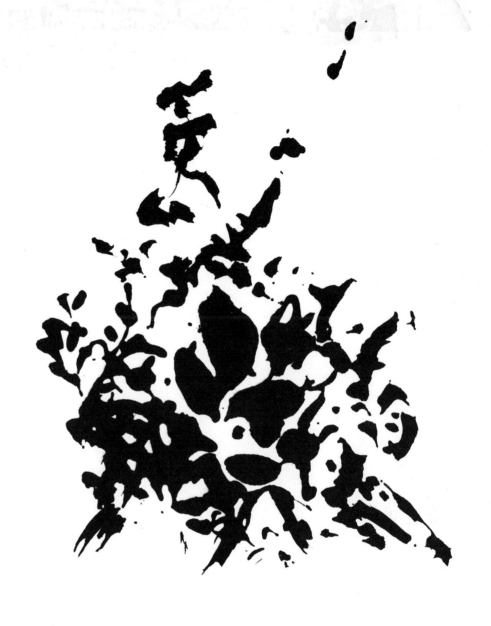

Mauronier
67

89

Let us end our digression with the German art historian, Conrad Fiedler: 'Artistic activity began when man found himself face to face with the visible world as with something immensely enigmatical. ... In the creation of a work of art, man engages in a struggle with nature, not for his physical but for his mental existence.'[1]

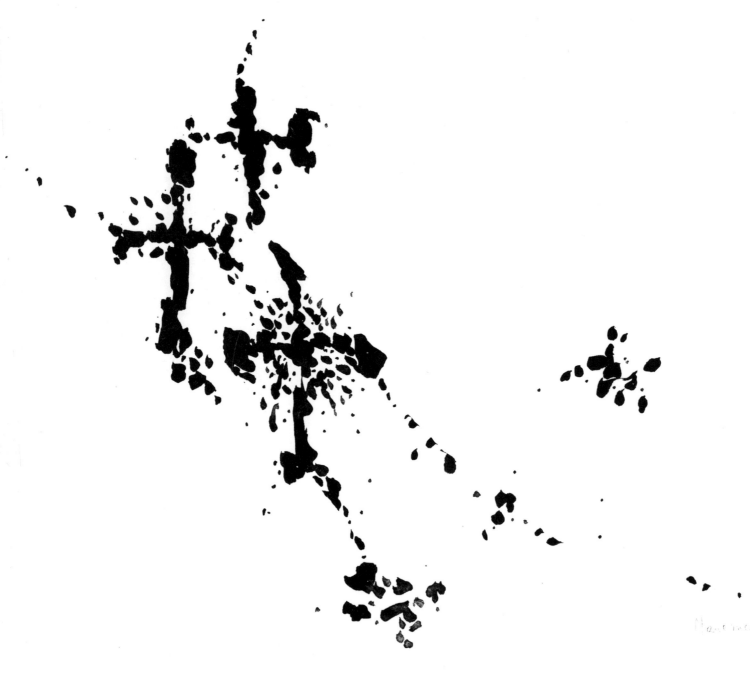

 [1] Conrad Fiedler, *On Judging Works of Visual Art*, Berkeley, 1949.

e Canada

In the autumn of 1966 the Director General of the National Arts Centre, Hamilton Southam, and the architect Nebenson, came to France to study the possibilities offered by the State Industry for the production of a large tapestry for the theatre foyer of the Centre. Disappointed with their investigations they had decided to return to Canada when they met Bernard Dorival who advised them, before they boarded their plane, to visit the studios of Plasse–Le Caisne at Houx. There they agreed with the weavers to meet Manessier to commission a tapestry from him which was to be mounted on the loom a few months later.

Manessier went to Canada in July 1967 to acquaint himself with the building, then under construction, and to study the light and the character of the country which were unknown to him. He and Jacques Plasse–Le Caisne were welcomed by Hamilton Southam who invited them to stay with him during their visit in his house on a little island of Lake Rideau near Ottawa. A personal sympathy soon arose between the artist and his sponsor and grew as they became better acquainted. The invitation was renewed when Manessier returned to Canada in 1969 for the tapestry to be hung.

On a sailing boat tour on this lake in 1967 Manessier had been captivated —as Mr Southam recollects—by the reflections of the light through the water and this became one of the structural elements which we find on the tapestry, *The Secret Lake* in Ottawa. The experience of Canada, its vast dimensions and its many lakes which resulted in two series of paintings—the one in large-size canvases and executed between 1967 and 1969 and the other small studies painted after the second visit to Canada in 1969—is the experience of the North again, this time on a new scale connecting the present with the painter's earliest impressions from Le Crotoy and the bay of the Somme and even from wintery Holland.

What happened in Canada and during the two years afterwards is what we have realised already as Manessier's creative rhythm. Every single annotation of his during this time, every single sketch opened up in due course the first strong impressions of the new landscape, its structure, the tonality of its colour scheme,

the character of its precious details. Manessier penetrated deeper and deeper into the essential aspects, into the image of this great country which one-by-one revealed its secrets to the refined sensibility of the painter, without his being aware of it. The colour scheme of these Canadian pictures is predominantly cold —blues, greys, greens, whites— suggesting the silence, the vastness of space, wind, cold, winter, frost. But what a sophistication of tonal values on the base of these colours! We encounter here a symphonic work of high poetic quality.

The predominantly large angular shapes correspond to this cold colour scheme reflecting again the vastness of the scenery and the majestic forces of nature which are involved. There was, however, also that primary feeling of witnessing a stage in the creation of the world experienced particularly on that island where Mr Southam was host to the artist. Here Manessier conceived what finally became the theme of the largest composition of the whole series: *Fishes' Sanctuary* (116/117) of 1969 (200 × 400 cm). The artist spoke of this extraordinary place as if of a revelation: 'I had there the feeling of having penetrated elemental nature. Never has a tree been cut there since the world was world; they decay on the spot and re-emerge in all their decay; the bottom of the lake is full of roots and of a decomposed vegetation; and nature is reborn by way of all this. Never have I experienced a similar sensation. I discovered a prehistoric dimension.'[1]

When asked whether he had added the sensation of the Great North to this experience, the artist answered: 'Unfortunately not, but I could dream my way into it through the narrative of another person, Eric Gordeau, a man whom I did not know but who had wanted to meet me for a long time. His life is not at all banal; he has devoted it to the destiny of the last groups of Eskimos who have not yet been touched by the white civilisation. He wished to show me the Great North and make me know these people. We spoke for hours, planned to travel together. ... Finally the journey did not take place — except in myself, secretly. The strangest thing is that flying over the country from the North to the South

[1] Léone de la Grandville, *Entretien avec Alfred Manessier*, in Manessier Catalogue, Galerie de France 1969. See also *Plaisir de France*, Paris, February 1970.

on my second visit —my pictures having been finished for quite a while— I could verify that they were... right. Oh, and then these flashes of steel, this light of Greenland! I will have to paint it one day too. ...'[1]

The power of this Northern light evokes in the artist certain reminiscences. 'I dreamed anew of the harmonies of a more subtle, a more tender light of my own country and its great flat spaces. And now after so many deviations I wish to take up again the themes of my childhood's landscape and stroll in it at leisure.'[2] So it came about that Manessier painted his *Flood Tide in the Somme Bay* (119), 1969 (third version), *The Sea of the North*, 1969 and other compositions from the North of France.

Just as the landscape of his childhood called for new attention so did the experiences of winter re-appear. Manessier painted *Frosted* I (115), *Winterly, Winter Sun* and other pictures and also the visions of Spring such as *The Storm, Lichens* I and II, etc.

In a painting such as *The Blizzard* (112) of 1968 all the elements are already contained which define Manessier's style inspired by Canada: the shapes, the cold colours, the dynamics. There is a strong movement in all of these paintings and a certain rigidity, the severity of the North: *The Great North* (113) of 1968. Sometimes the movement is horizontal as in *The Blizzard* (112), sometimes centrifugal rays of energy emanate from the centre of the composition: *Frosted* II. Mostly however, the movement is diagonal, as in *The Large Root, The Great North* (113), or *Fishes' Sanctuary* (116/117), in which Manessier utilised a theme for the tapestry in Ottawa. One feels intensely in this composition the mystery of life in nature, its wealth and intimate significance. The large purple shapes on a deep blue background (the sea) in *The Secret Lake* move upwards more steeply than in *Fishes' Sanctuary*. We recognise the image of the sun or the moon and there is that immensity of space and depth which speaks of true and strong feeling. It never happens that Manessier is able to express the impact which an experience makes on him in only one painting. He said once: 'One painting calls for another

[1] Léone de la Grandville, *Entretien avec Alfred Manessier.*
[2] Léone de la Grandville, *Entretien avec Alfred Manessier.*

one, I need a whole series to express myself. One painting is never sufficient, I leave the painting behind for the answers which it demands, something which may be the opposite, which is different. ... It is a world which is being constructed in this way. ...'[1]

In the peace of Emancé during 1968 and 1969, in the seclusion of the Ermita in 1969, the vision of Canada matured in Manessier. In numerous drawings and washes of stones, of bark, of nature's manifold aspects, the artist proceeded with his creative adventure finally formulating the essence of his experience in one major painting after the other.

[1] Michel George Bernard, *Nature et Peinture dans l'Œuvre d'Alfred Manessier*, Catalogue Galerie de France, 1969.

8 THE PEACE OF EMANCE

In February 1956, Manessier bought a small farmhouse with outbuildings and a garden, in Emancé, on the fringe of the province of Beauce, some sixty kilometres from Paris. Here he now spends more than half the year, to benefit from the peace and the calm light, to work with a greater tranquillity of mind than in Paris. 'I love that immense and peaceful plain that leaves me free. Here I have been able to translate on to my canvases what I have received from my travels in Holland, in Provence, in Spain and in Canada. The impact of a landscape in the Midi is so strong that I cannot free myself from it.' He often prepares his work in the studio above his flat in the rue de Vaugirard in Paris. Here in the country, however, he has all the space he requires and the conditions for the concentration his incessant productivity calls for. It is true that he does not produce more than fifteen to twenty paintings a year, but it is also true that the intensity of his work is astounding when we consider the problems involved in such monumental pieces as the paintings produced for the Venice Biennale of 1962, or the huge and exact designs for the stained glass windows which the specialists then translate into glass. Manessier has transformed a large and lofty barn into a studio where he can work on vast compositions. Here most of the paintings which we have described in the previous pages were finished, here also most of his designs for stained glass and tapestry saw the light of day.[1] From Emancé to Chartres, where the Ateliers François Lorin are situated, it is only 20 kilometres. In

[1] See Appendix.

Chartres Manessier can follow step-by-step the emergence of the windows from his designs, which are elaborated by him down to the smallest detail, in the finest nuances of a colour. This is a feature of that type of work as opposed to designs made for tapestries. In Houx, again not further than ten kilometres from Emancé, so that the painter can travel with ease within the small triangle, Emancé — Houx — Chartres, (in this landscape which has become famous through Marcel Proust's novel *A la Recherche du Temps Perdu*) there is the atelier of Plasse–Le Caisne, masters in the art of weaving and the creators of all the tapestries designed by Manessier. A small design giving only the colouring and the composition is there translated into a tapestry of large proportions. What in fact happens is the prolongation of one creativity into another. From Houx to Chartres again it is ten kilometres. We realise what concentration of effort and planning lies in these bald figures.

Here in the peace of Emancé the walls of his studio have seen him struggle with that language which he has over and over again to discover anew, to awaken it from its unformed, shapeless stage into a means of communication.

'I look... I wait... on the watch like a hunter. I put a little paint here... a little there... I feel my way, I search for coincidences, for connections between forms and colours. ... And then, suddenly, something rises up before me... I feel it very strongly... the dialogue is plotted... all I have to do is to follow it... it is so rapid. ... Then the canvas begins to live... we converse. ... I am no longer alone... I am in my truth as a painter. ... Sometimes you lose the trail... how shall I put it? ... One starts to suffer. The freedom that one had acquired, the ease, the forward drive, is all drained away. The overture has become a blind alley. You are in a trap. Agony. ... Many times in my life I have told myself... it is finished, I am finished. Spiritually, the work of an artist develops over a whole lifetime, like a plant. But, materially, it is rather more like a skeleton: you are on a track, you follow, there comes a moment when you strike against rock; you are blocked up, shut in, dead. Until now I have had luck: it has left me again. ... I am there, I stamp, I make some drawings, some order. ... Then,

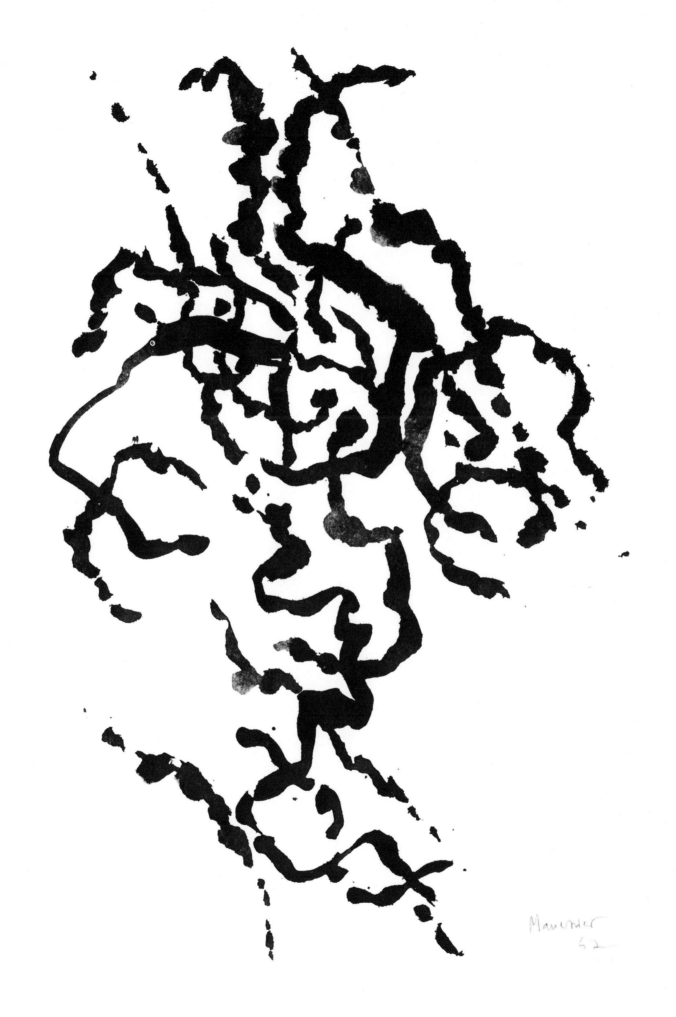

Mauensee
62

97

something makes an impact—a landscape, some flowers, a stone that I have collected which corresponds to something in me. Everything starts again. I must become accustomed to it. Each time it is the same: each canvas is a death and a resurrection. And each time, I give battle anew. I forget all that I have done, all my experience. I am as naked as an infant before that work which resists me: it is terrible. ... Inasmuch as will-power goes for nothing. In painting "I will" always turns against you. One yields to one's inspiration: one does not command it. And sometimes it takes years to germinate. There are catastrophes: visits. Even the idea that someone will come to see me at the end of the day paralyses me. Someone passes, looks without saying anything; I suspect hostility. I feel that he does not follow... After all, it is for others that I paint. To speak to them. If I do not know how to make myself heard, what's the good?... And then, the studio is enormously full: the great old masters, the geniuses: Rembrandt, Goya, Delacroix. ... They must be shown the door. It is difficult... they return. ... The other danger: the critical spirit. There is in me a person who tends continually to hate what I do. A destroyer. He springs up in the middle of the canvas, he sneers. It is the worst form of criticism, it does not help. Little by little, meanwhile, I prepare myself. I hold myself on a leash. I say to myself: This is not the moment. Later... later. ... The worst of it is: I haven't any discrimination. I bask in delight before a bad canvas. I am in despair before my best work. ...'[1]

Once, when asked about the moderns who brutalise reality rather than seek for harmony, he said: 'It seems to me that there is a difference between the arts of rape and those of love. The first, as with Picasso, yield the best of their fruit at the beginning; while the second, as with Bonnard, ripen and are continually enriched right up to the end. For myself, I belong to the mild group. I would call myself a primitive, if I dared. But I also know the violence that is in me. And I do not want to choose. I want to keep an intensity in me, for I want to express at the same time the frenzy of my century and the light of Hope, of which I know

98 [1] Jean Clay, *Alfred Manessier, Ma Vérité de Peintre*.

I am the bearer. Rembrandt, Cézanne, Hals, prove to me that a work stretches itself out and is judged over an entire lifetime. ... Between the timorous first painting of Cézanne, who spread out on his canvas twenty colours two inches in thickness, and the *Sainte Victoire* of the end, the themes did not change. It was simply that in the *Sainte Victoire* there were no more than two shades, barely indicated —one cold and one warm— which is much more telling. There is wisdom in allowing time into your game. I am in no hurry. I dispute that painting which —notably in the United States— explodes in two years and then is silent for ever. It is all a problem of corruption by success: too many artists are commercial representatives of their art. I do not believe in this Van Gogh who has a Cadillac and three bathrooms. Ultimately, in their way, they are the dandies. The avant-garde today? Everyone belongs to it. Just as everyone is abstract — that is the fashion. It seemed to me, however, that to be in the avant-garde formerly was to question again —mournfully, anxiously— dead truths. It was to feel life absurd and impossible if one did not break through the wall. The amateurs have not recovered from having missed the boat with Impressionism. They venture into opposite excesses. The idea of selling my canvases would never have occurred to me at the age of twenty-five. Perhaps that is a form of romanticism or self-defence: I detest official life; participating in that world of embassies and biennales, which transform painting into a fancy-dress party. Either you come in a dinner jacket and you are disguised; or else in shorts and you are picturesque. The joy of painting is of another order. Rembrandt lost his fortune unexpectedly; Cézanne awakened one morning, a millionaire: none of this made any difference to their work.

A lifetime for a work: no less. Who knows what discoveries await us? In any case I must continue in my own way, until my last breath. Until a certain age one has a choice. But afterwards, when you hold something solid, which overwhelms you —and for me, as I have told you, it is the encounter on the canvas with the spiritual life and the outer world— then you must hold on to it, pursue that vein, like a miner, going deeper and deeper after it, without allowing yourself to be distracted by the experiences which often captivate the youngsters. One

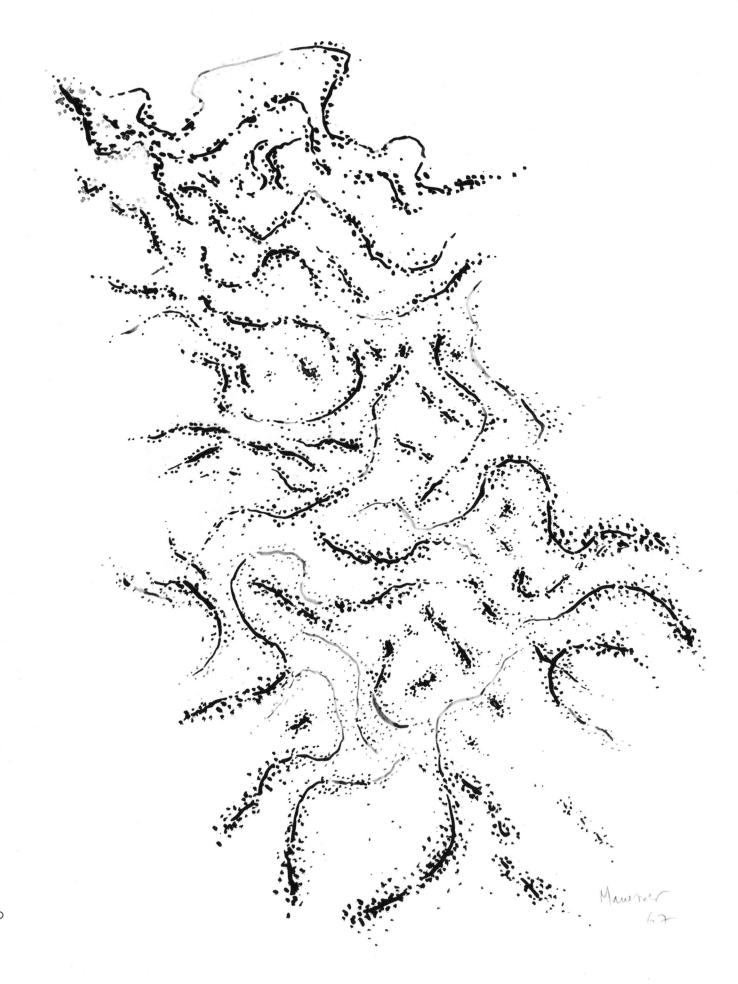

100

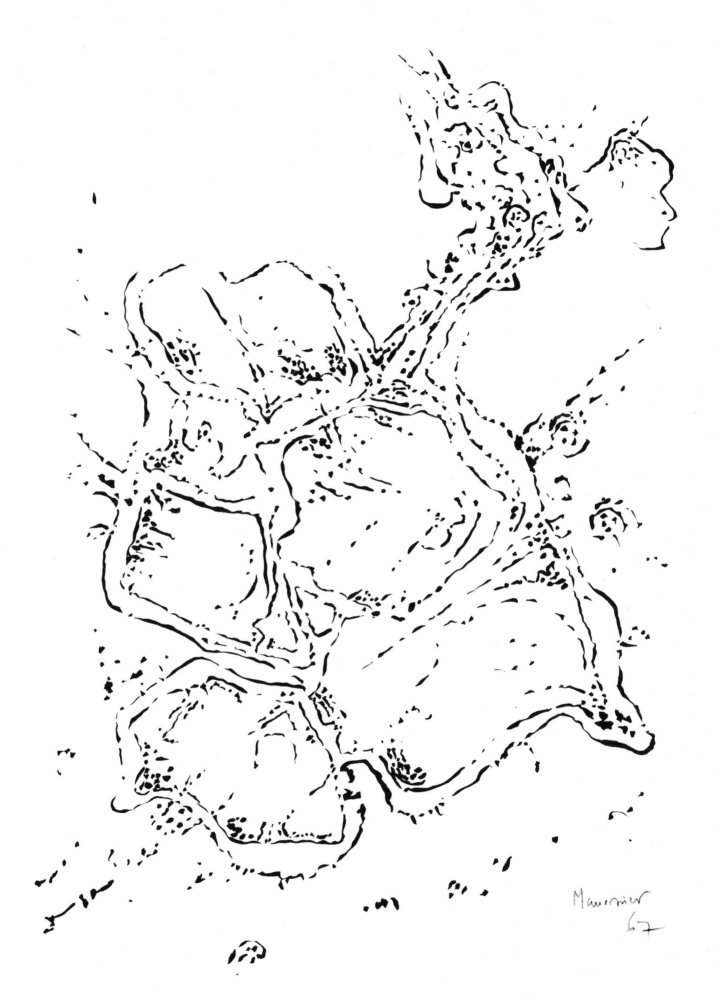

Maurnier
67

must accept the ageing of one's school. Renoir, Degas, Bonnard knew Cubism. They were not foolish enough to copy it. So much the better: their main works were painted on the threshold of death. What is important is not the movement to which one belongs: it is to go as far as possible in that movement.

Then your life takes on a meaning. You witness for man. For I have the deep conviction that through this labour, always being recommenced, that patient quest, that endless sequence of setbacks and victories, of deaths and resurrections, one pledges a great many other things than one's own destiny. Just as a man who degrades himself degrades man, so the painter, according to whether he has done well or badly, carries a certain responsibility towards his fellows. In an epoch hinged like ours, where spiritual values are in question, where culture is menaced by death, where we are filled with an obsession for gain and comfort which damns the very meaning of art, it is our duty to pass on a conviction. We are perhaps the last to know that certain truths cannot be valued against either money or privileges—but are without price. It is because we are in the century of speed that it is necessary to say: "Watch the corn sprouting." The painter cannot remake man unaided: at least he must know that within his silent epic, there as elsewhere, the fate of the species is at stake.'[1]

To 'witness for man'! That is the secret of Manessier's art and that is the secret and hard core of his character, that is the meaning of his life and of his work. If only one man like him can prove that the values which he stands for are strong and great and important enough to devote one's whole life to them, to suffer for and to believe in them —these and nothing but these— then there is hope even for a world which in its general trend seems to deny them.

[1] Jean Clay, *Alfred Manessier, Ma Vérité de Peintre*.

THE PLATES

Manessier, 1970

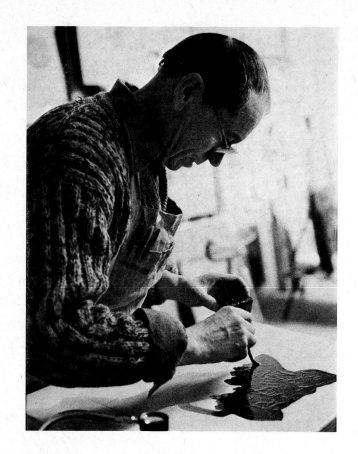
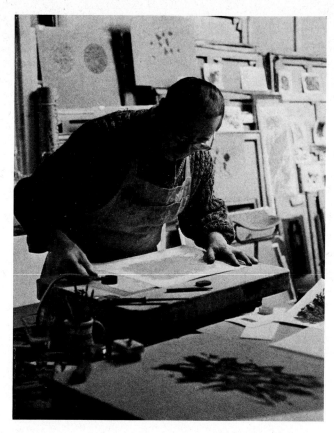
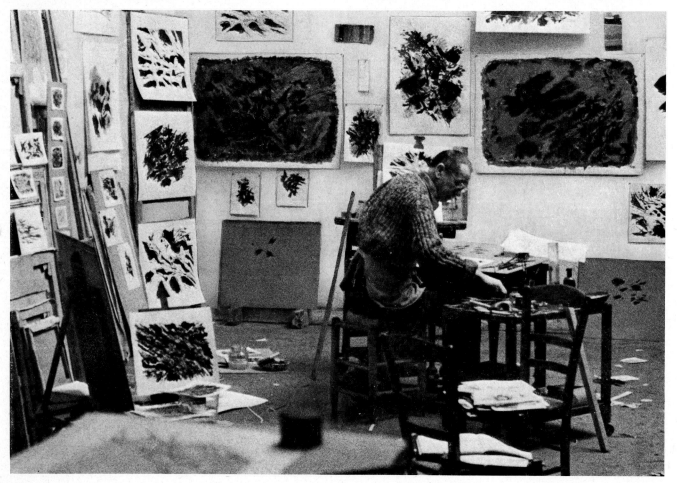

Manessier working
on some lithographs
in his studio,
Paris, 1971

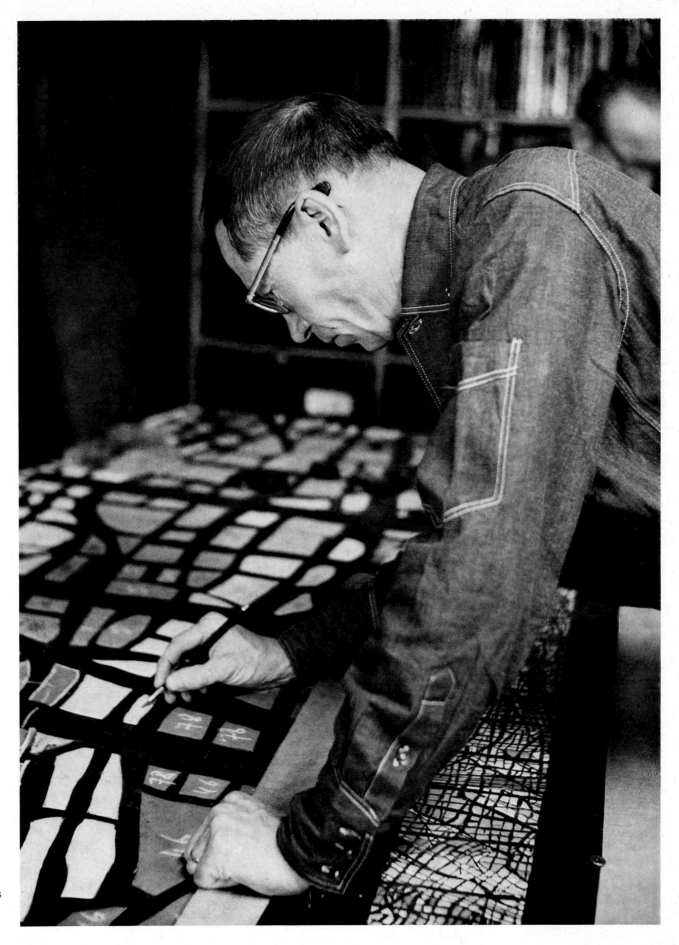

Manessier working on
sketches for the windows
at Moutier, studio of
J. Barillet, Paris, 1964

Charles Laughton and Alfred Manessier
on the Chartres road, 1959

Manessier's studio in Paris, 1954

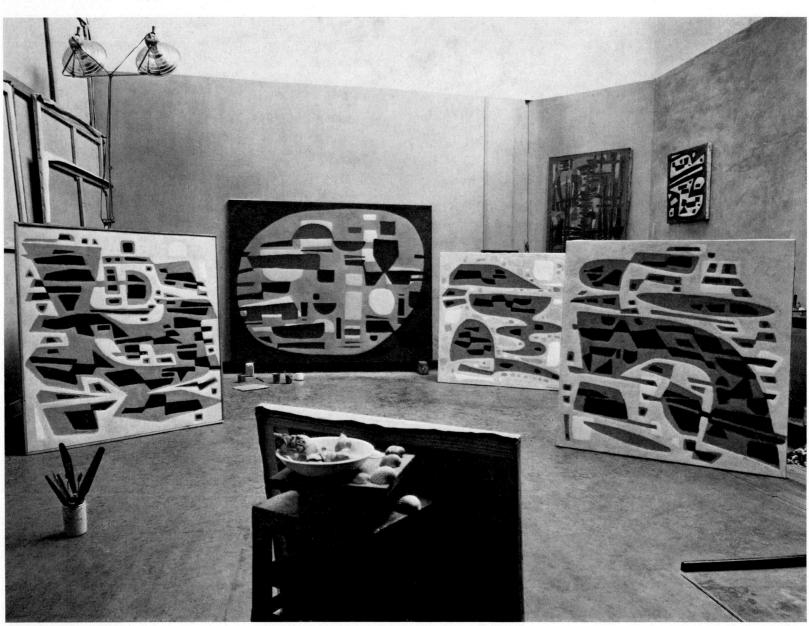

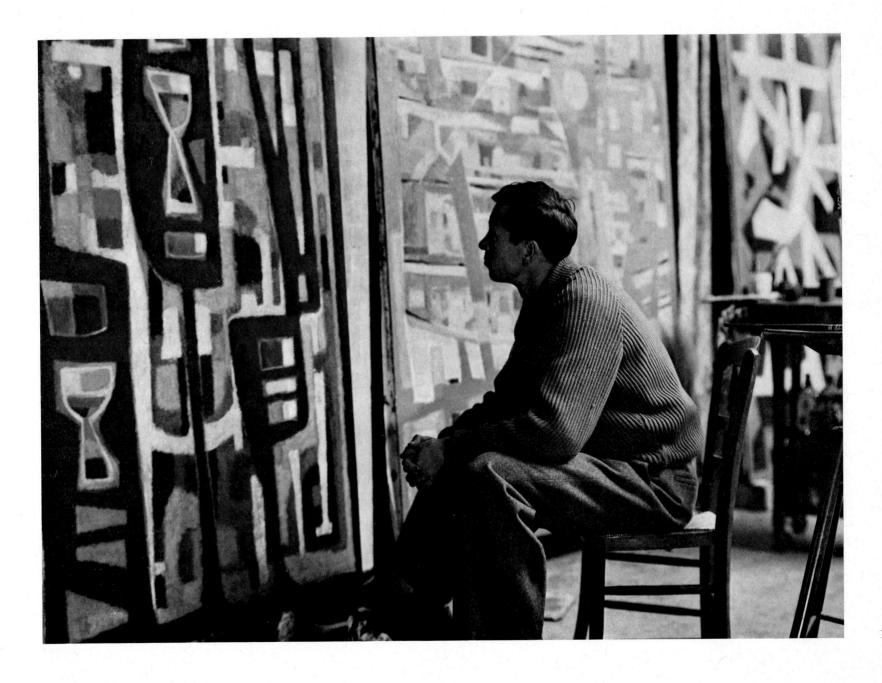

Manessier, 1949

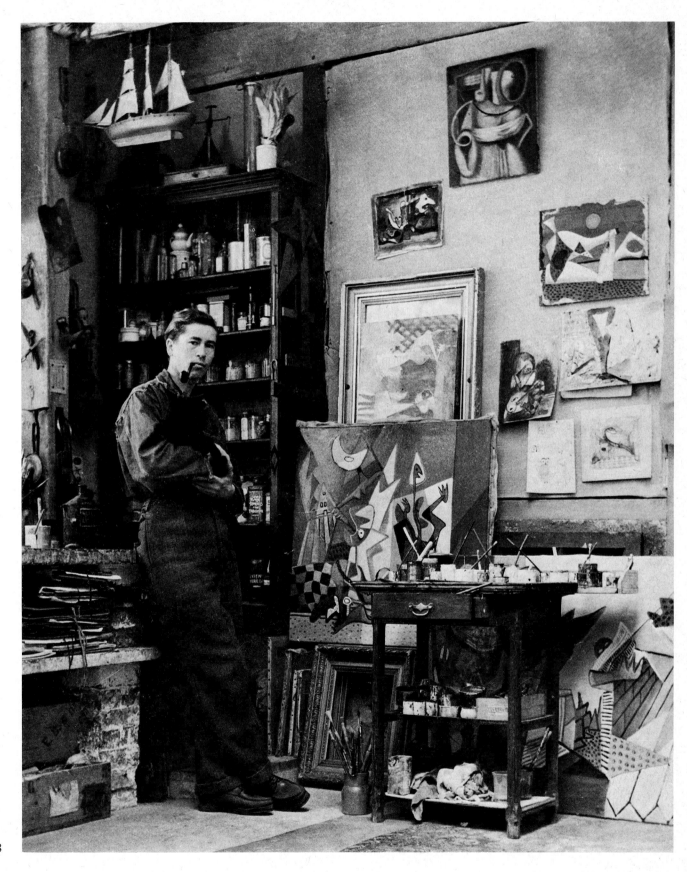

Manessier
in his Paris studio
at rue Franquet, 1938

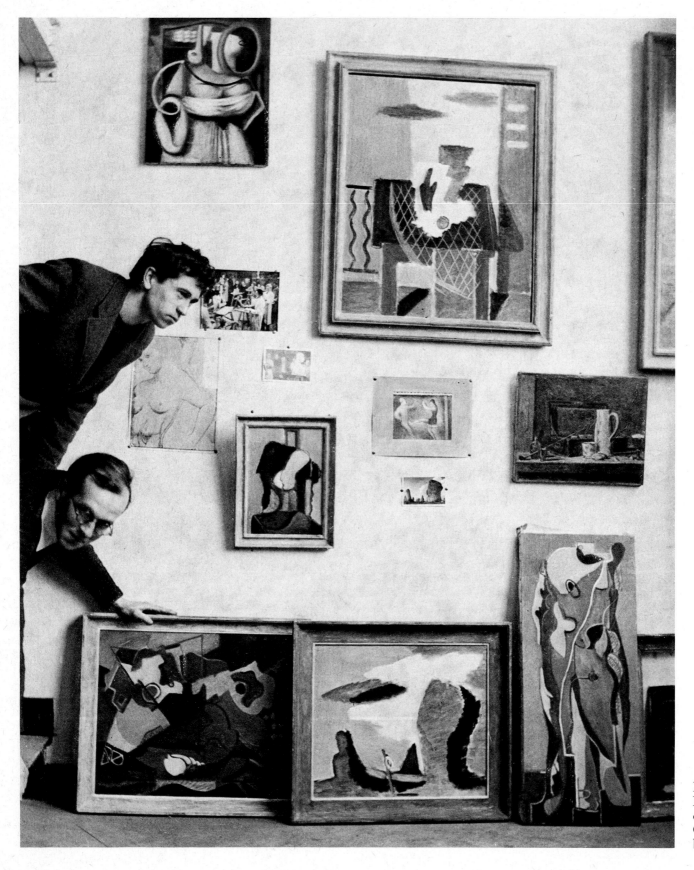

Manessier and Le Moal in
Paris, rue Notre-Dame
des Champs, 1935
On the wall are canvases
by Manessier and Le Moal

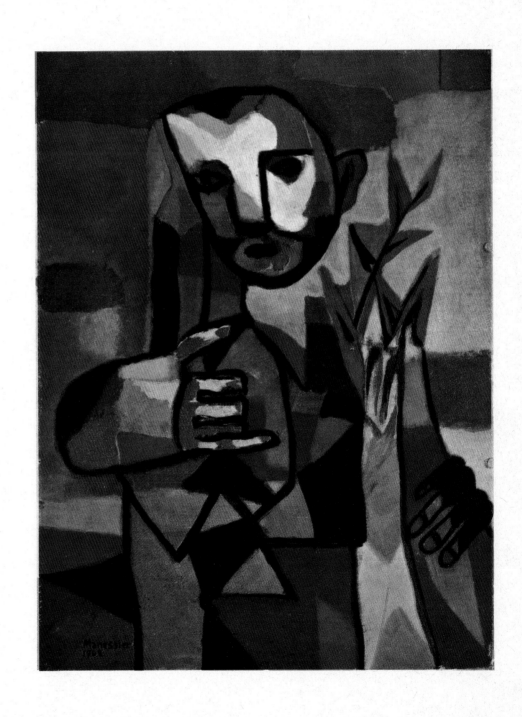

1 Man with the Branch
1942
35 × 27 cm
Private collection

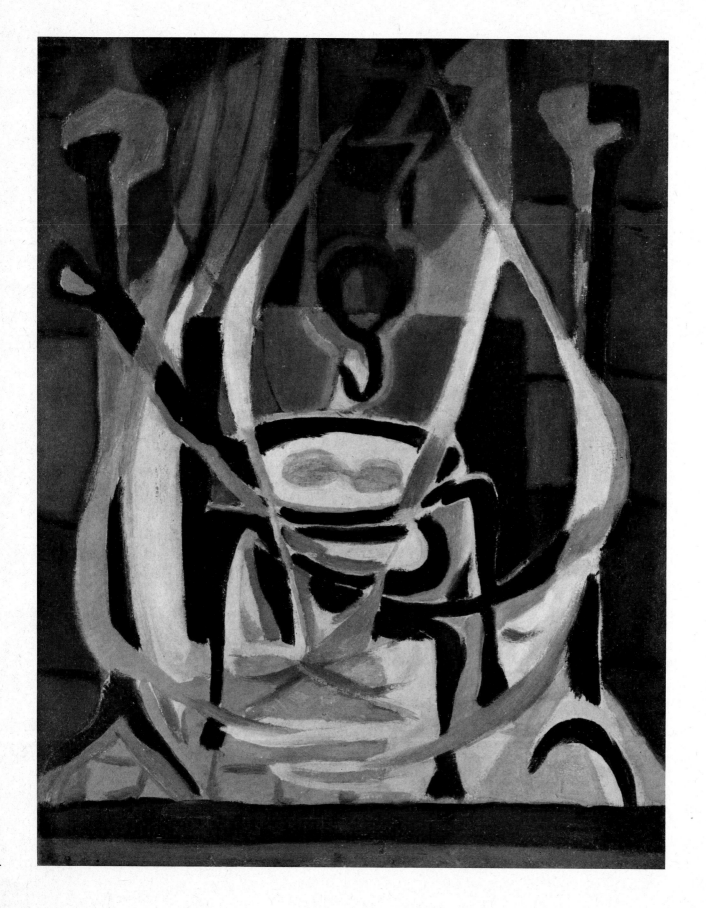

114

2 The Two Eggs
1943
35 × 27 cm
Private collection

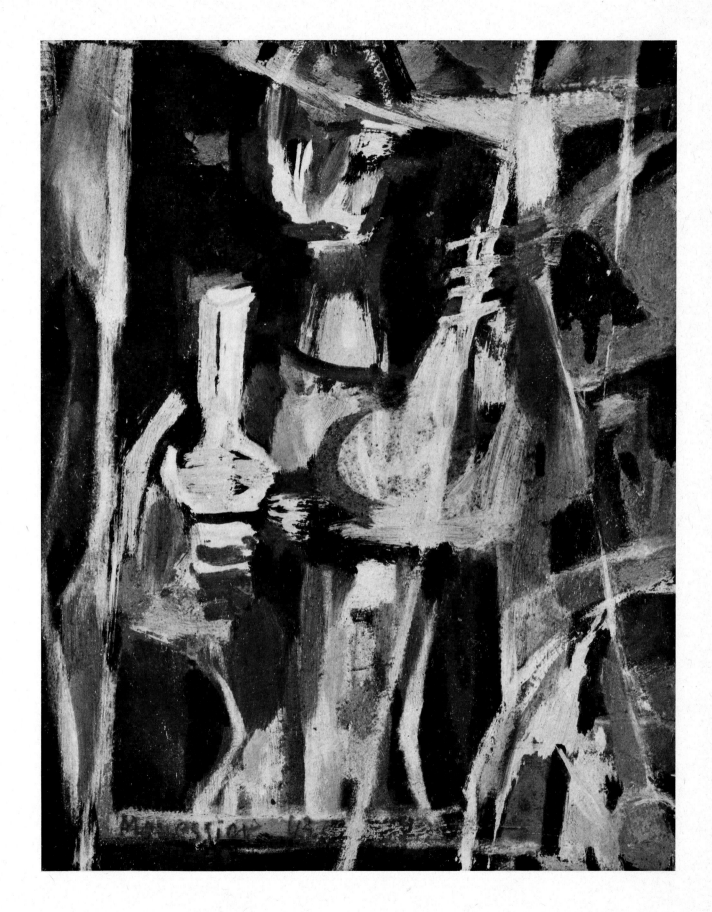

3 Clown
1943
20 × 16 cm
Private collection

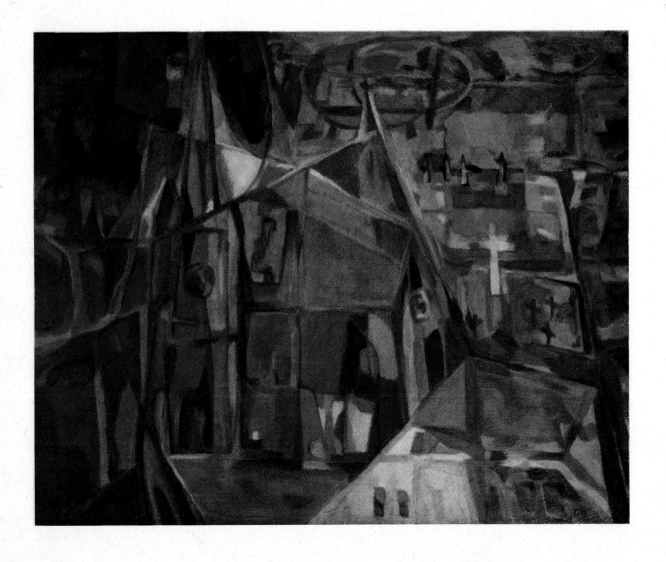

4 La Grande Trappe
1944
81 × 100 cm
Private collection

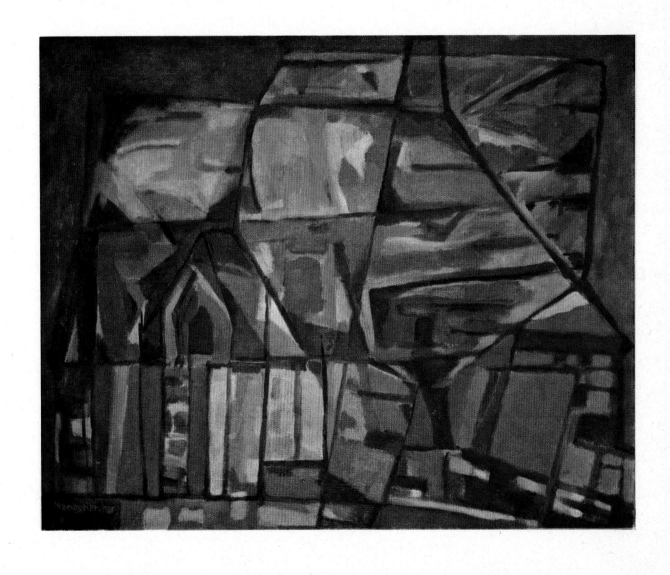

5 Le Bignon at Night
1945
65 × 81 cm
Private collection

117

6 Towards Port-Lagaden
1945
22 × 27 cm
Private collection

7 Lighthouse at Port-Navalo
1945
41 × 33 cm
Private collection

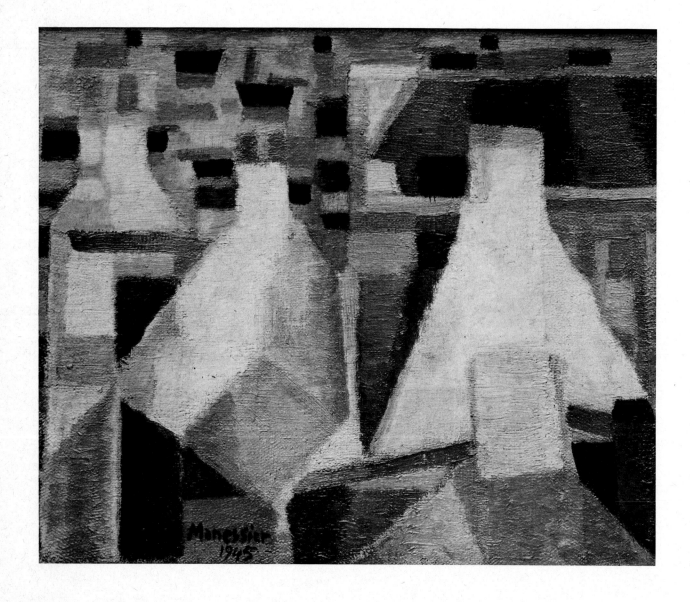

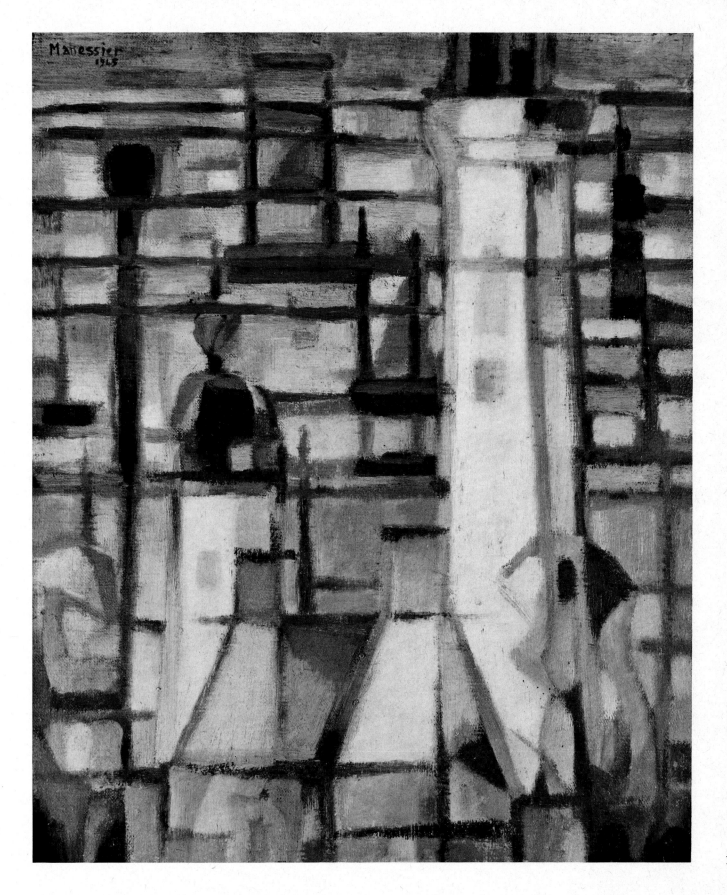

119

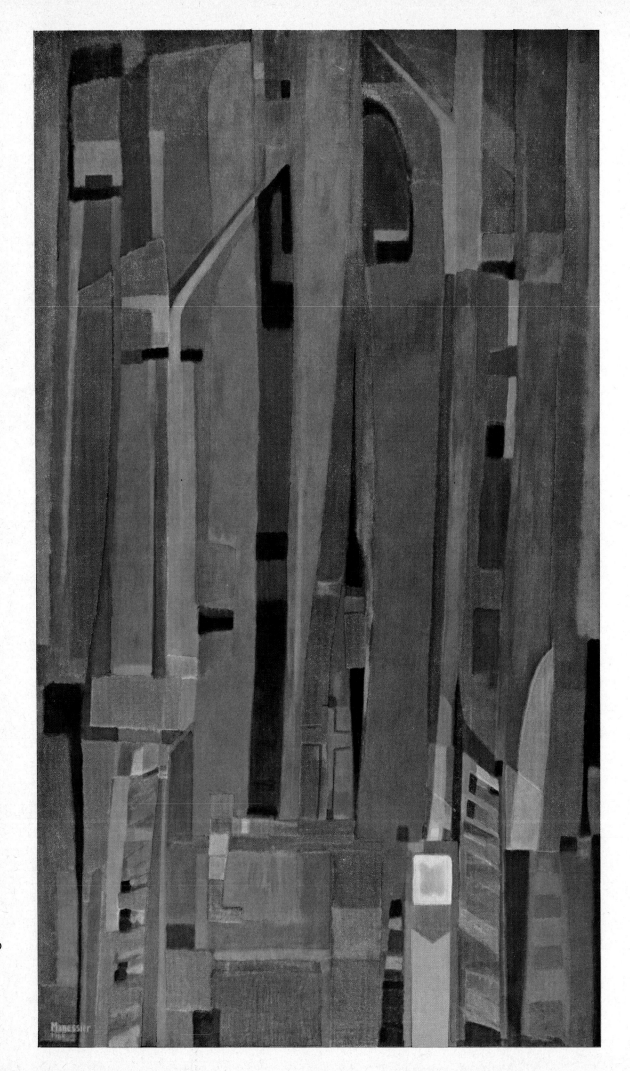

8 Salve Regina
1945
175 × 115 cm
Musée des Beaux-Arts, Nantes

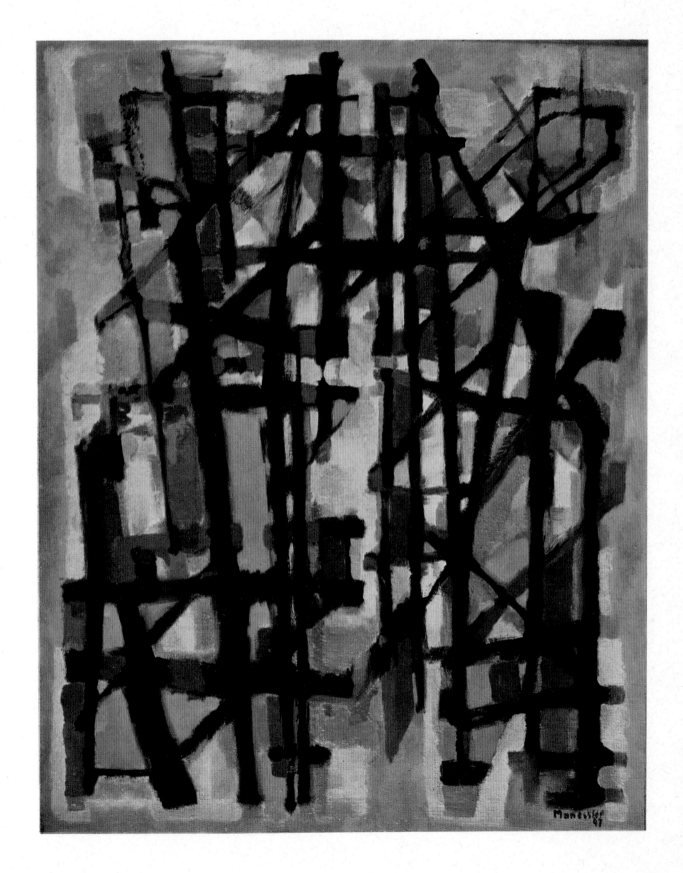

9 St George in Combat
1947
122 × 79 cm
Private collection

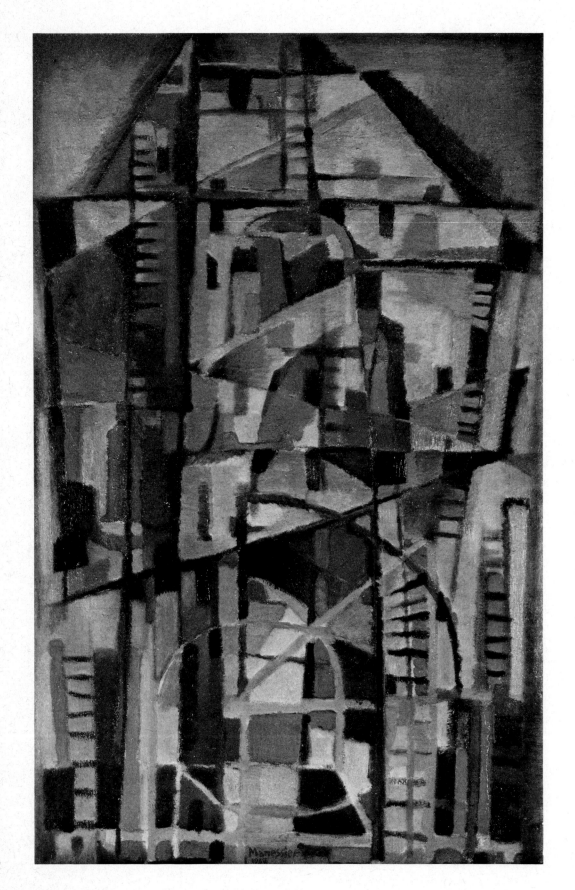

10　Angelus domini nuntiavit mariae
1946
116 × 73 cm
Private collection

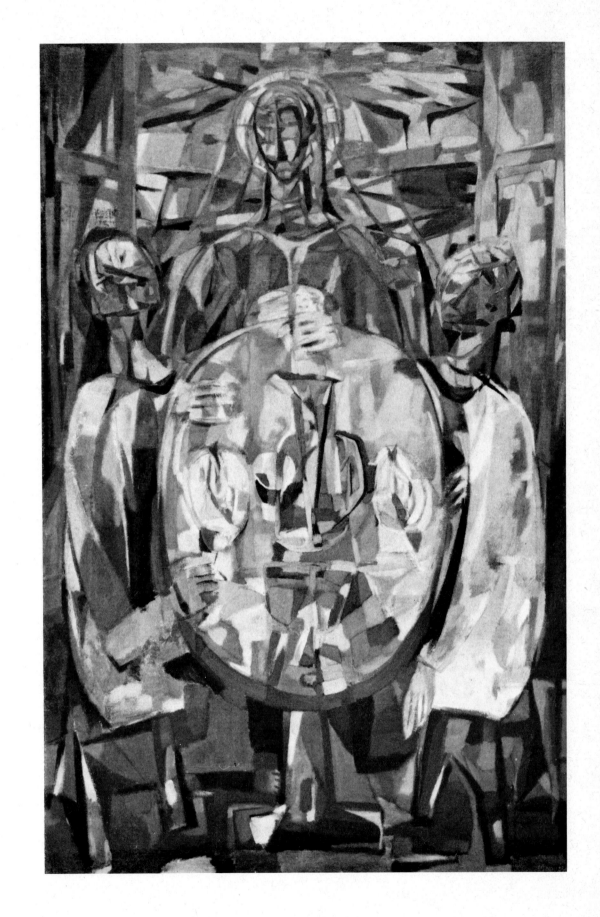

11 The Pilgrims of Emmaus
 1944
 195 × 130 cm
 Private collection

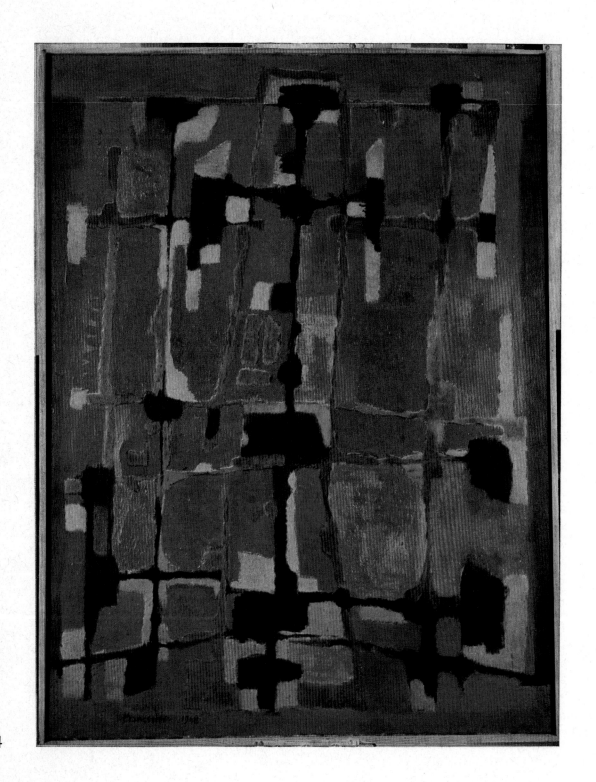

12 The St Matthew Passion
1948
46 × 38 cm
Private collection

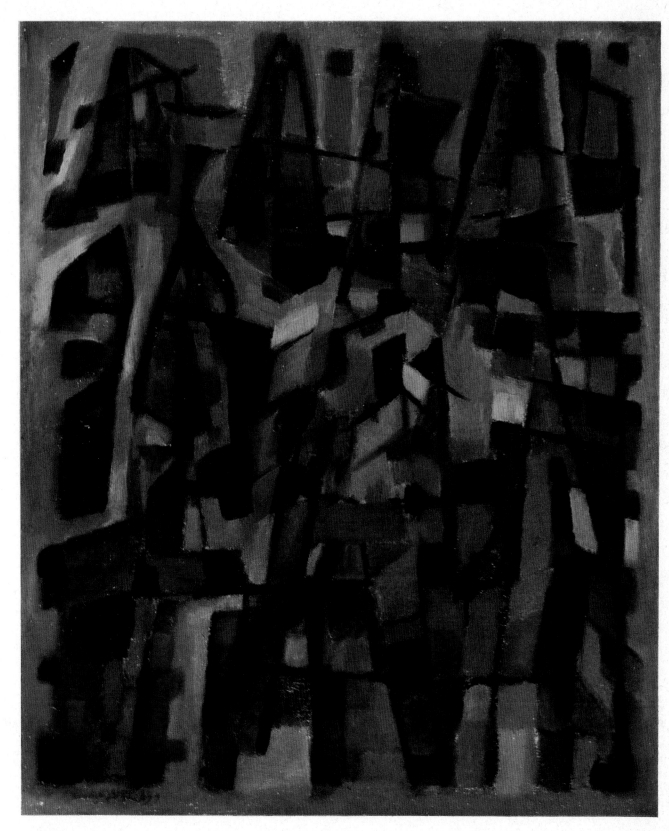

13 The Ascent to Les Bréseux
1949
116 × 89 cm
Private collection

125

14 Morning space
1949
130 × 162 cm
Musée National d'Art Moderne, Paris

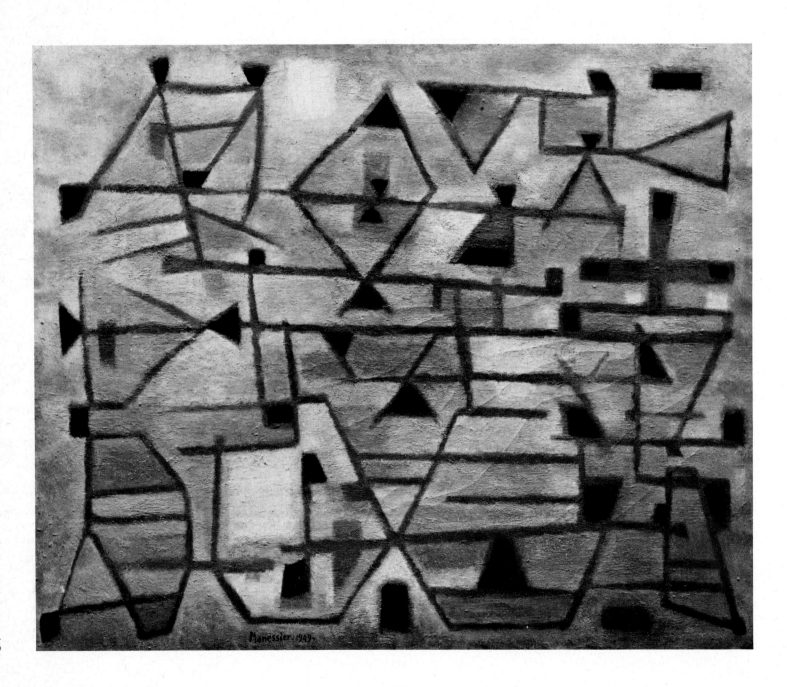

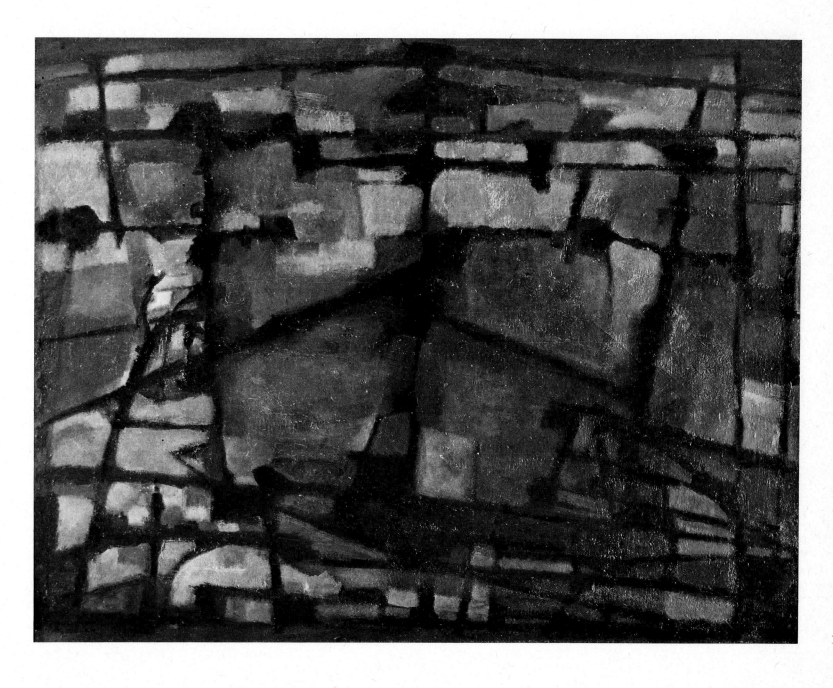

16 Landscape for Easter Day
1949
73 × 73 cm
Private collection

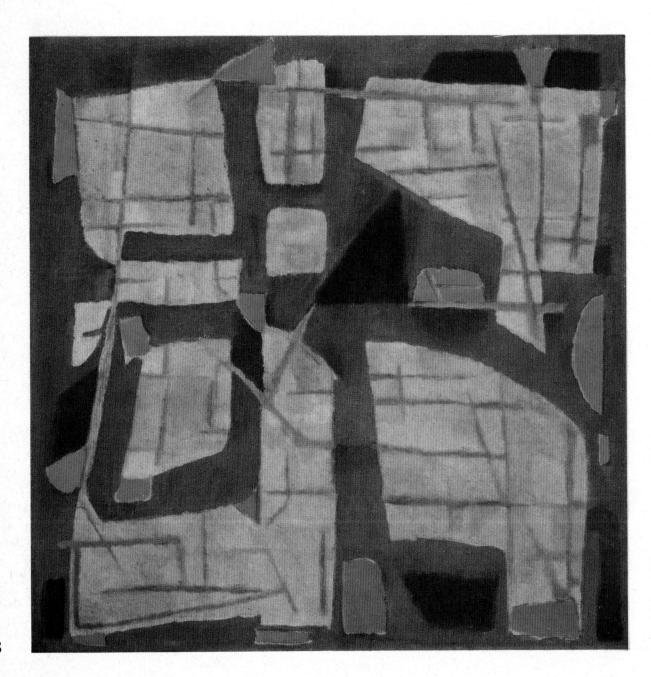

17 Study for Games in the Snow
1951
50 × 61 cm
Solomon R. Guggenheim, New York

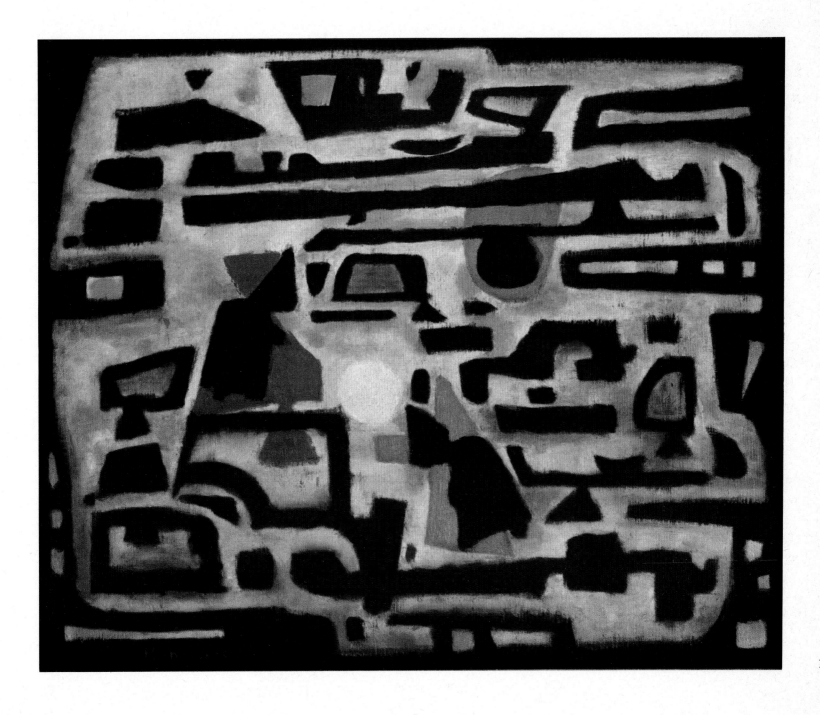

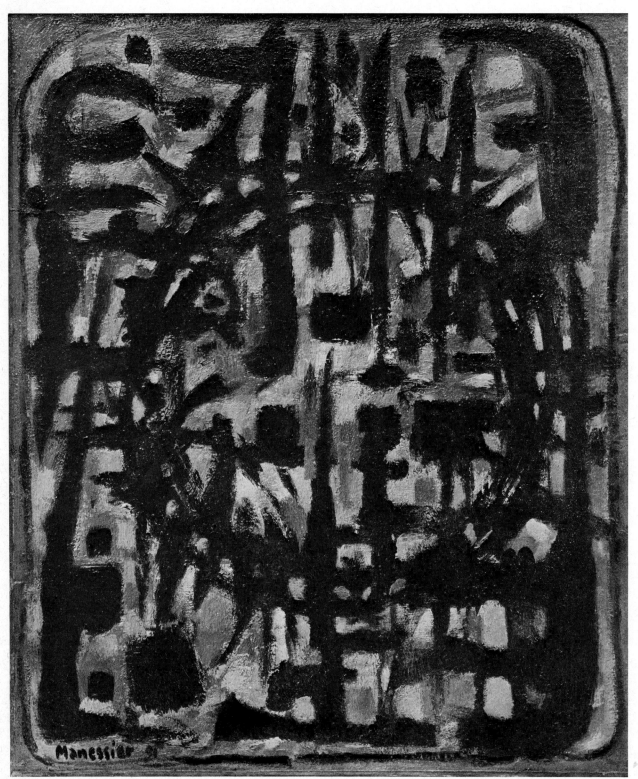

18 Crown of thorns
1951
58 × 46.5 cm
Museum Folkwang, Essen

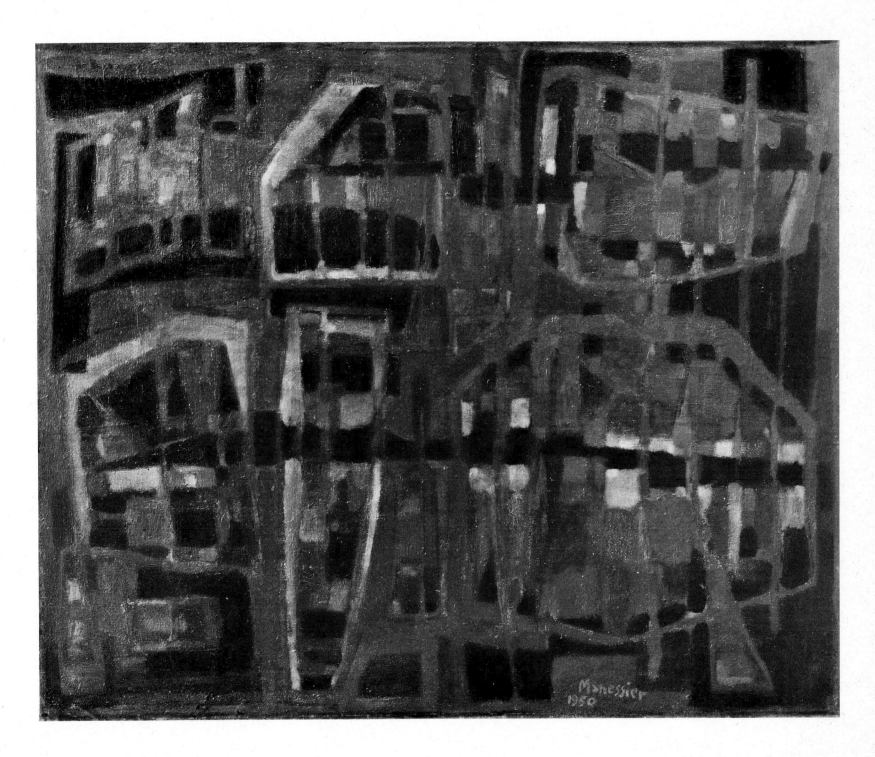

20 Flood tide in the Somme Bay
1949
81 × 100 cm
Private collection

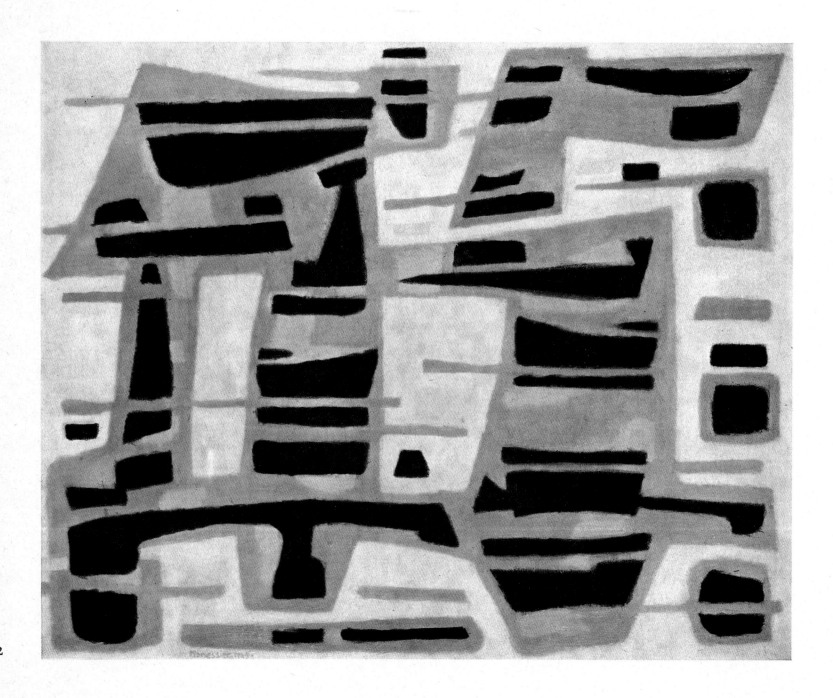

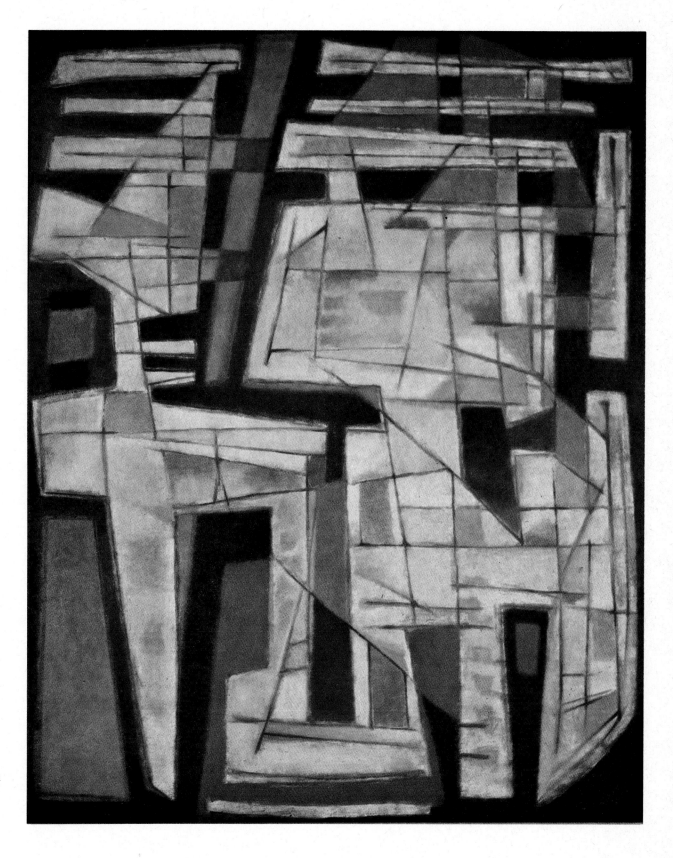

21 Fort and Harbour at Oléron
1950
100 × 81 cm
Private collection

133

22 Harbour at night
1950
54 × 65 cm
Museum Boymans van Beuningen, Rotterdam

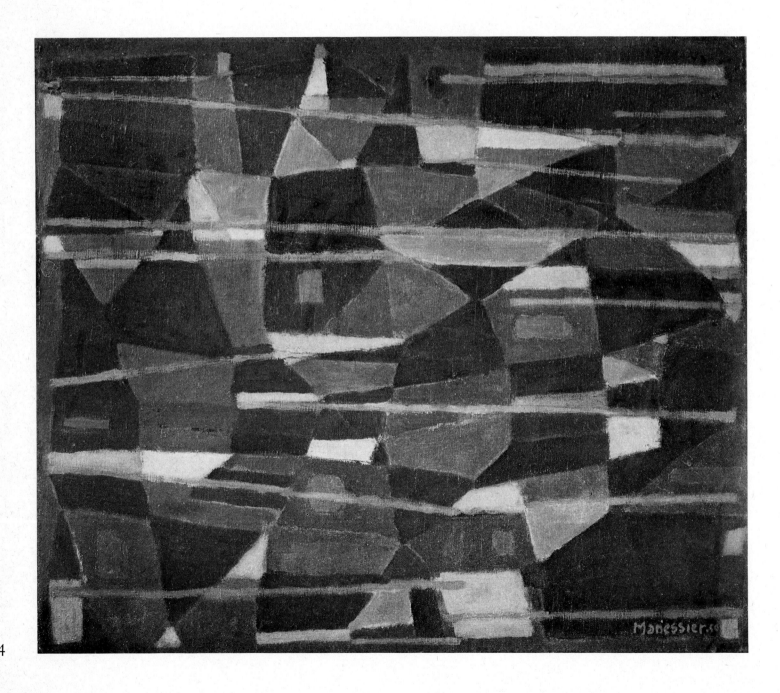

23 Easter Gardens
1952
73 × 100 cm
Niedersächsisches Landesmuseum, Hanover

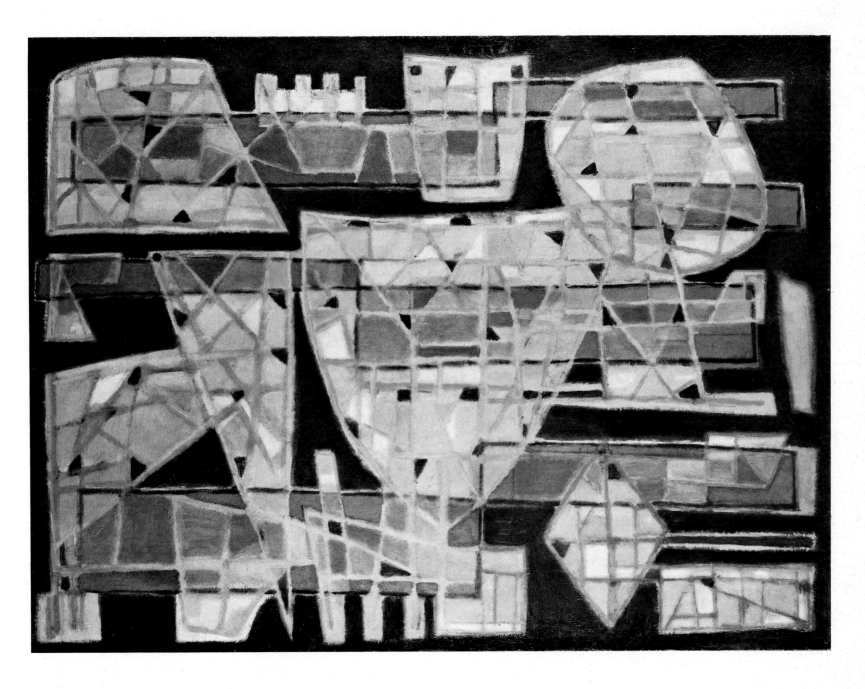

24 Longwy at Night
1951
134 × 167 cm
Museo Civico di Torino, galleria civica d'arte moderna, Turin

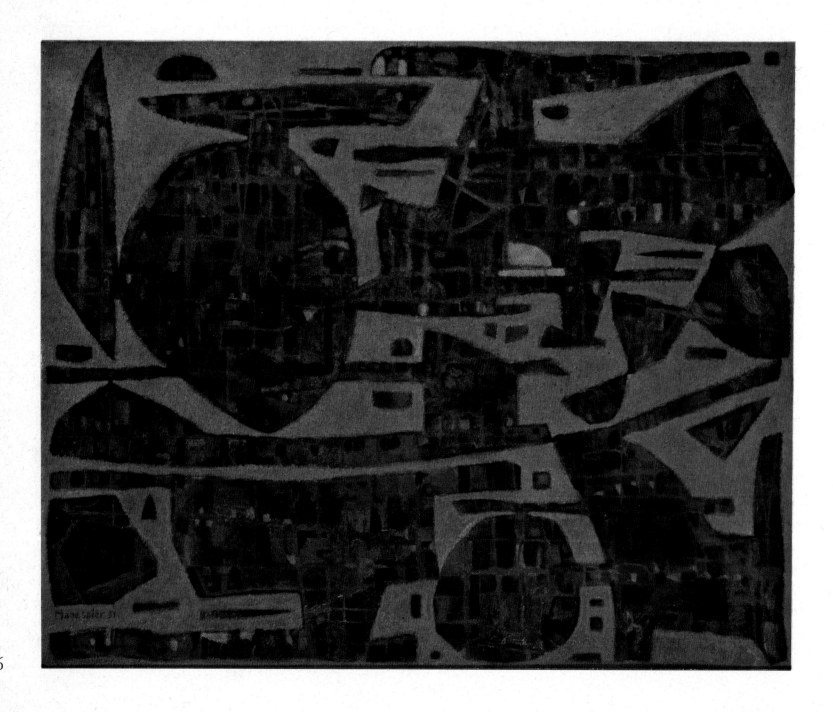

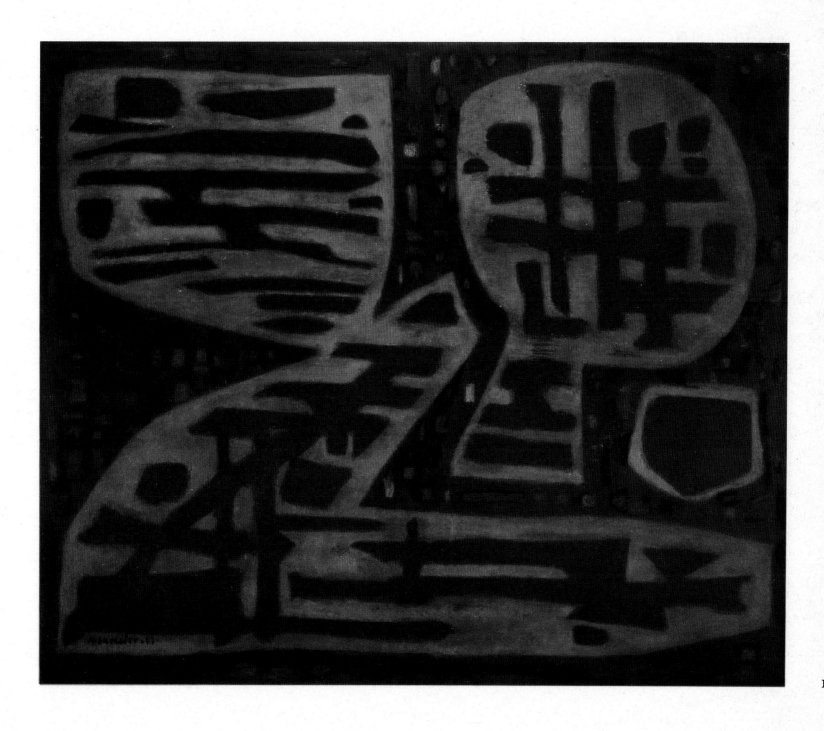

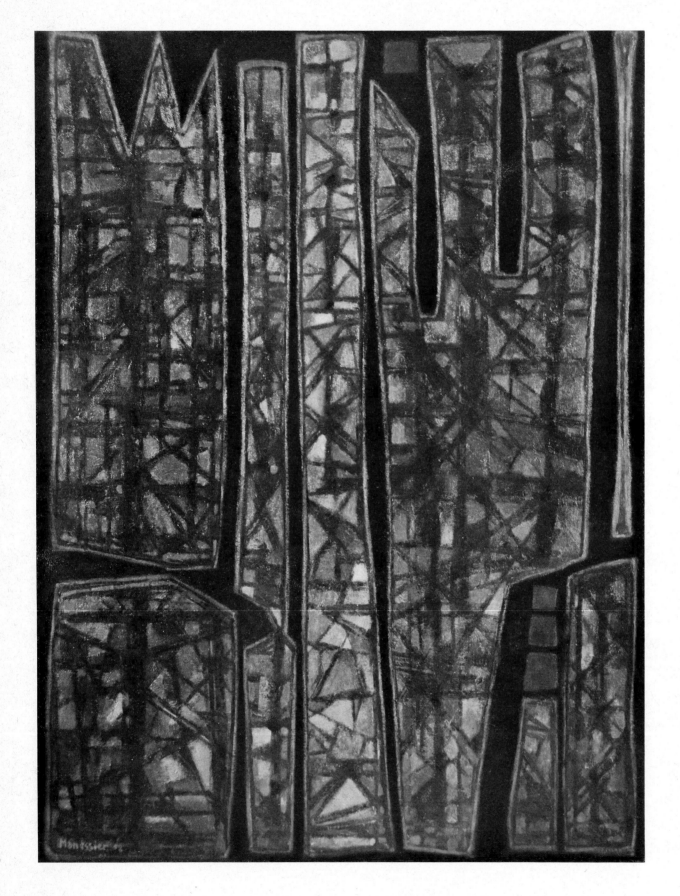

26 Nocturnal Reflection II
 1952
 200 × 150 cm
 Private collection

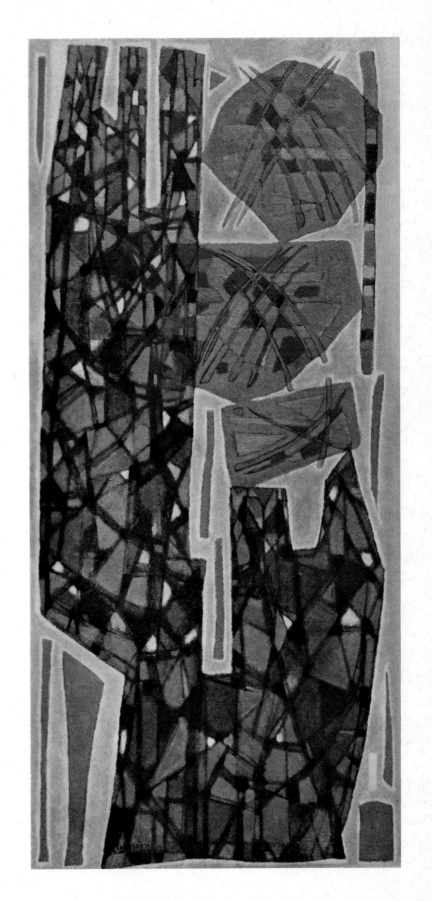

27 Harvest Magnificat
1952
220 × 100 cm
Private collection

28 Nocturnal Reflection I
1952
220 × 100 cm
Private collection

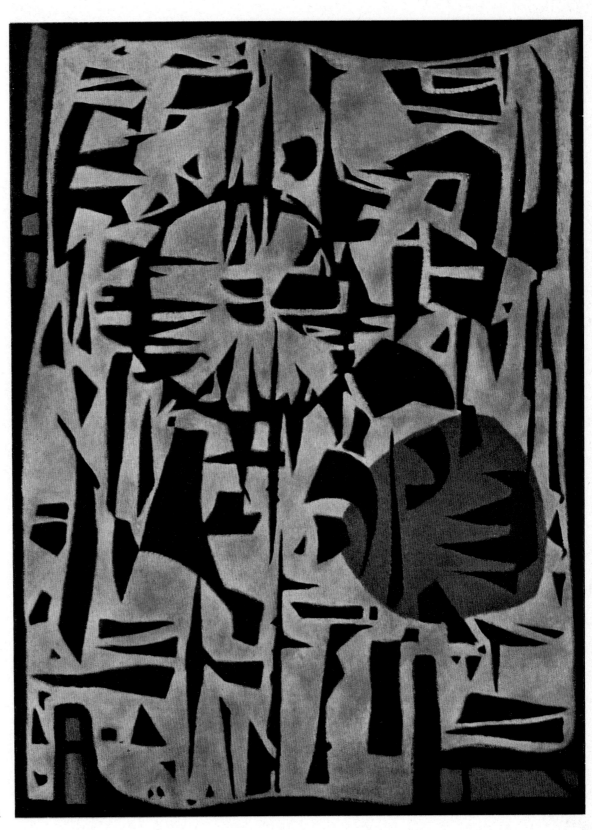

29 Barrabas
1952
200 × 150 cm
Stedelijk van Abbemuseum, Eindhoven

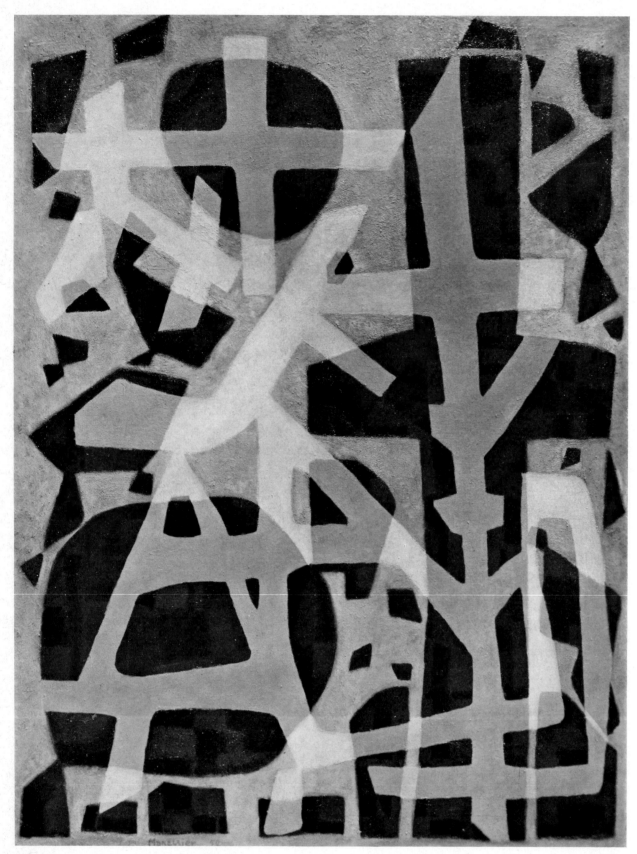

142

30 For the Feast of Christ
the King
1952
200 × 150 cm
Museum of Modern Art,
New York
(Abby Aldrich Rockefeller
Fund)

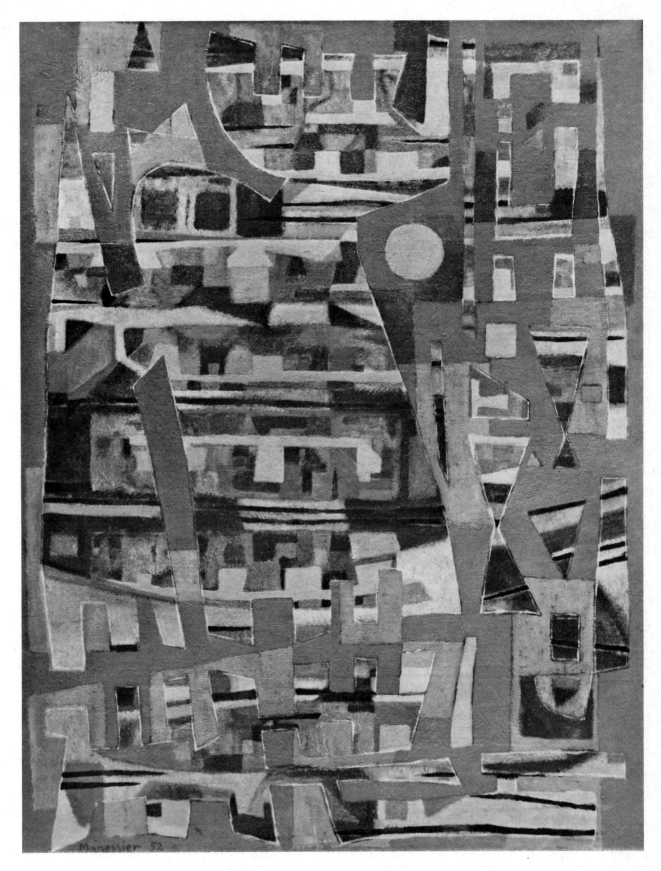

31 Turris Davidica
1952
200 × 150 cm
Kunsthalle Bremen, Bremen

143

144

32 The Passion
of Our Lord Jesus Christ
1952
200 × 150 cm
Musée des Beaux-Arts,
La Chaux-de-Fonds

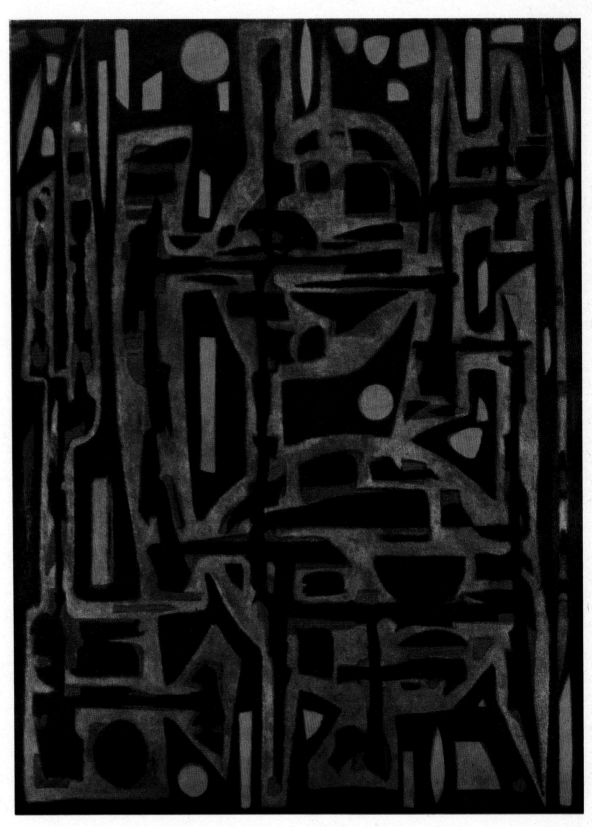

33 Night in Gethsemane
1952
200 × 150 cm
Kunstsammlung Nordrhein-Westfalen,
Dusseldorf

145

34 Hallelujah I (a), Hallelujah II (b), Morning Star (c), Veronica (d),
1952
50 × 50 cm each
Private collections

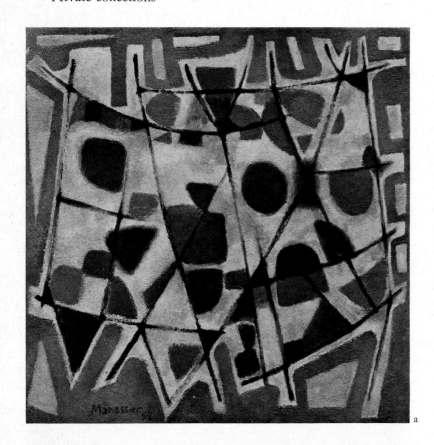

a

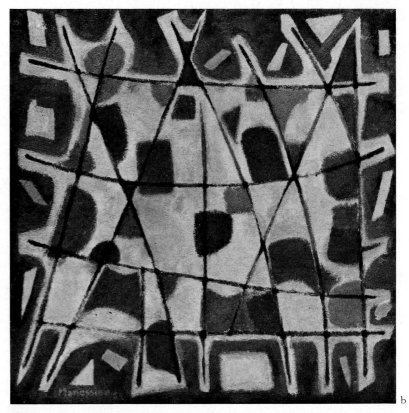

b

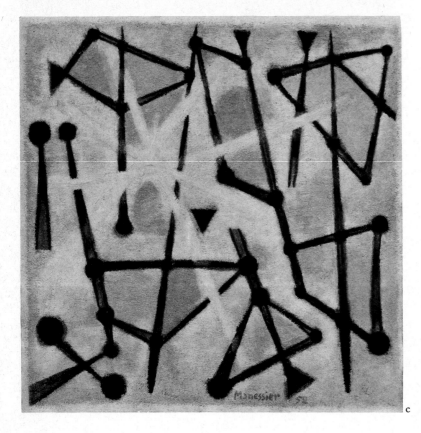

c

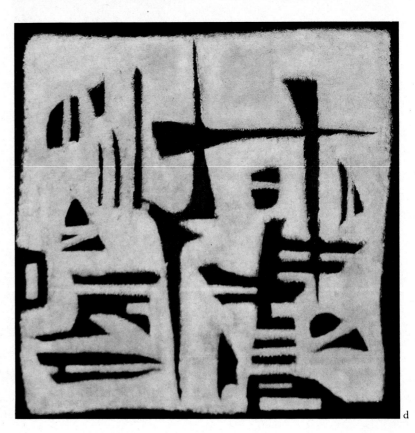

d

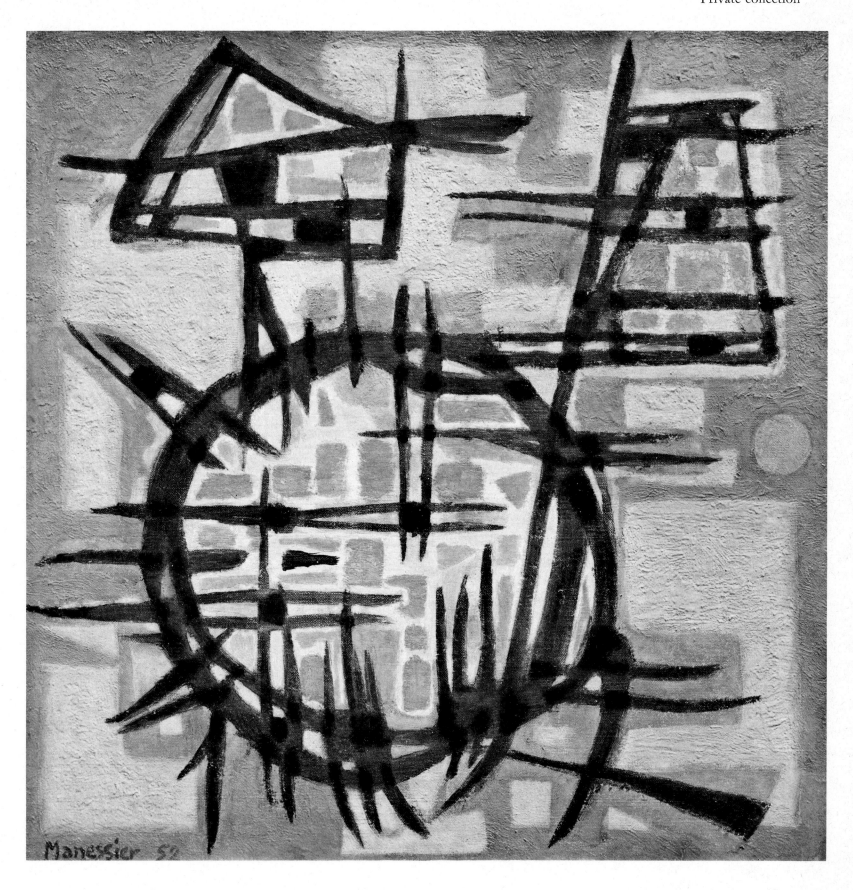

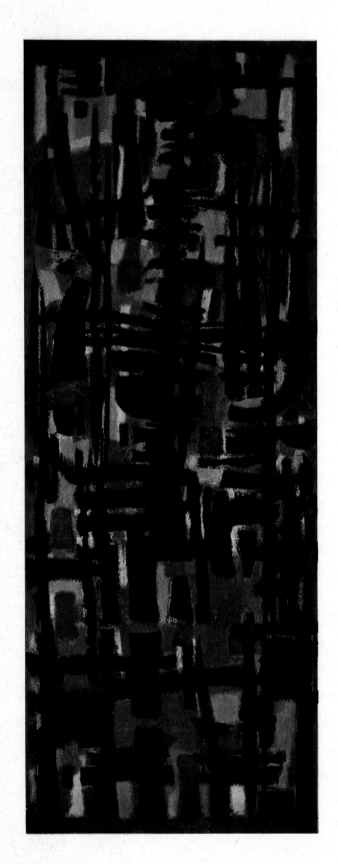

36 Lord, shall we strike
with the sword
1954
200 × 80 cm
Musées Royaux des Beaux-Arts de Belgique, Brussels

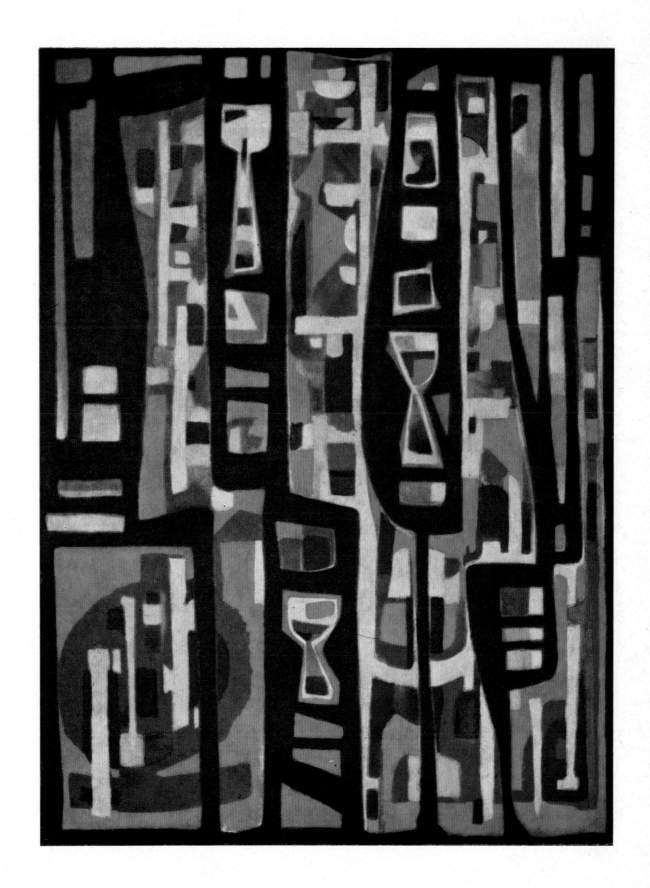

37 Evening Litanies
 1951/2
 200 × 150 cm
 Museu de Arte Moderna,
 Rio de Janeiro

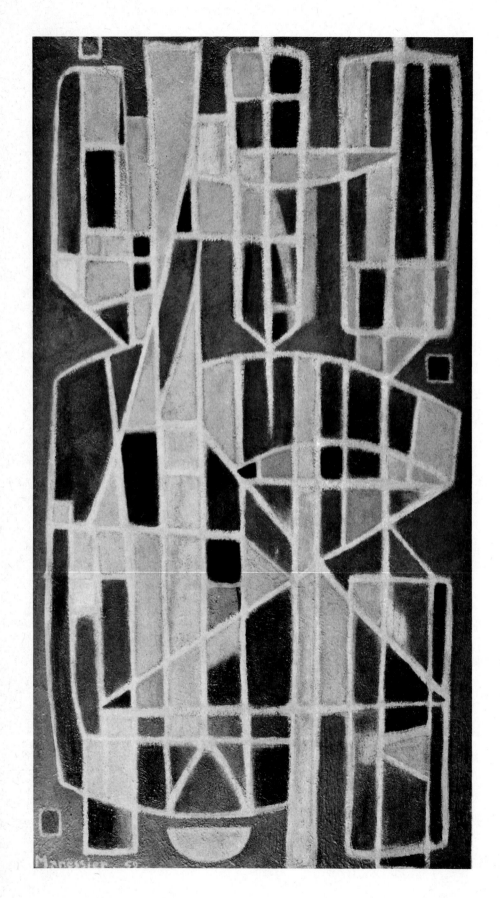

38 At Peace
1954
92 × 50 cm
Musée des Beaux-Arts du Havre, Le Havre

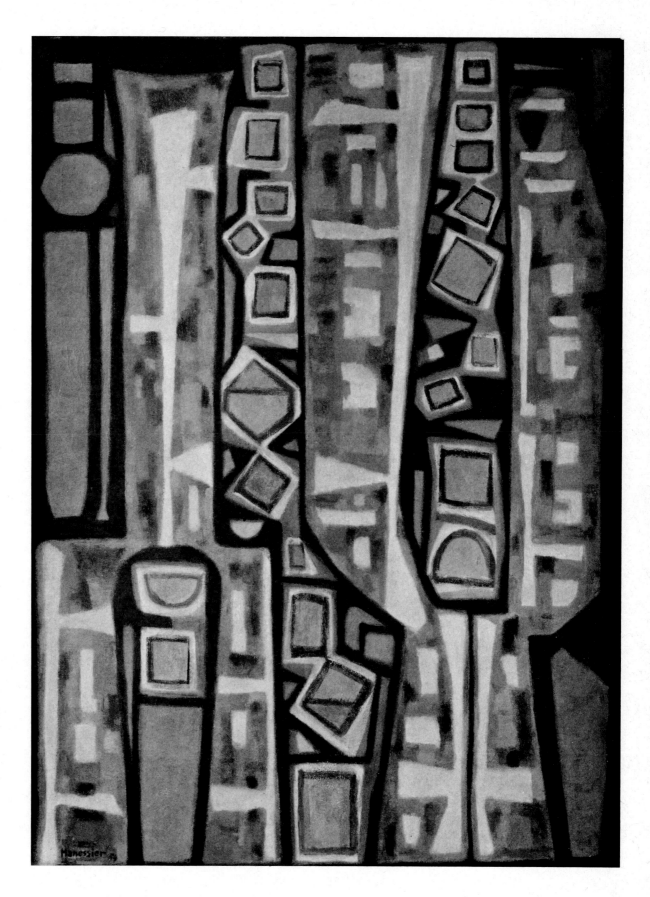

39 Eventide offering
 1954
 200 × 150 cm
 Museum
 Boymans van Beuningen,
 Rotterdam

151

40 The Crown of Thorns
1954
114 × 162 cm
Museum of Art, Carnegie Institute Pittsburgh,
(Patrons' art fund)

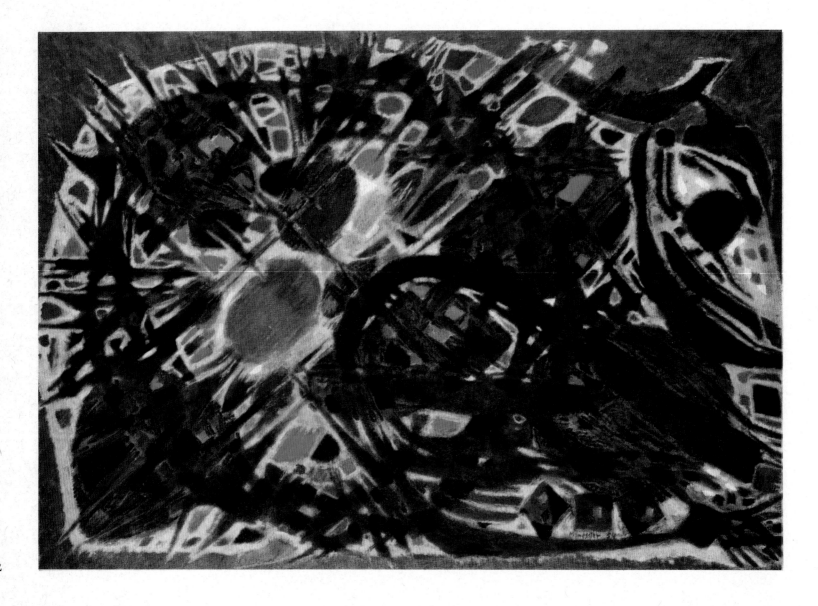

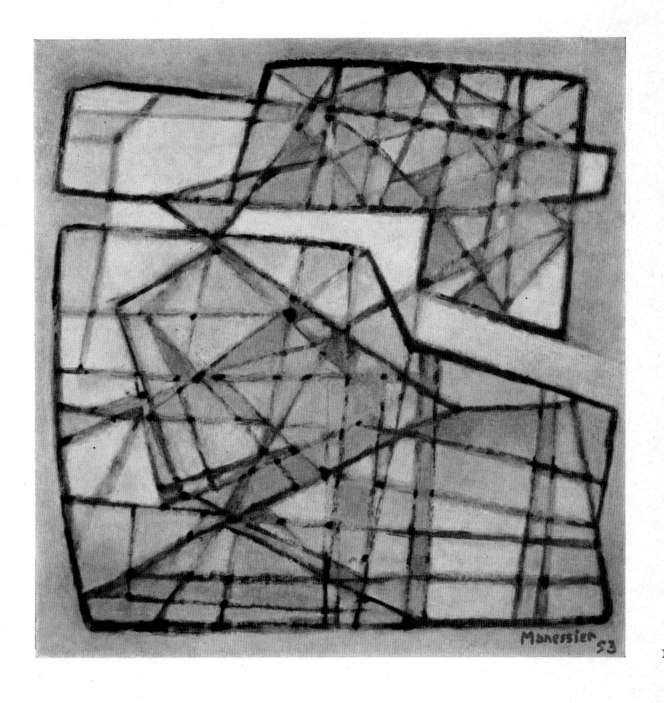

42 Rising tide
1953
115 × 115 cm
Private collection

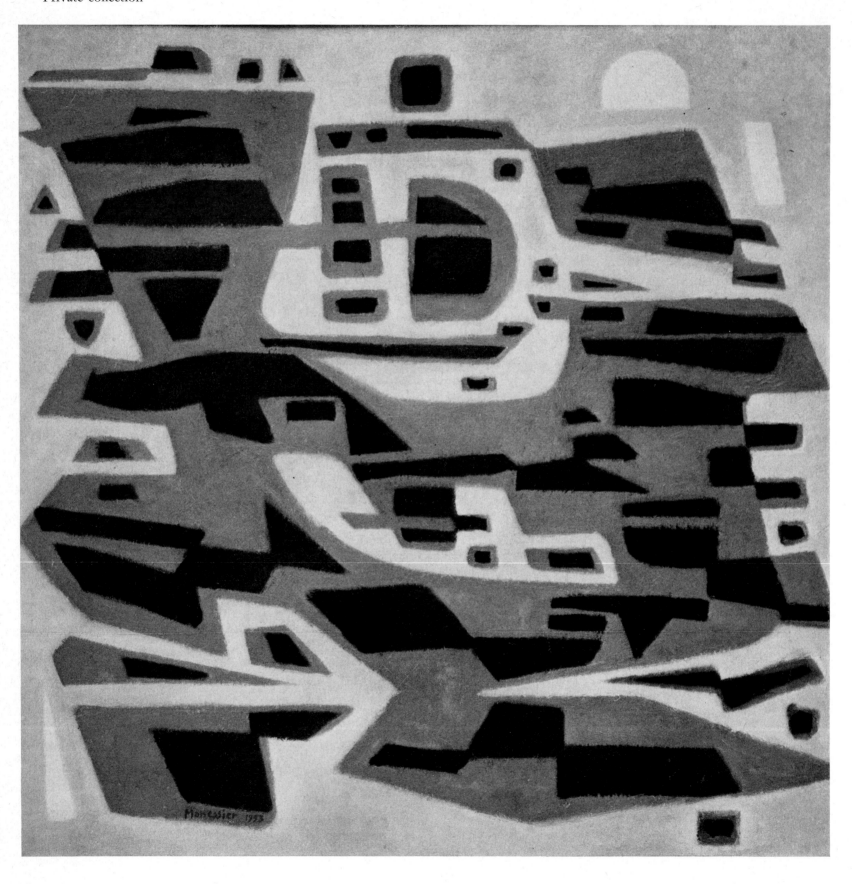

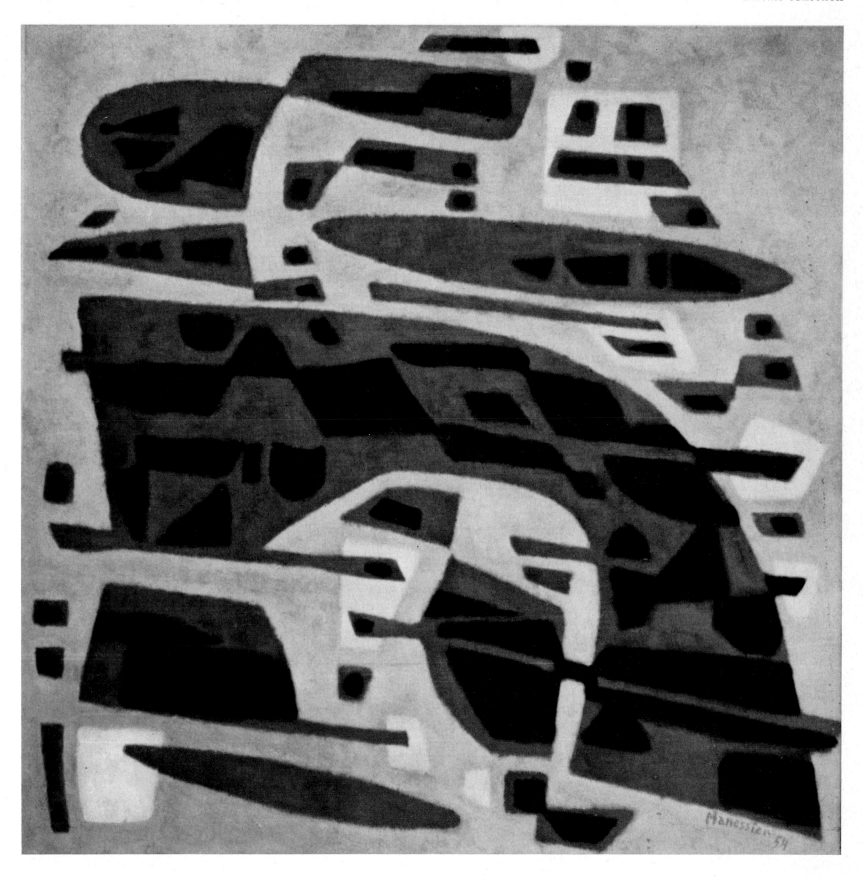

44 Dead water
1954
114 × 114 cm
Private collection

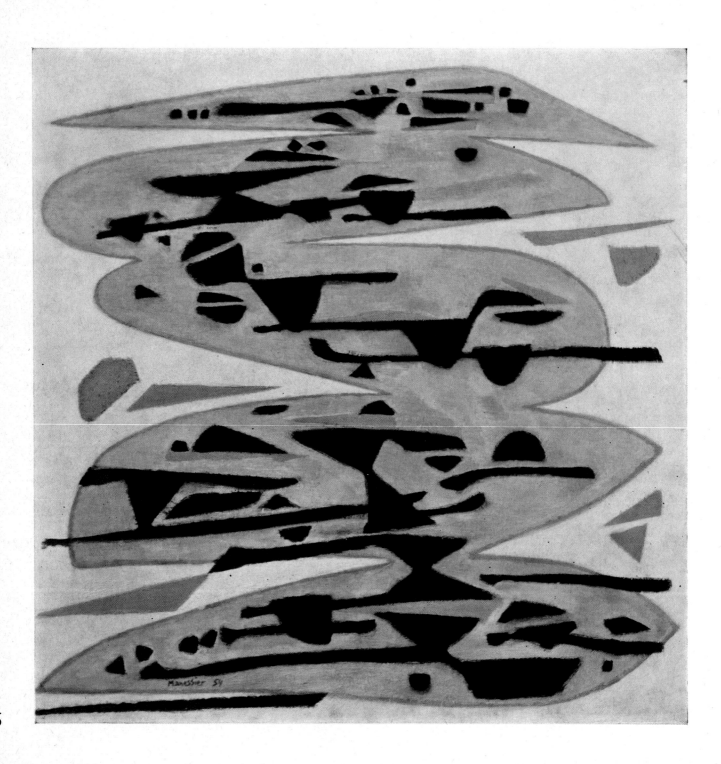

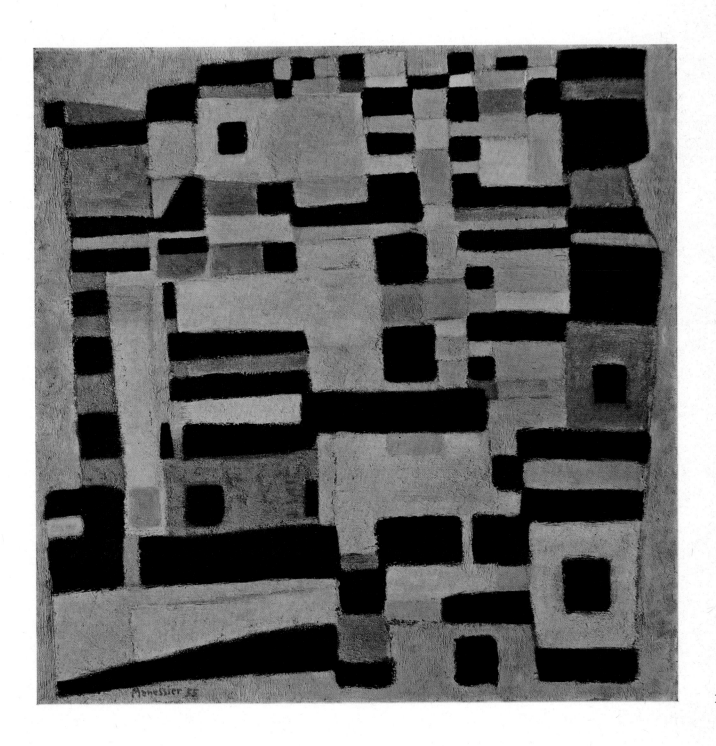

46 Barges
1954
50 × 50 cm
Private collection

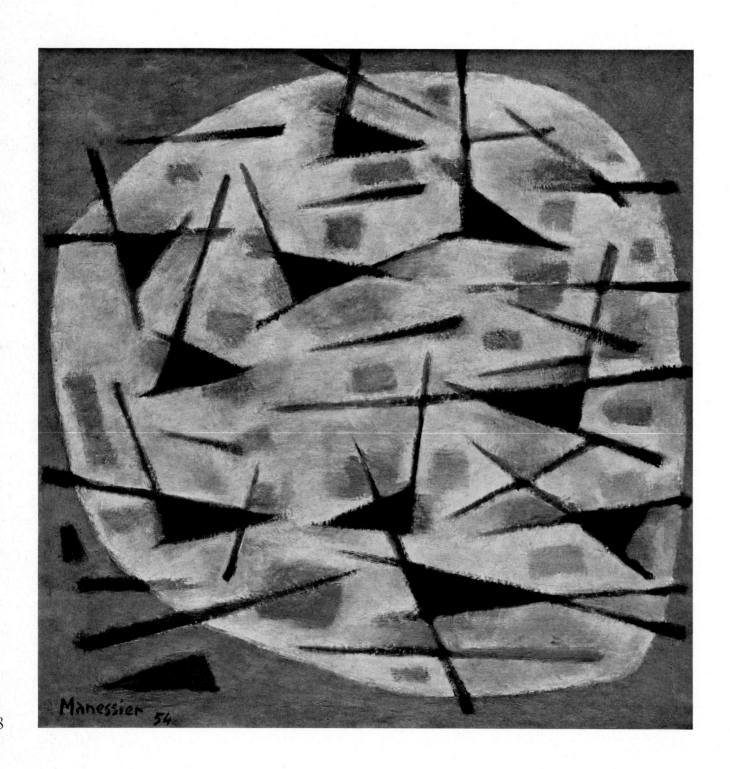

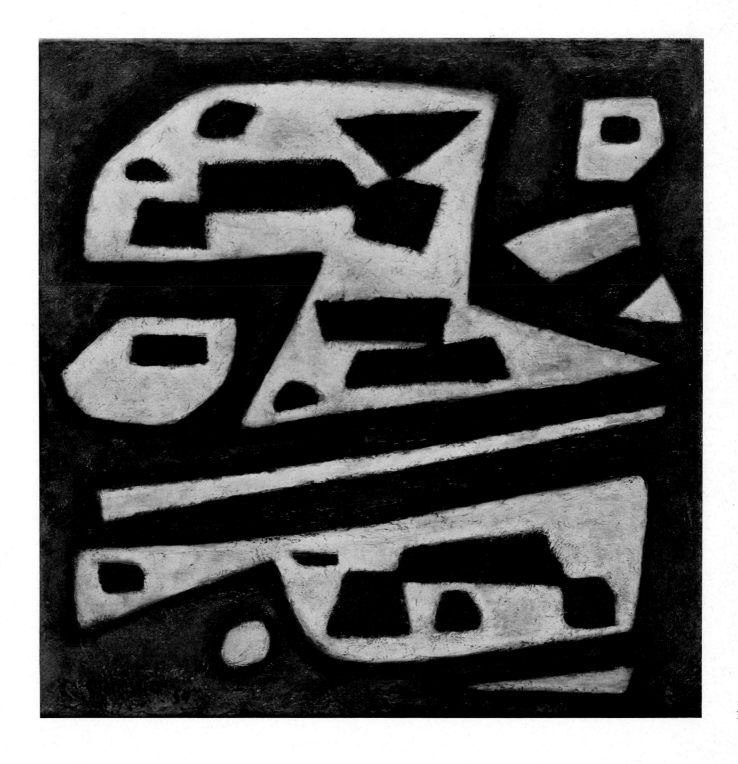

48 Per amica silentiae lunae
1954
150 × 200 cm
Museum Folkwang, Essen

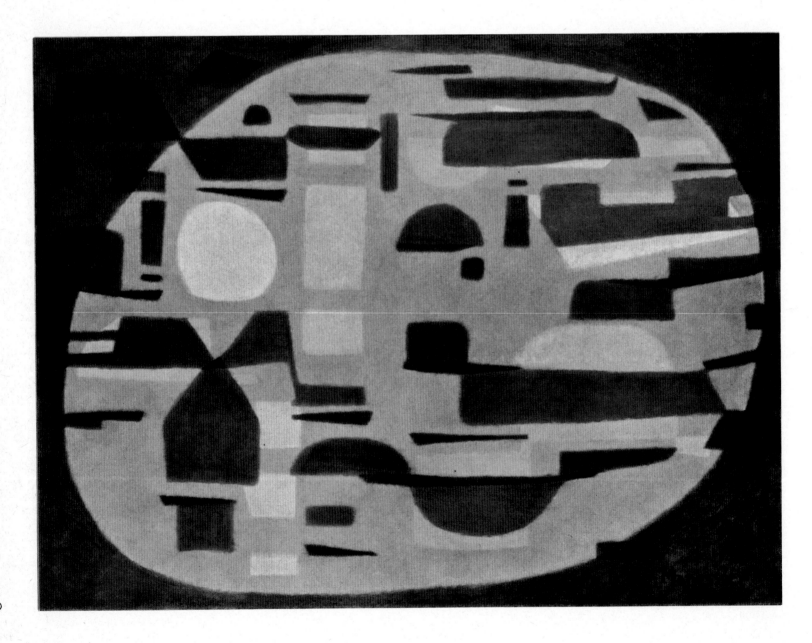

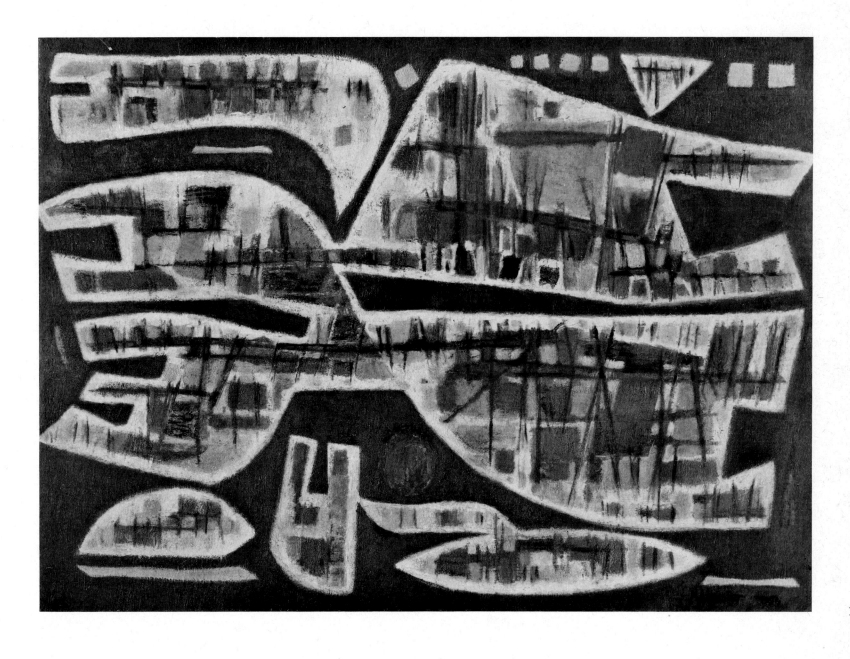

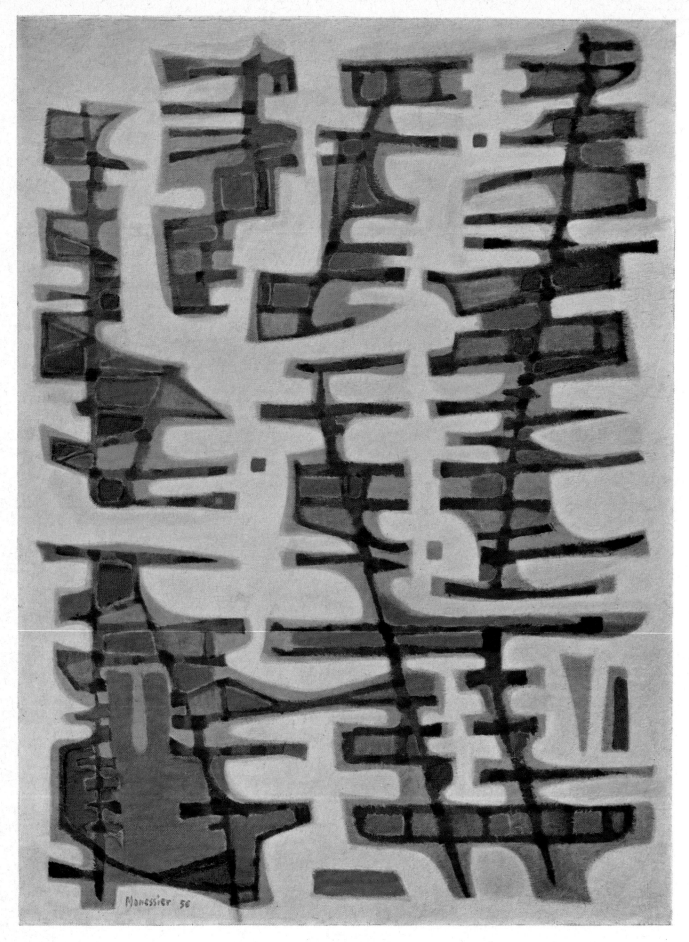

50 Polders enneigés
1956
200 × 150 cm
Private collection

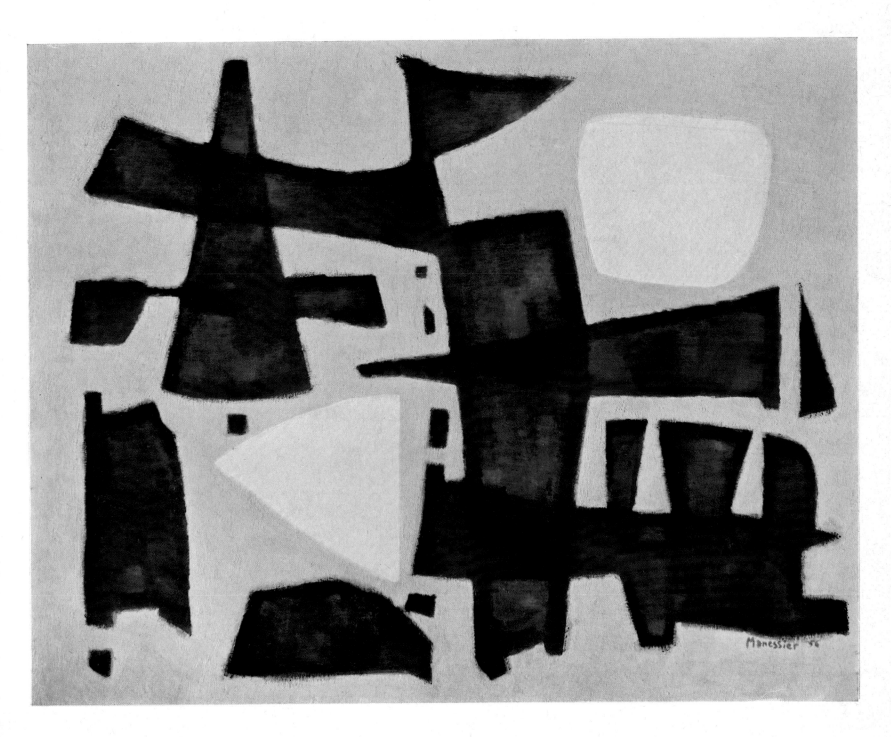

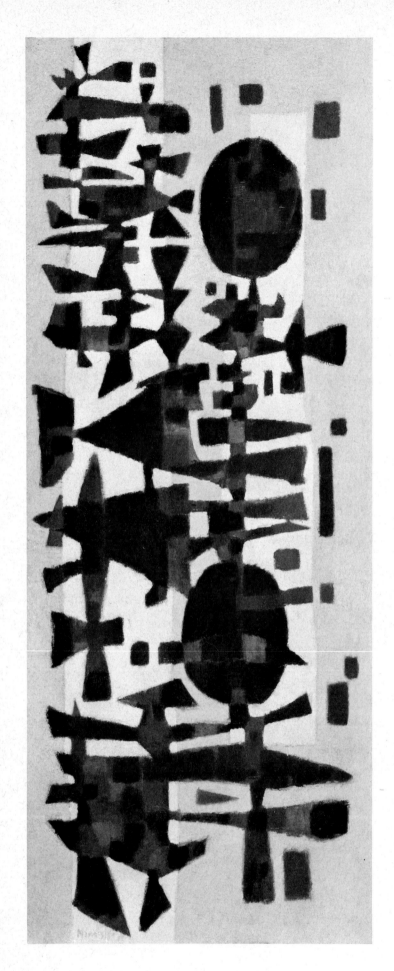

52 Festival in Zeeland
1955
200 × 80 cm
Hamburger Kunsthalle, Hamburg

53 February near Haarlem
1956
113 × 195 cm
Nationalgalerie, Staatliche Museen der Stiftung Preussischer
Kulturbesitz, Berlin

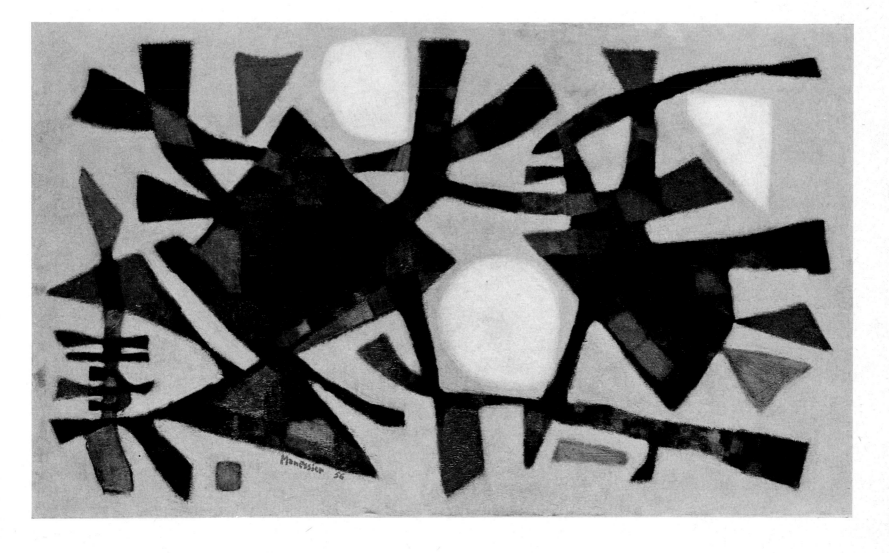

54 Bouquet
1955
60 × 73 cm
Sonja Henie-Niels Onstad Foundations, Blommenholm-Oslo

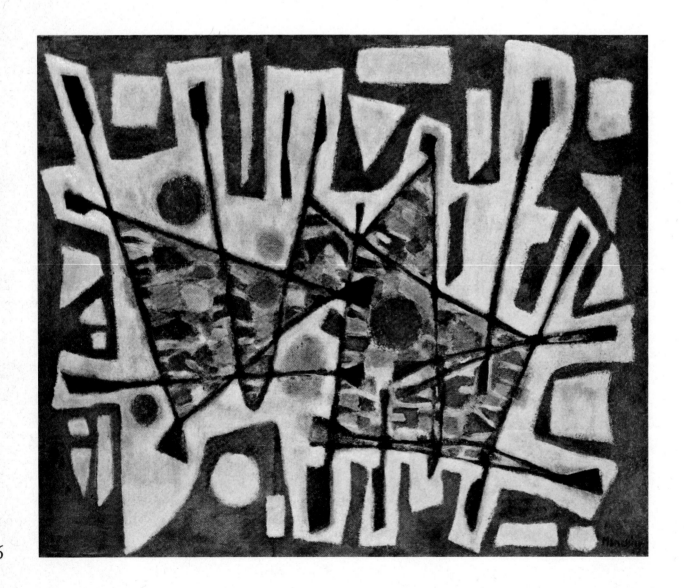

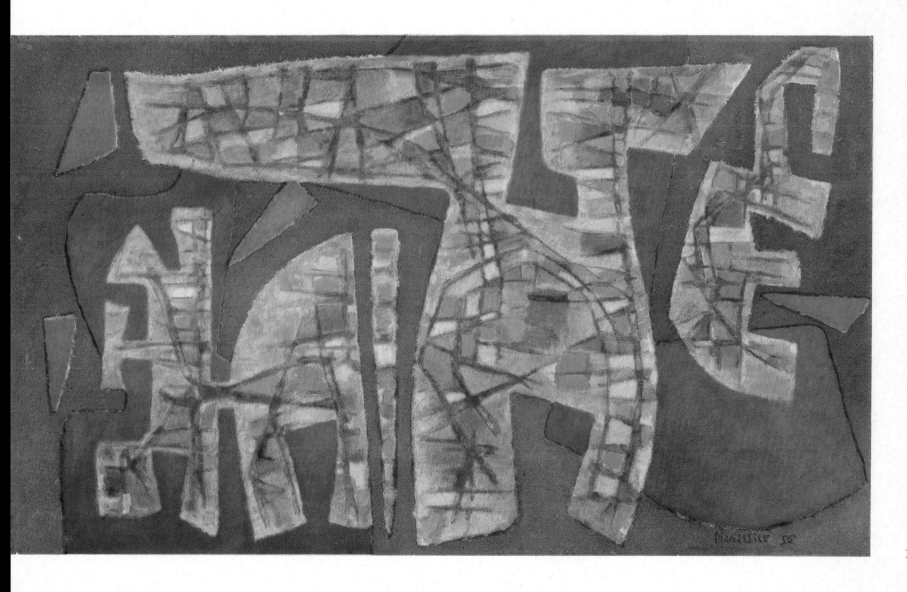

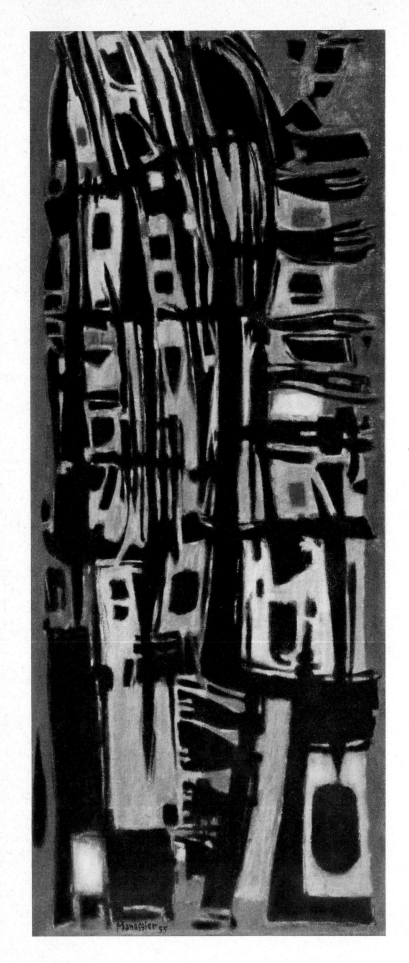

168

56 The Night of Holy Thursday
1955
200 × 80 cm
Moderna Museet, Stockholm

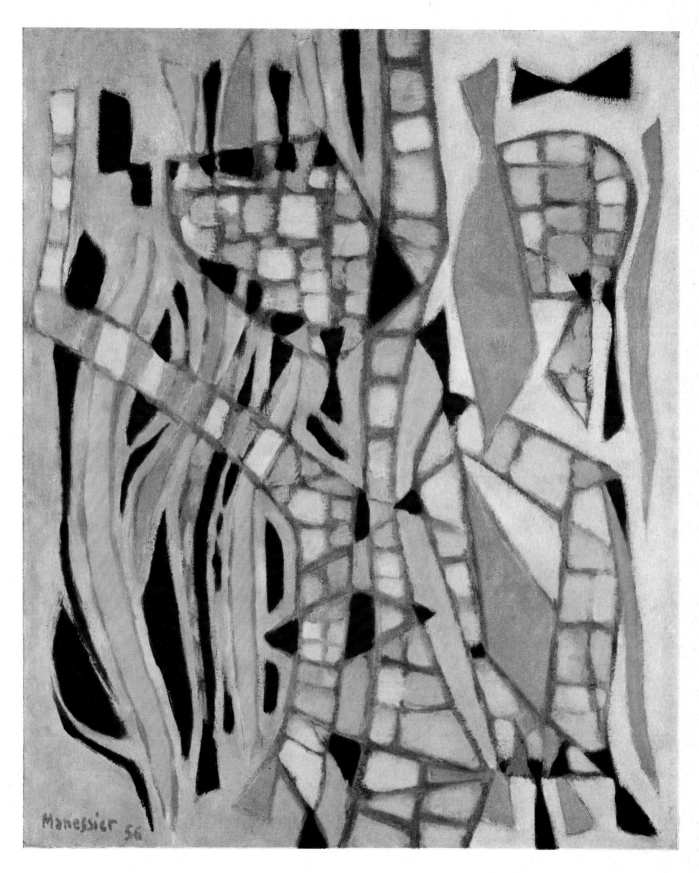

57 The White Bush
1956
73 × 60 cm
Private collection

58 Silvery Canals
1956
89 × 146 cm
Private collection

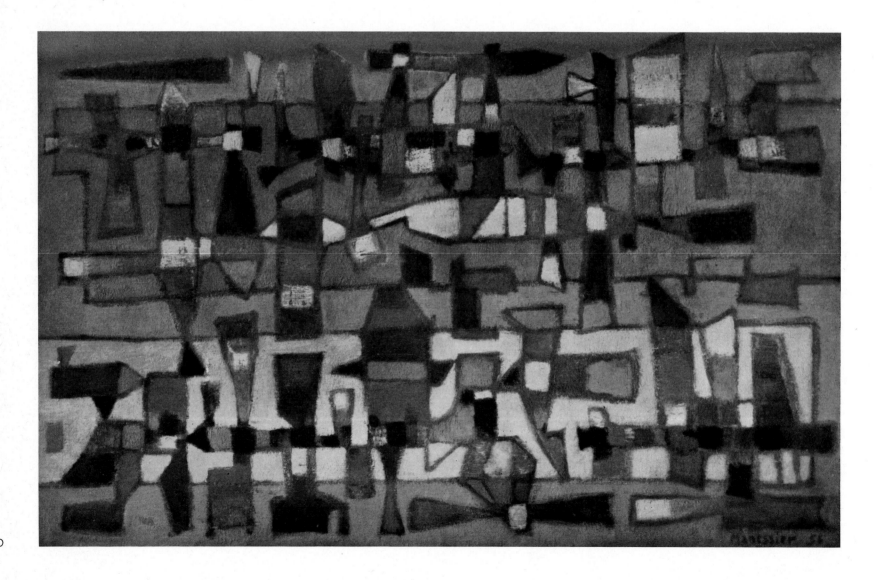

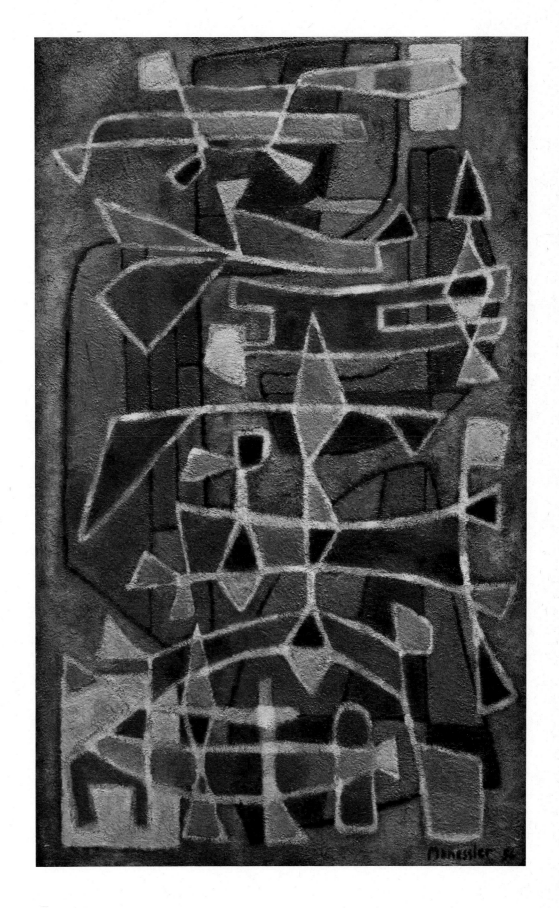

59 Little Dutch Landscape
1956
146 × 89 cm
Private collection

60 Near Haarlem
1956
114 × 195 cm
Musée des Beaux-Arts, Dijon

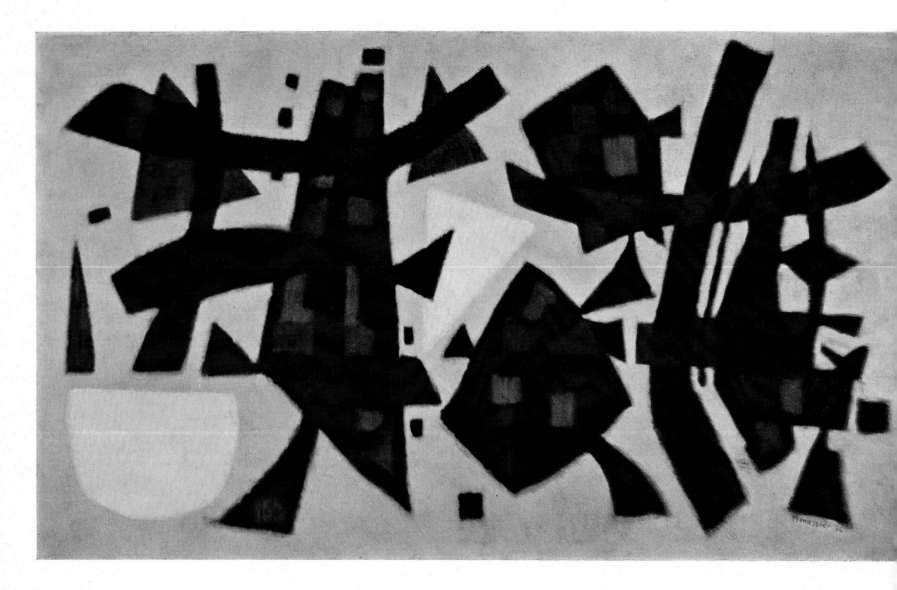

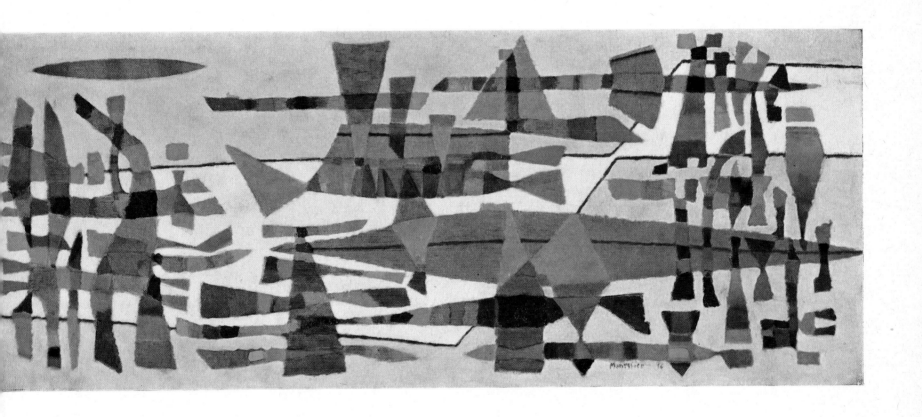

61 Festive Canal
1956
80 × 200 cm
Private collection

173

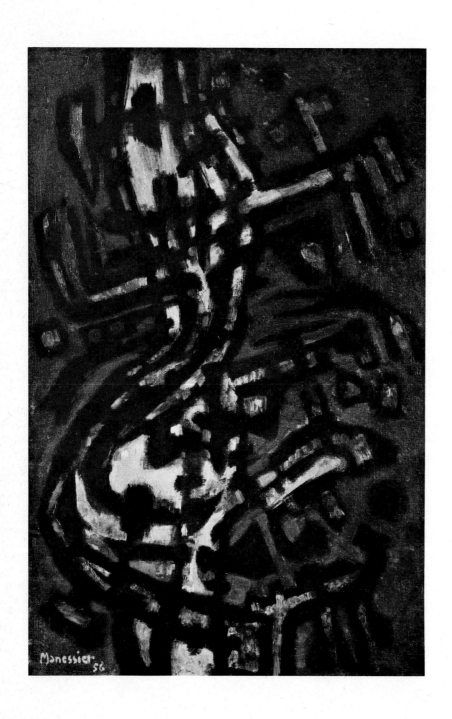

62 Freshwater spring
1956
100 × 65 cm
Private collection

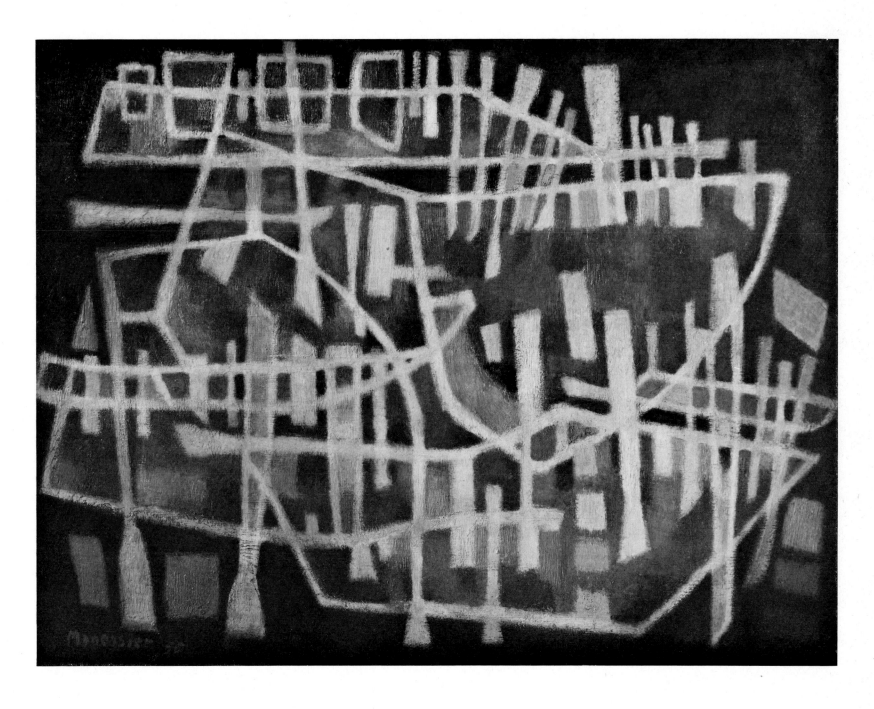

64 Requiem for November 1956
1956/7
200 × 300 cm
Staatsgalerie Stuttgart, Stuttgart

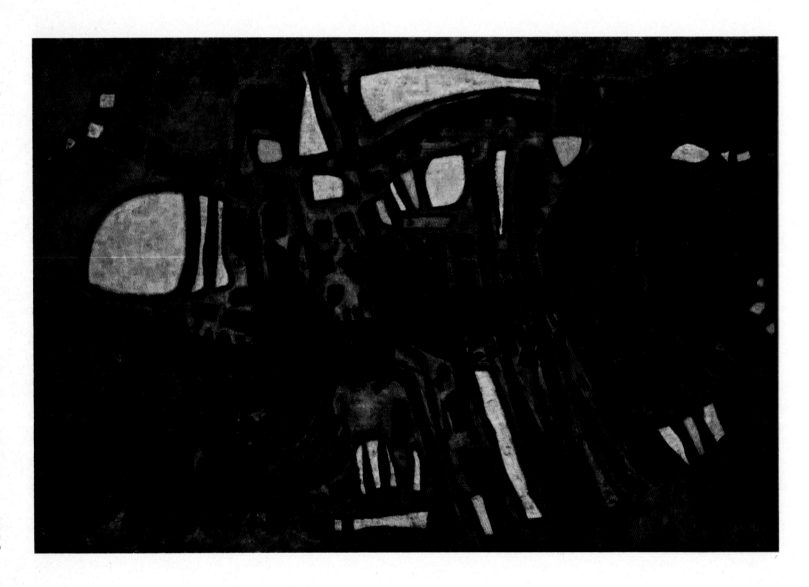

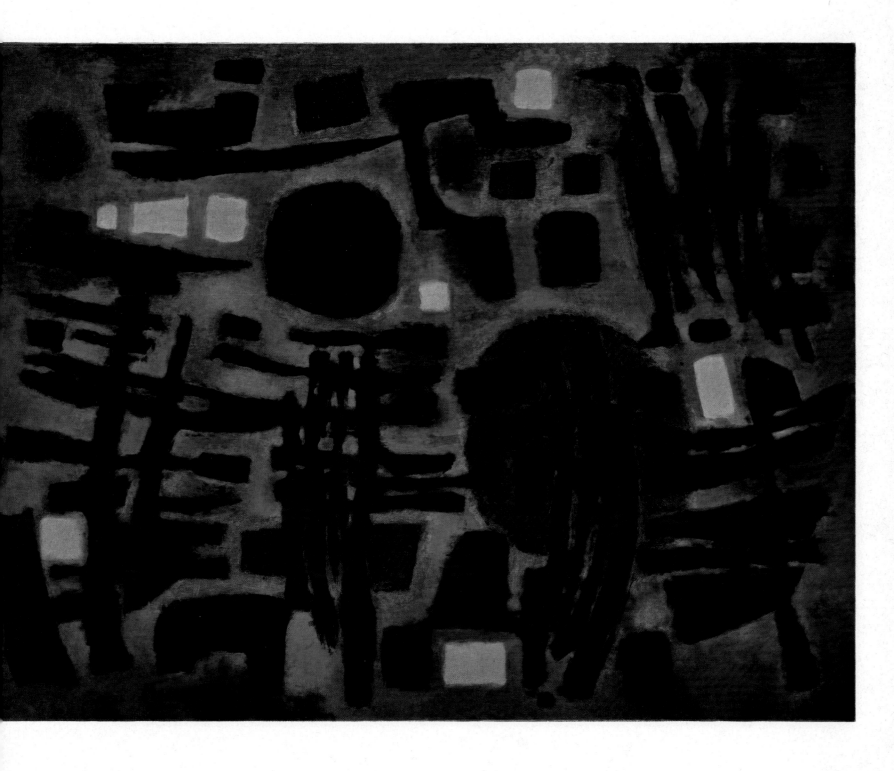

66 Pilgrimage
1957/8
81 × 100 cm
Private collection

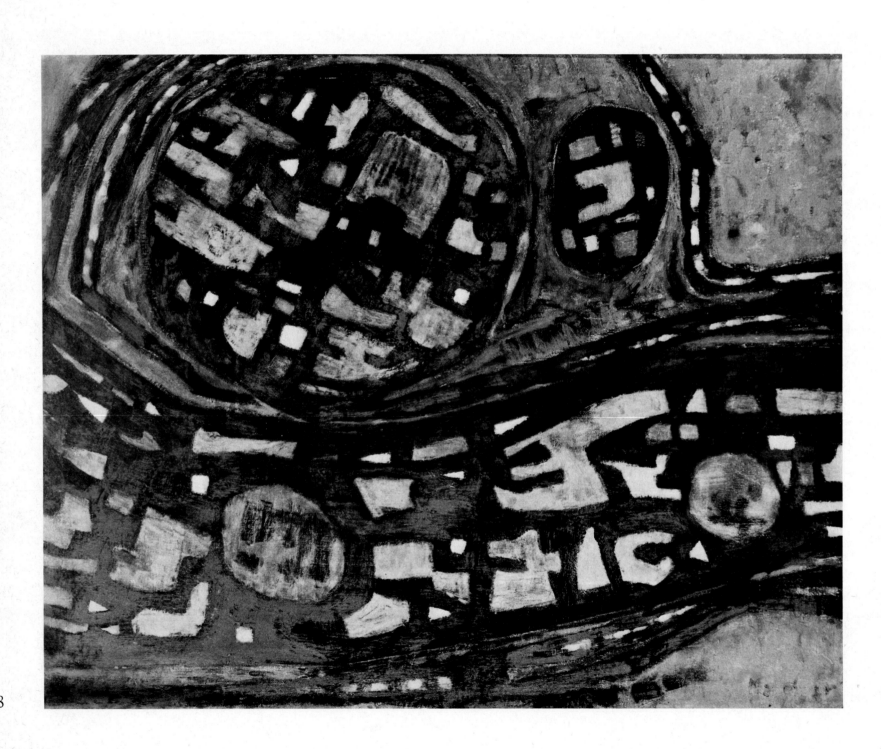

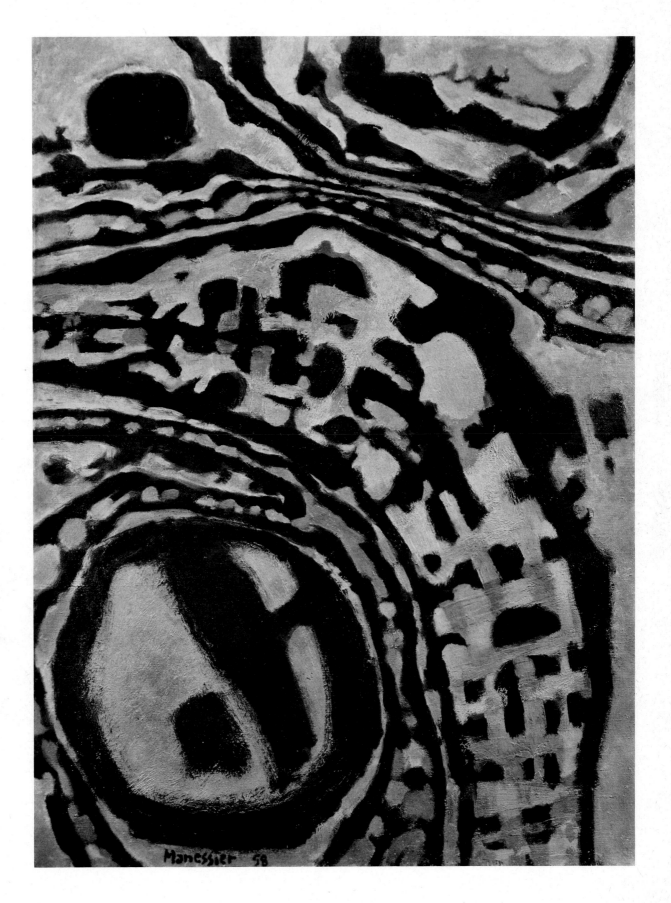

67 Night Descent
1958
100 × 73 cm
Private collection

179

68 Impetus
1956
98 × 130 cm
Private collection

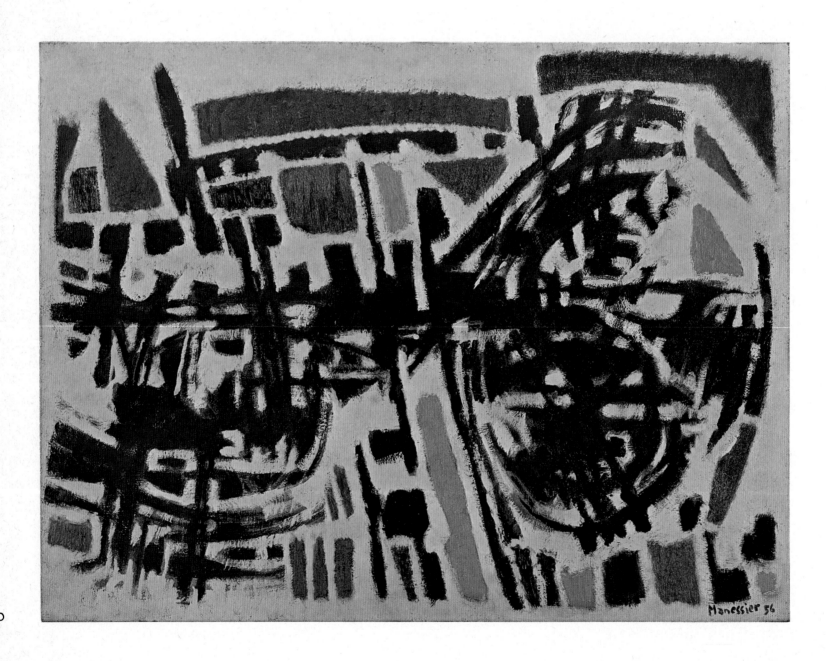

69 The Sixth Hour
1957/8
250 × 322 cm
Private collection

181

70 Study for Requiem for
November 1956/7
97 × 146 cm
Kunsthalle Bremen, Bremen

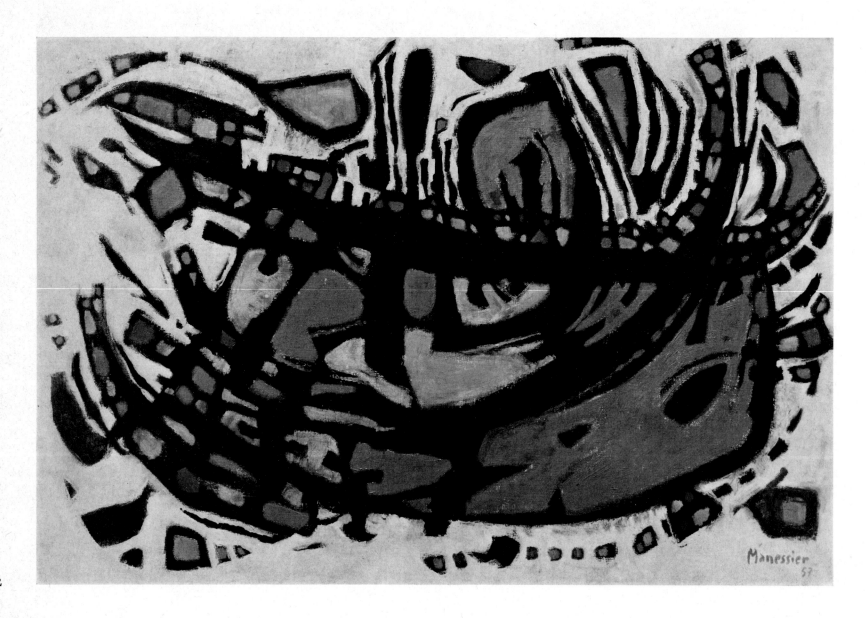

71 The Fire
1957
81 × 100 cm
Wallraf-Richartz-Museum, Cologne

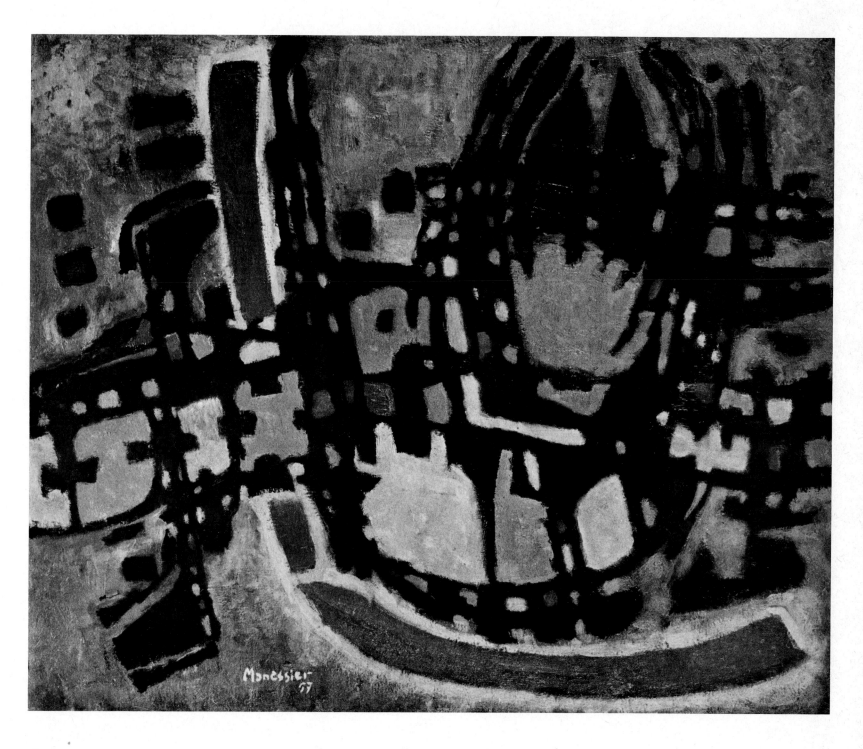

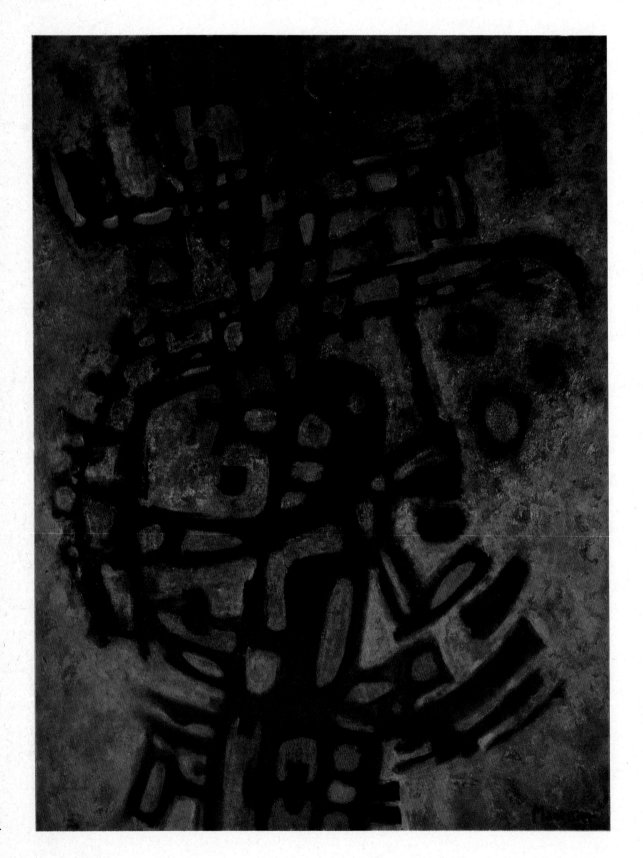

184

72 In the flame which consumes
1957
200 × 150 cm
Private collection

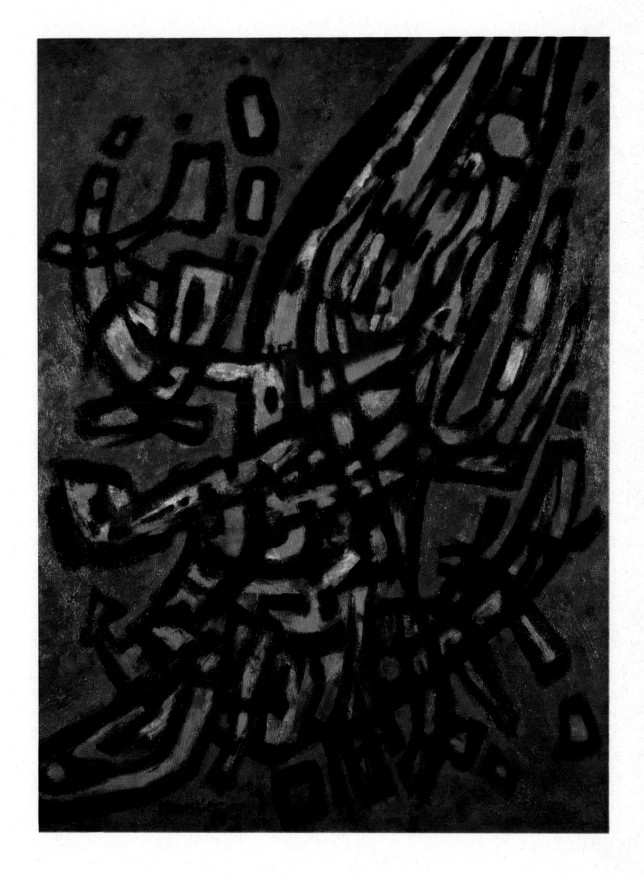

73 Homage to the holy poet,
St John of the Cross
1958
200 × 150 cm
Private collection

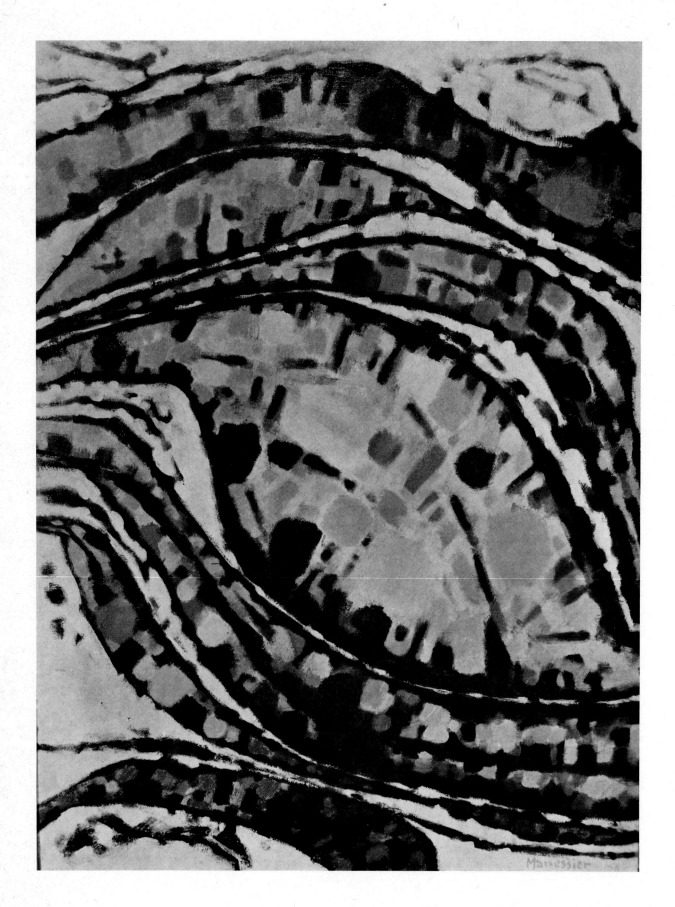

74 Dawn on the Garrigue
1959
130 × 97 cm
Musée des Beaux-Arts,
Lyon

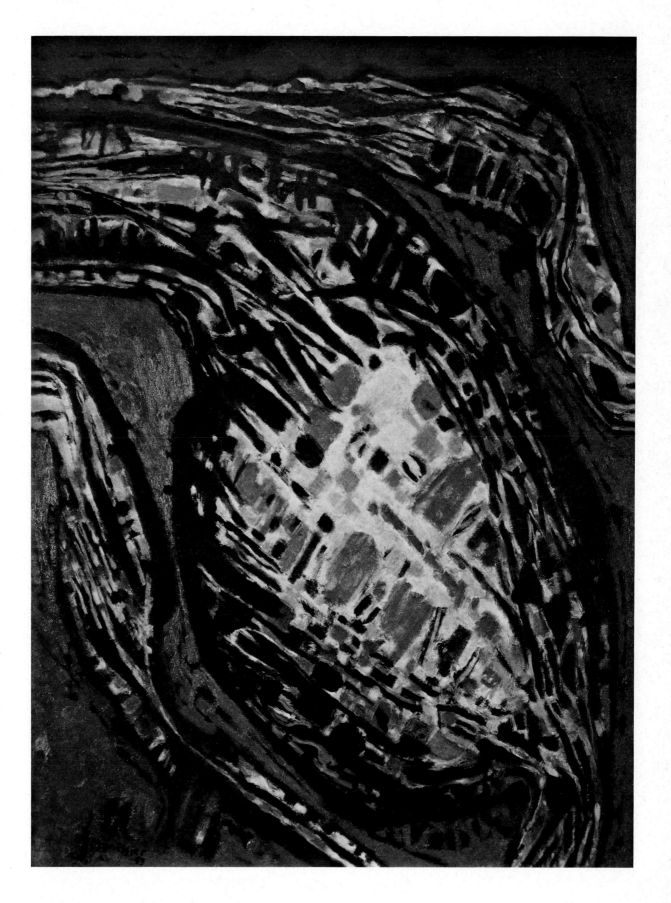

75 The Maures Mountains
1959
200 × 150 cm
Private collection

76-77 Dedication to St Mary Magdalen I
1959
60 × 73 cm
Private collection

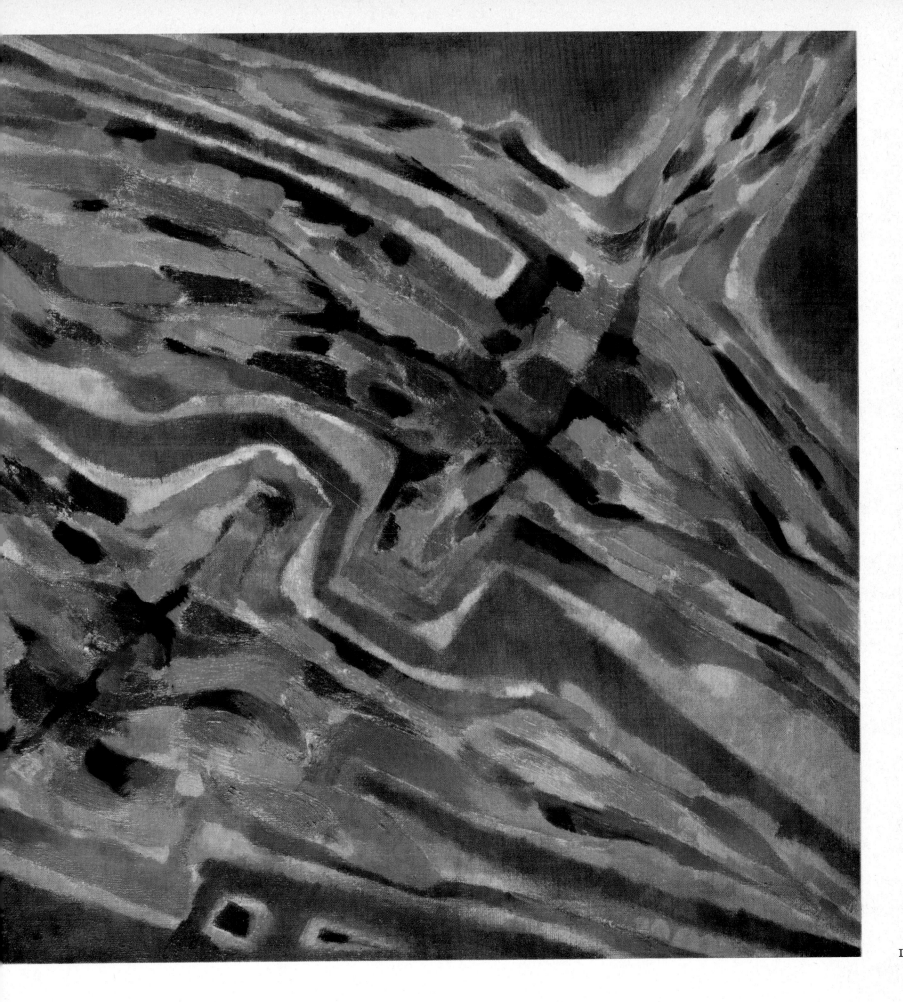

189

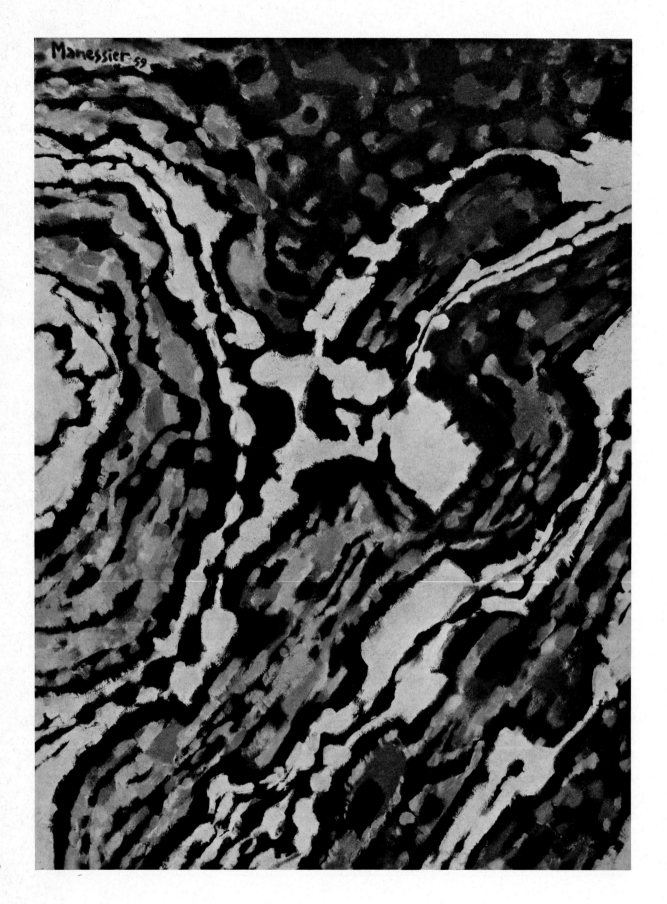

190

78 The Tributary
1959
130 × 97 cm
Private collection

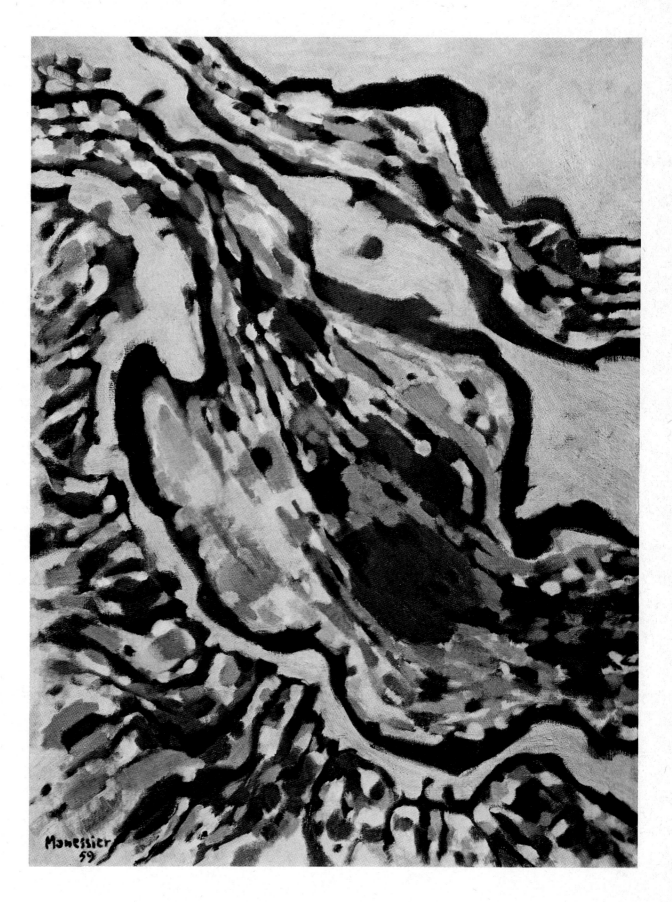

79 The River Durance
1959
130 × 97 cm
Private collection

80 The Eddy
1958
97 × 130 cm
Private collection

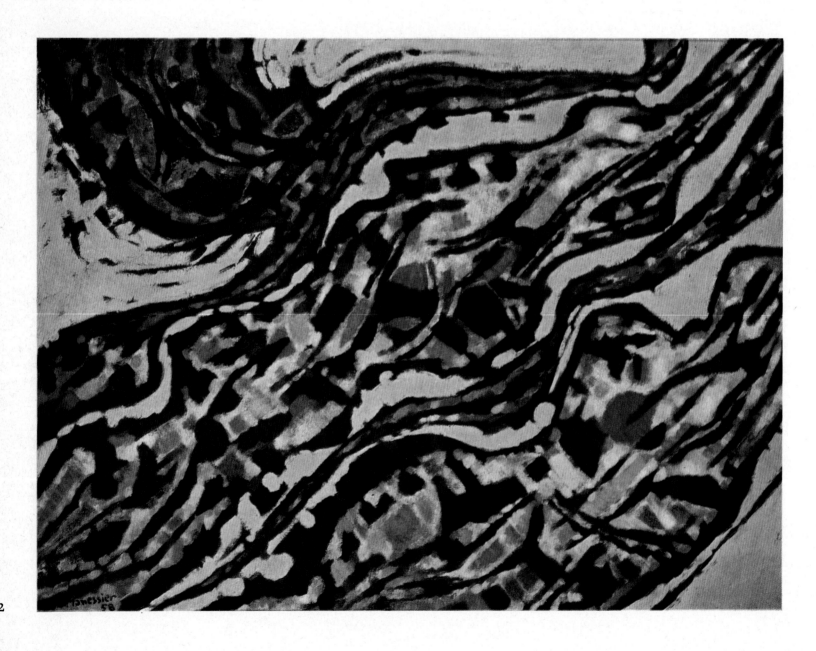

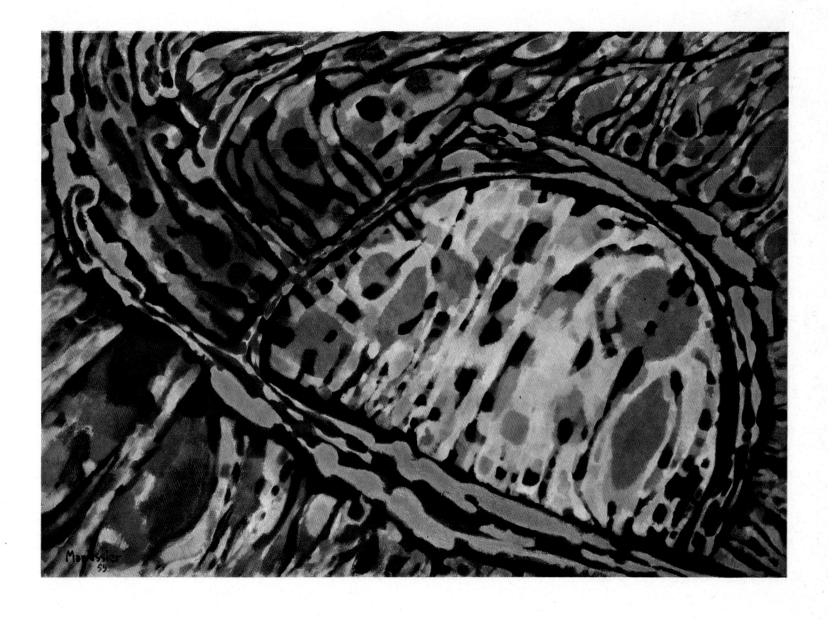

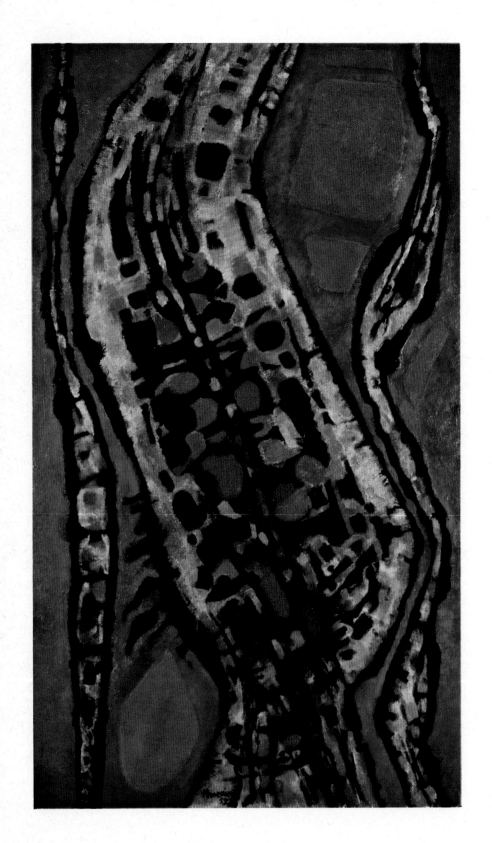

82 The Coast
1959
195 × 114 cm
Private collection

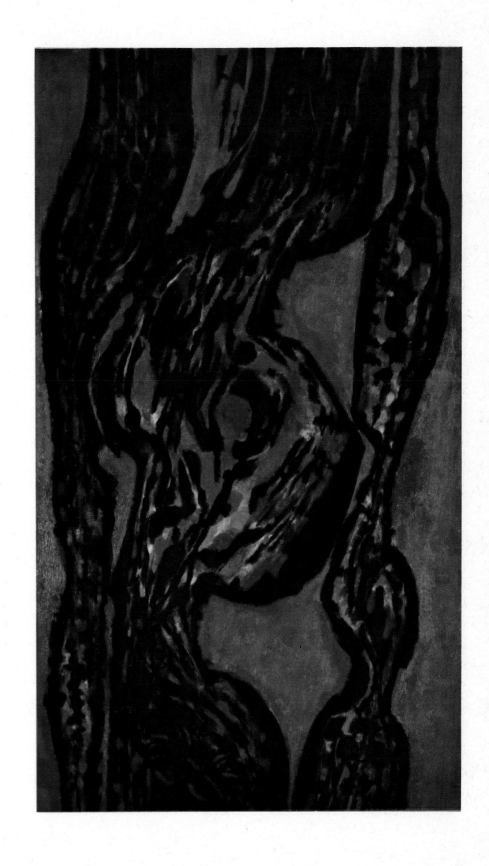

83 Night at Le Mas
1959
195 × 114 cm
Musée d'Art Moderne de la Ville de Paris,
Paris

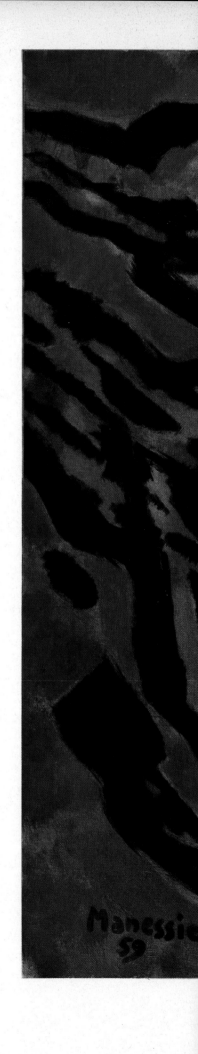

84-85 Mistral
1959
60 × 73 cm
Private collection

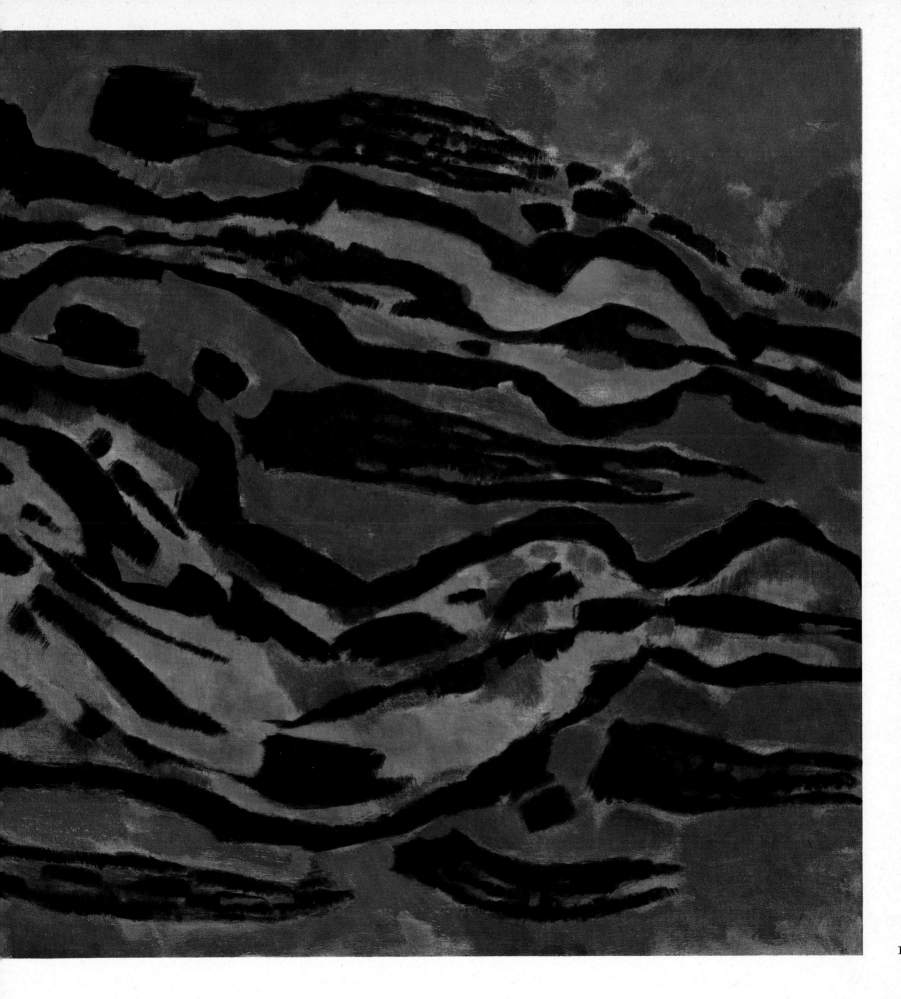

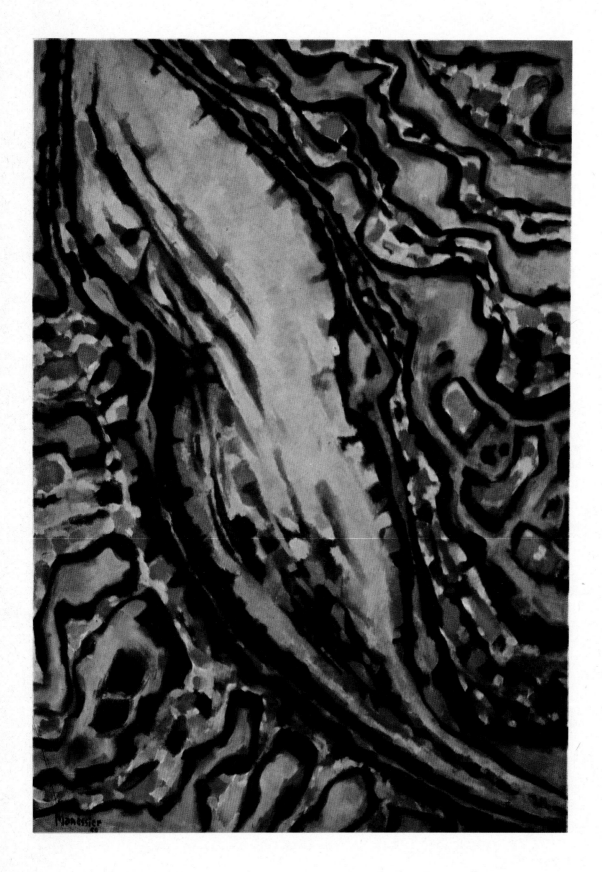

86 Springs
1959
162 × 114 cm
Private collection

Torrent I
1959
97 × 130 cm
Private Collection

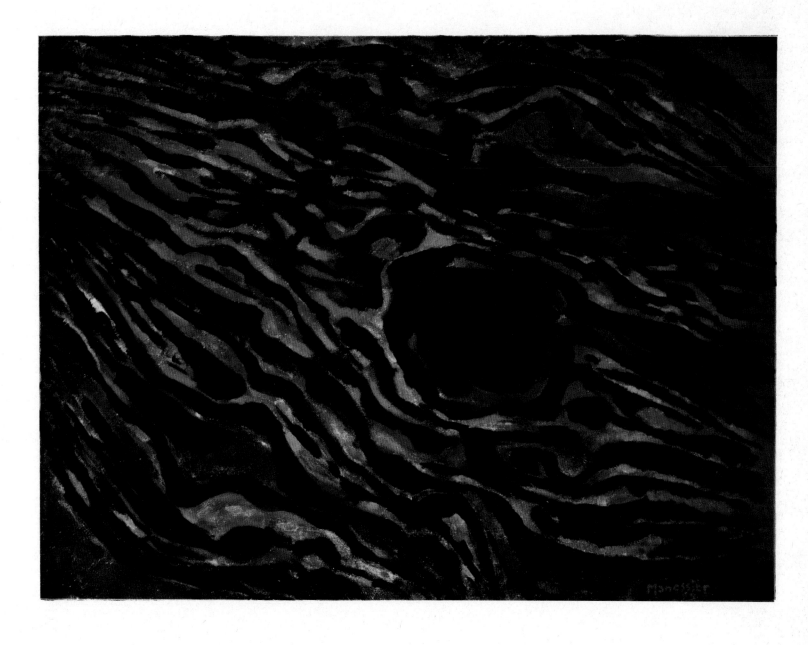

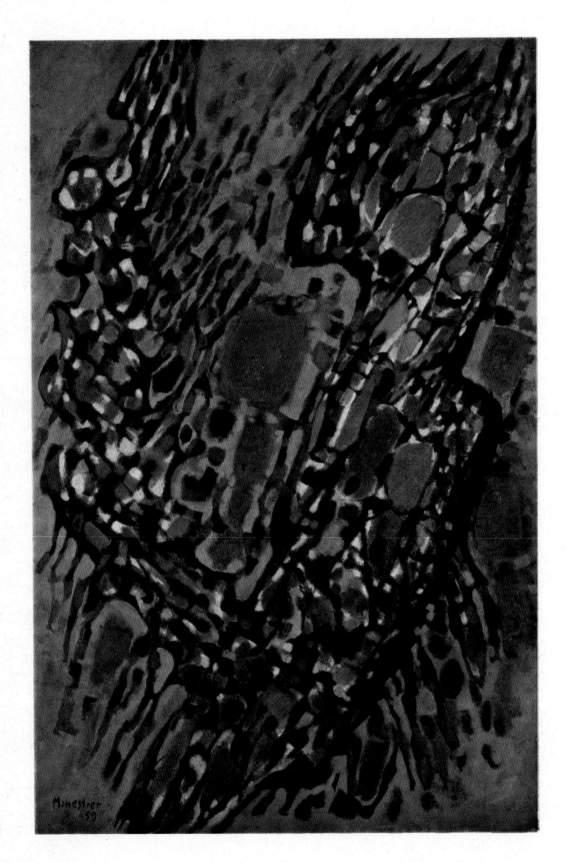

89 Et gloriam vidi resurgentis
1961
230 × 200 cm
Private collection ▶

88 Near Tourtour
1959
195 × 130 cm
Private collection

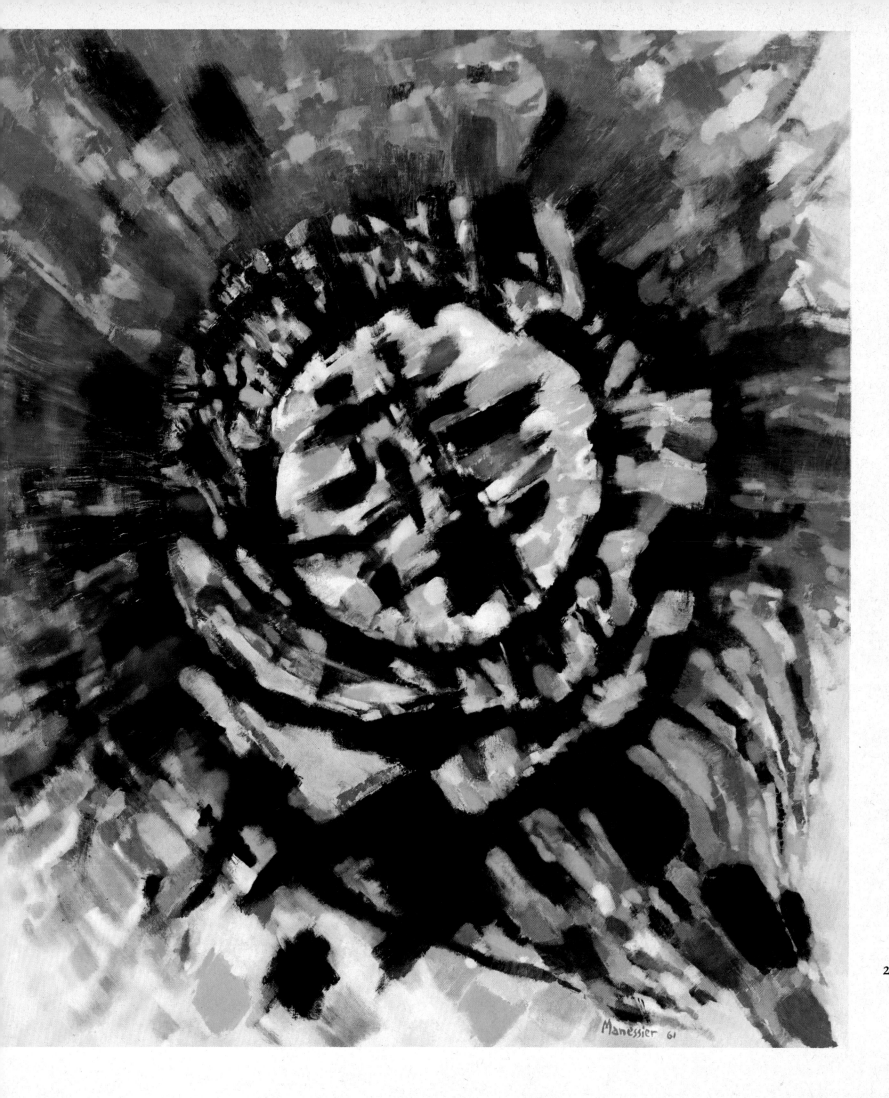

201

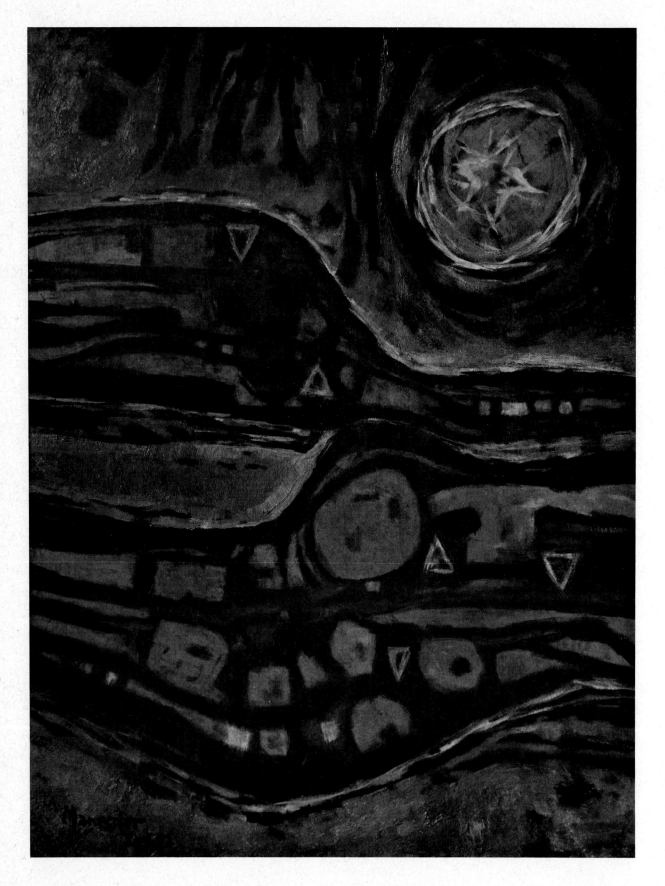

90 Epiphany
1960/1
200 × 150 cm
Musée d'Histoire et d'Art,
Luxembourg

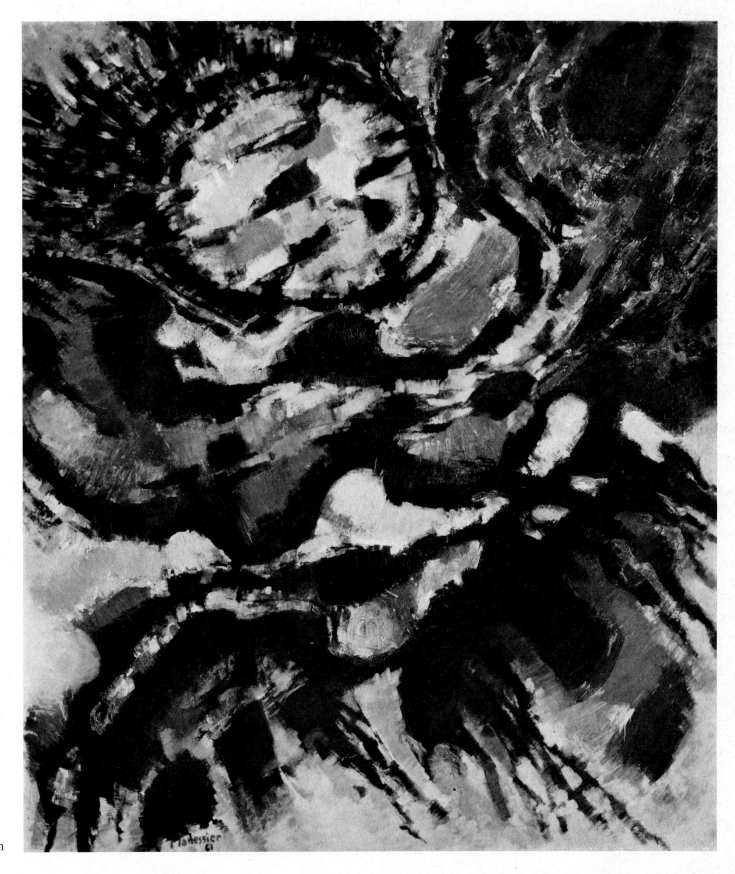

91 Resurrection
1961
230 × 200 cm
Private collection

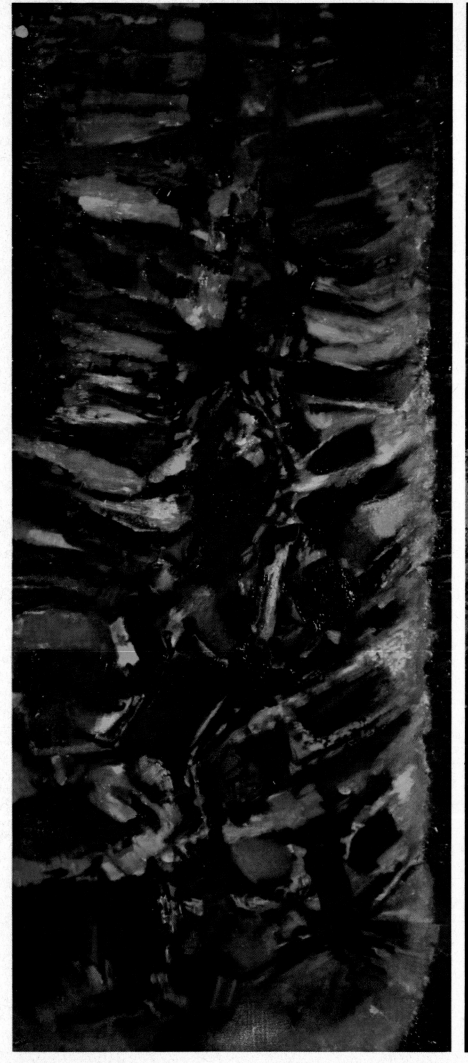
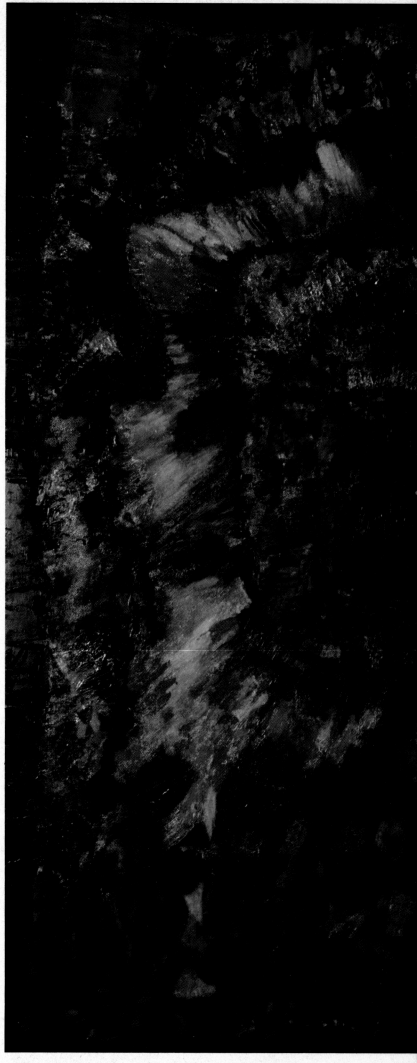

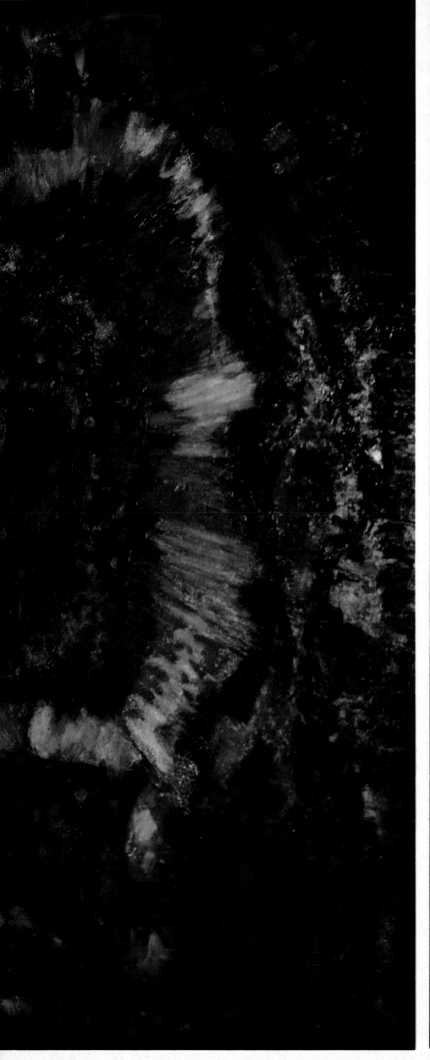
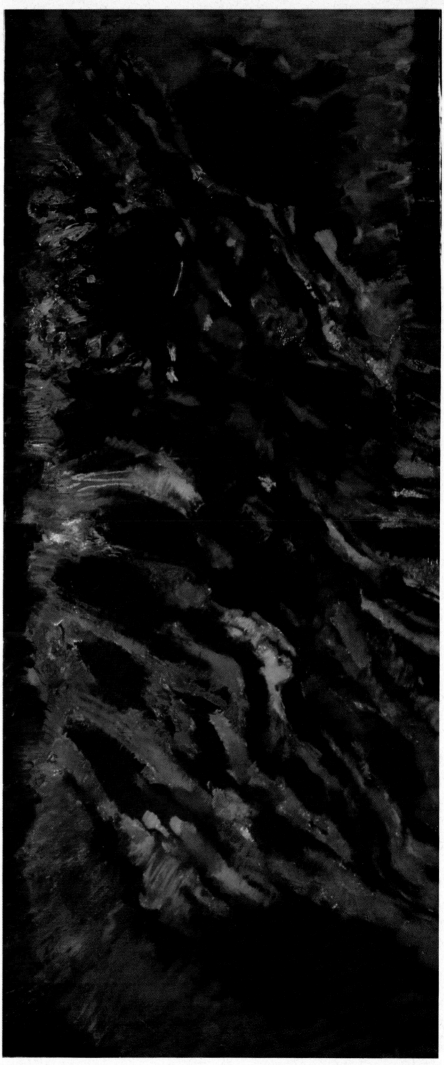

205

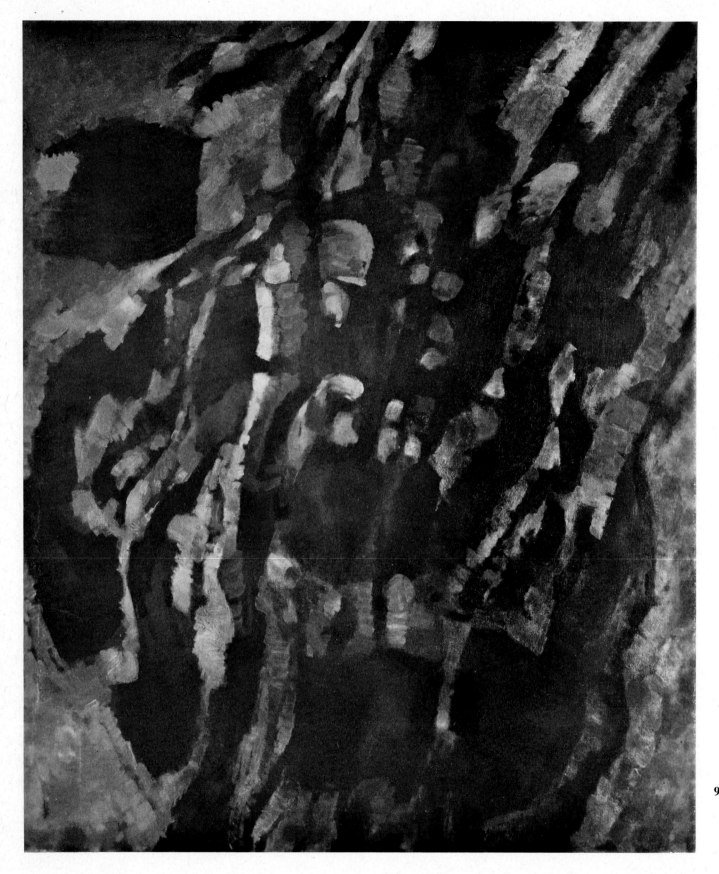

94 Tumult
1961
230 × 200 cm
Kunsthaus Zurich,
Zurich

Pages 204-205

92-93 The Image
1962
Right panel 230 × 100 cm;
Middle panel 230 × 200 cm;
Left panel 230 × 100 cm
Musée National d'Art Moderne, Paris

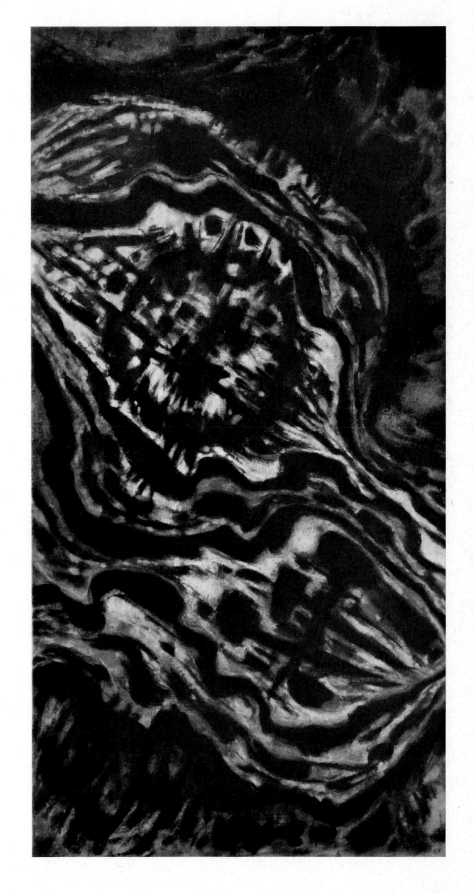

95 Buried
1961
290 × 150 cm
Collection du Vatican

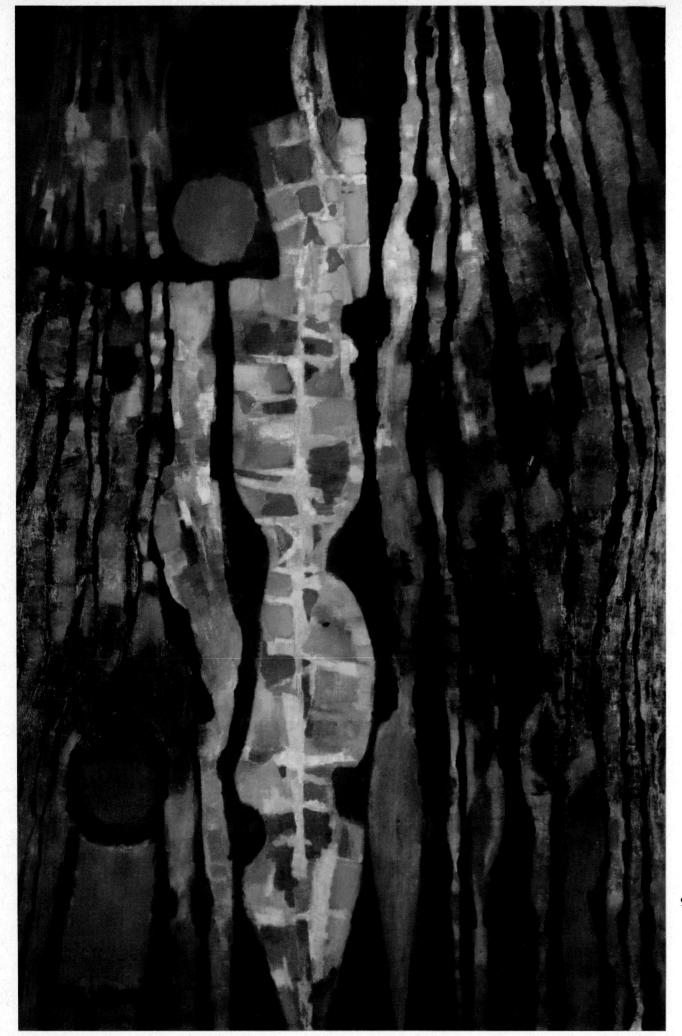

96 The Earth's offering
1961
300 × 200 cm
Private collection

97 Homage to Goya
1964
65 × 100 cm
Musées de Metz, Metz

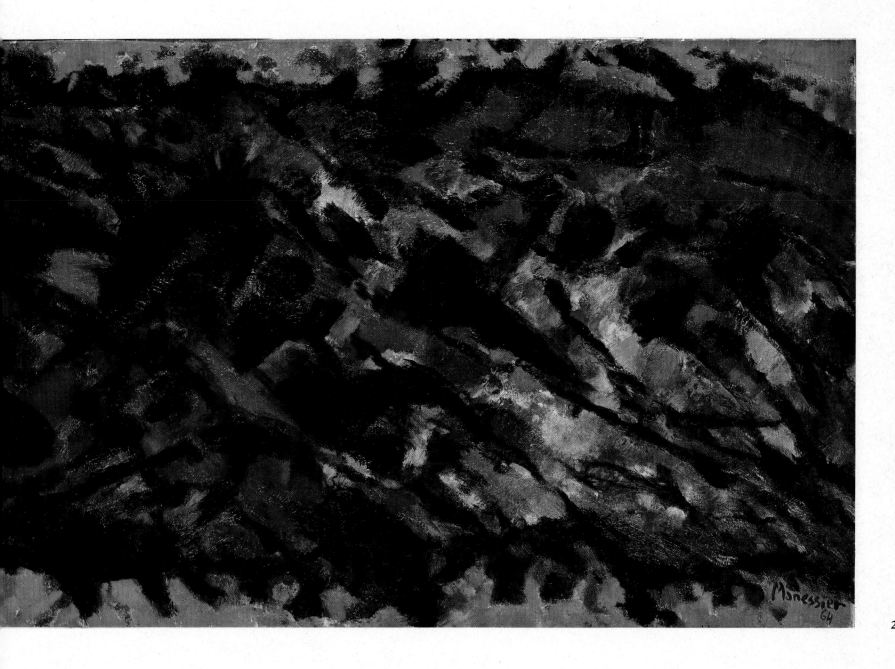

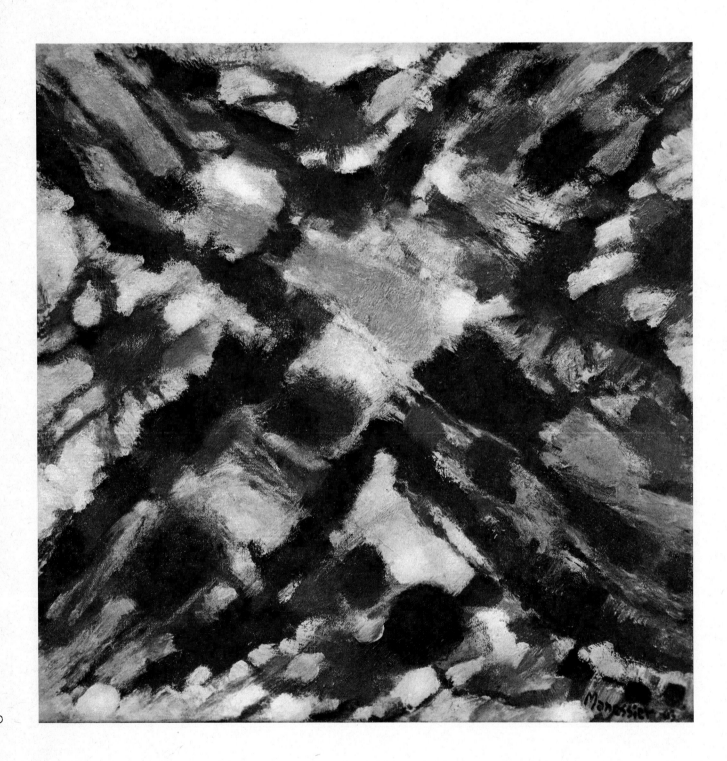

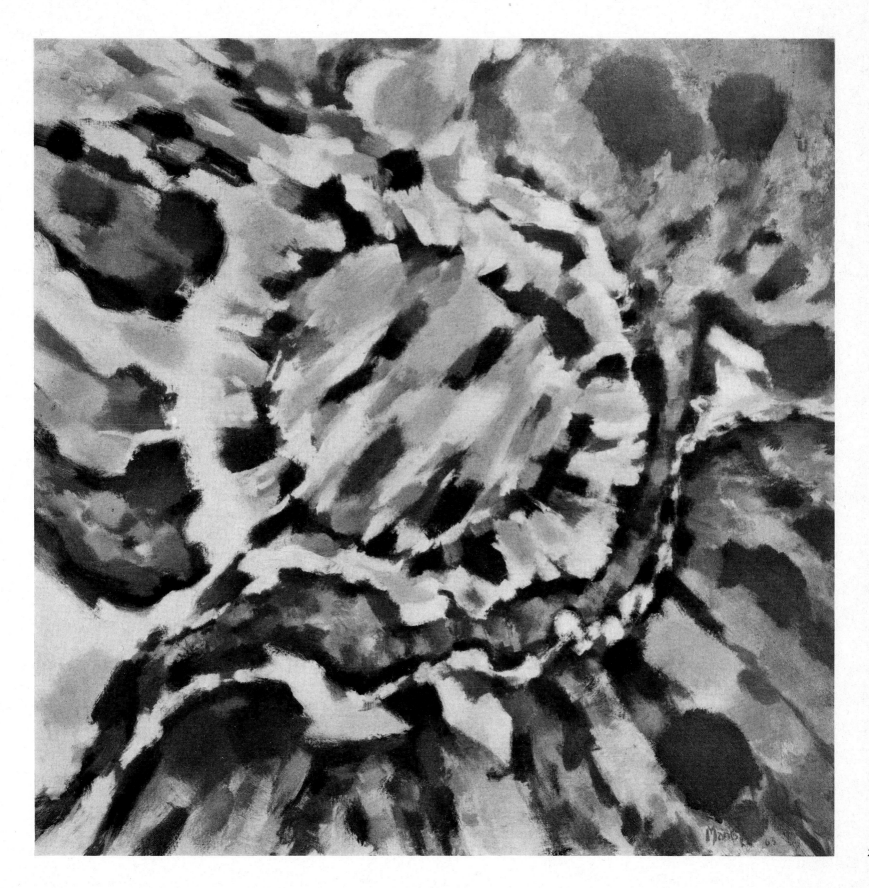

100 Holy Face I
1963
97 × 130 cm
Private collection

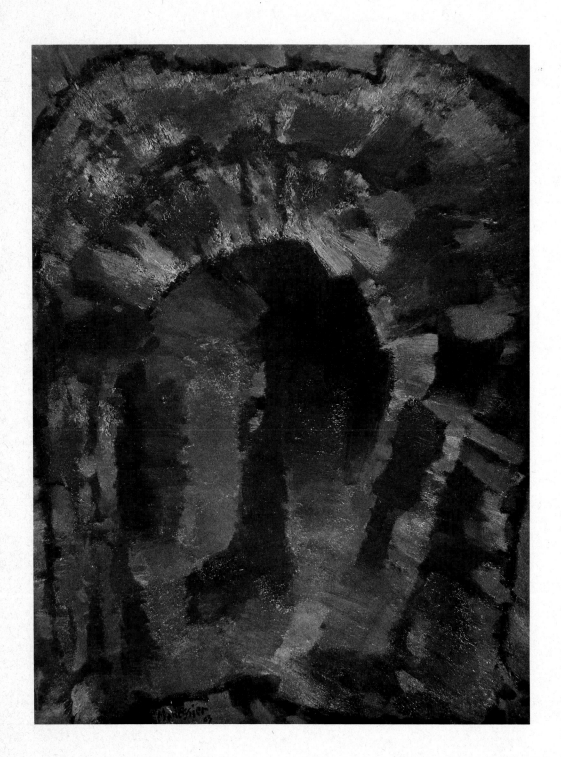

101 Large Blue Holy Face
1963
225 × 198 cm
Galerie de France, Paris ▸

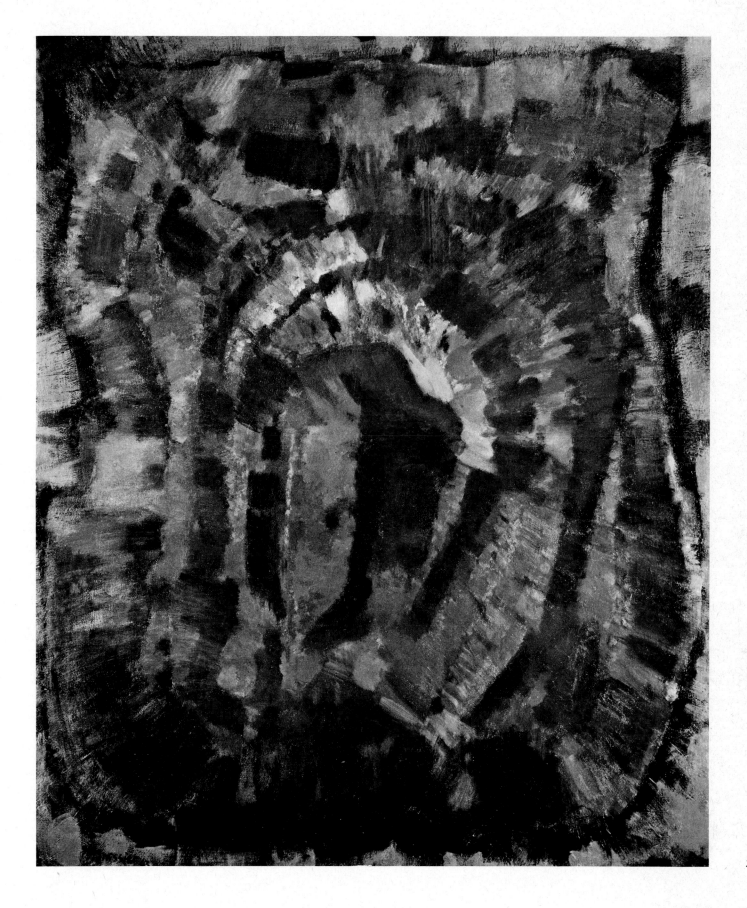

213

102 Study for The Garden of Olives or Homage to El Greco
1963
73 × 100 cm
Art Gallery, University of Notre Dame, Notre Dame, Indiana, U.S.A.

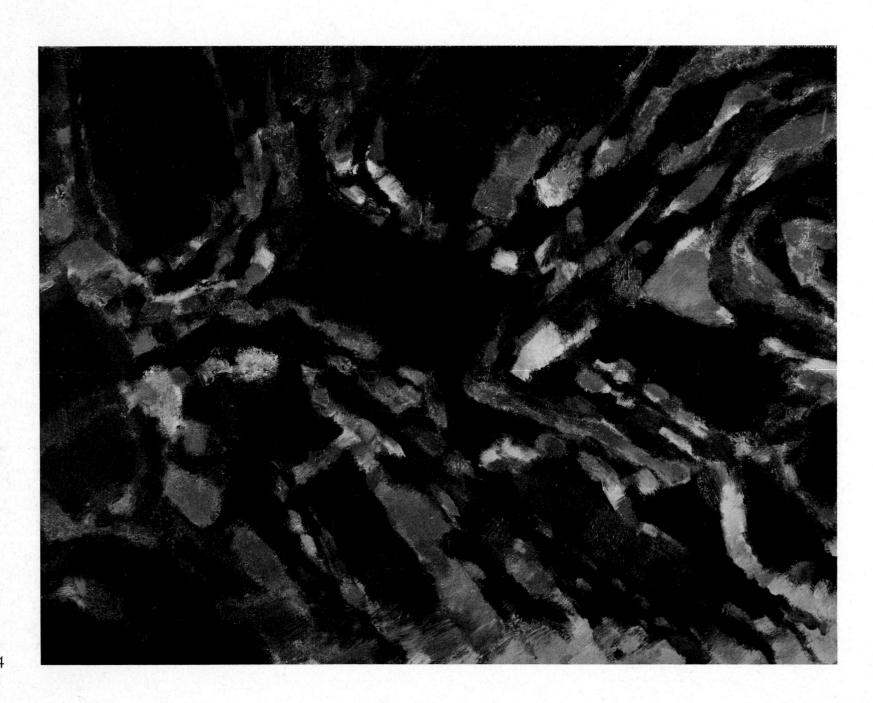

103 The Depths of Darkness
1963
73 × 92 cm
The Philips Collection, Washington, U.S.A.

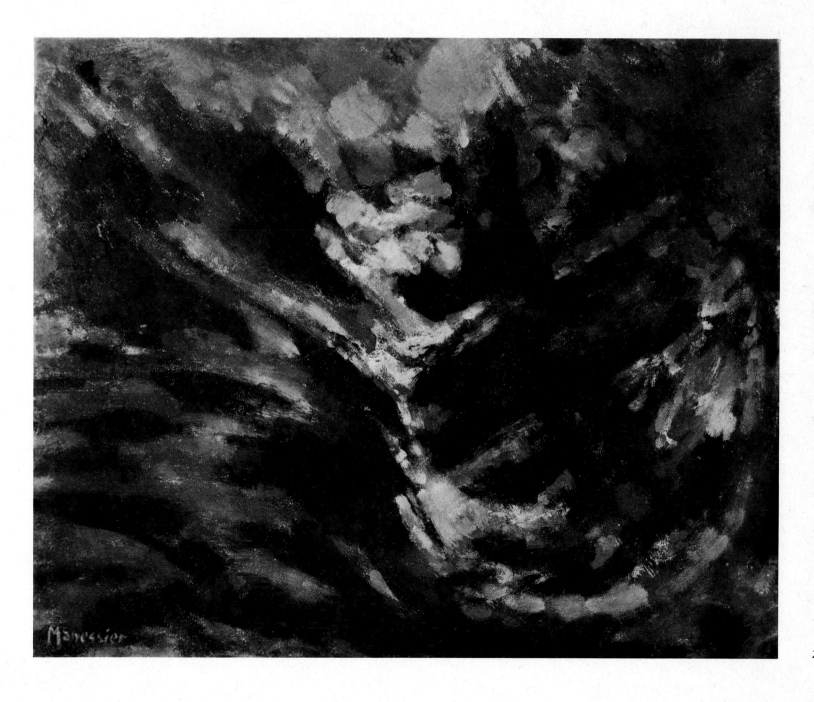

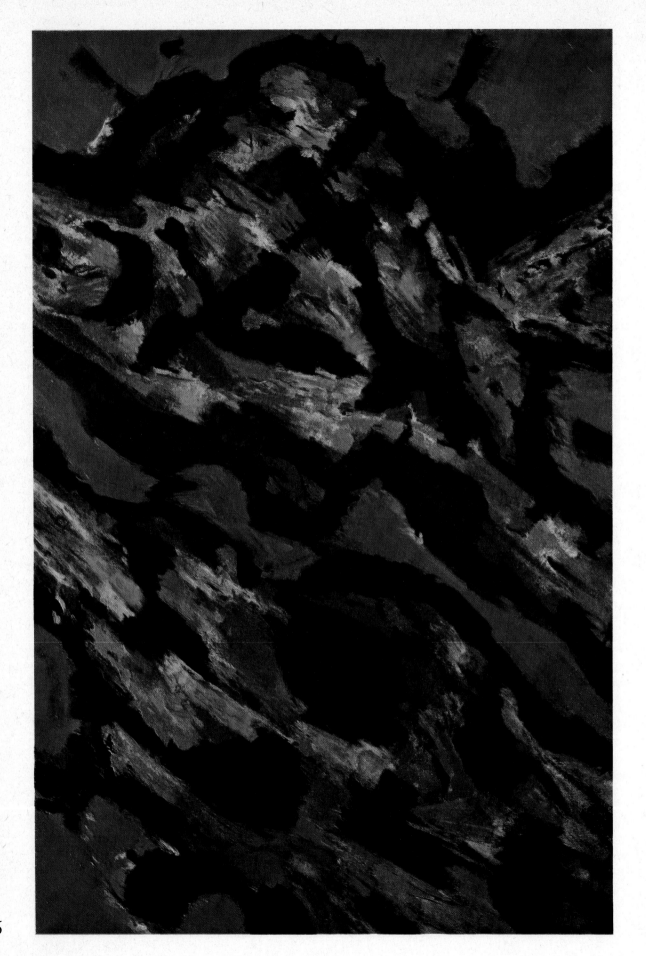

216

104 Homage
to Miguel de Unamuno
1965
195 × 130 cm
Galerie de France, Paris

105 Homage
to Martin Luther King
1968
230 × 200 cm
Galerie de France, Paris ▸

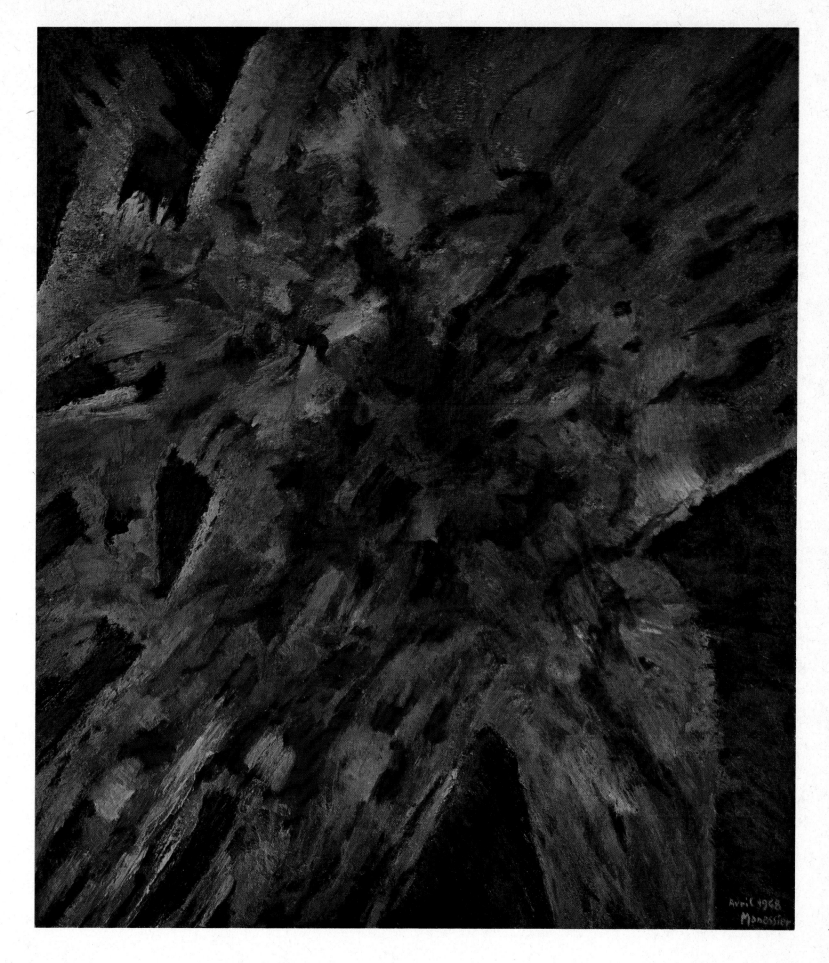

Avril 1968
Manessier

217

106 Grey rocks
1966
100 × 100 cm
Private collection

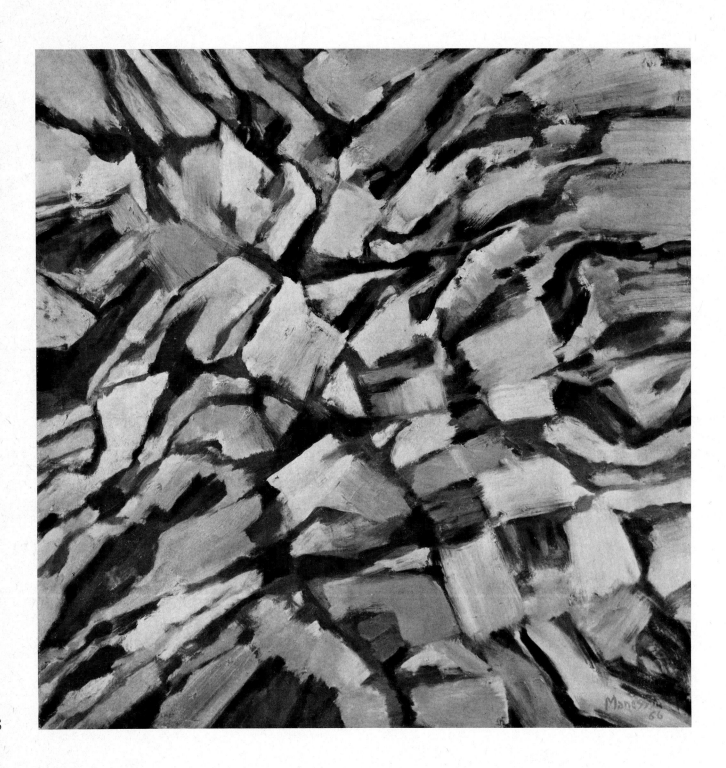

107 Night at the Ermita
1966
114 × 114 cm
Private collection

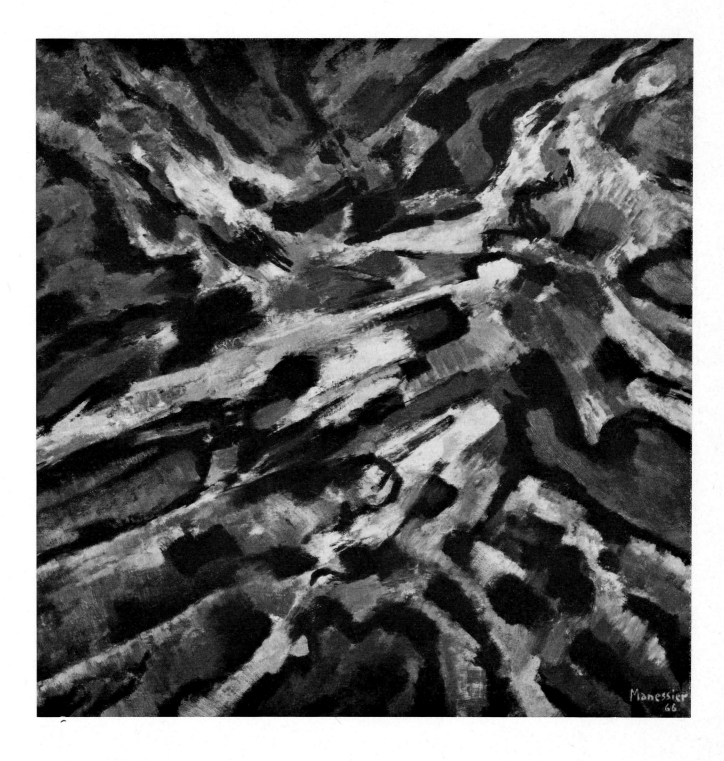

108 Spanish soil
1964
100 × 100 cm
Private collection

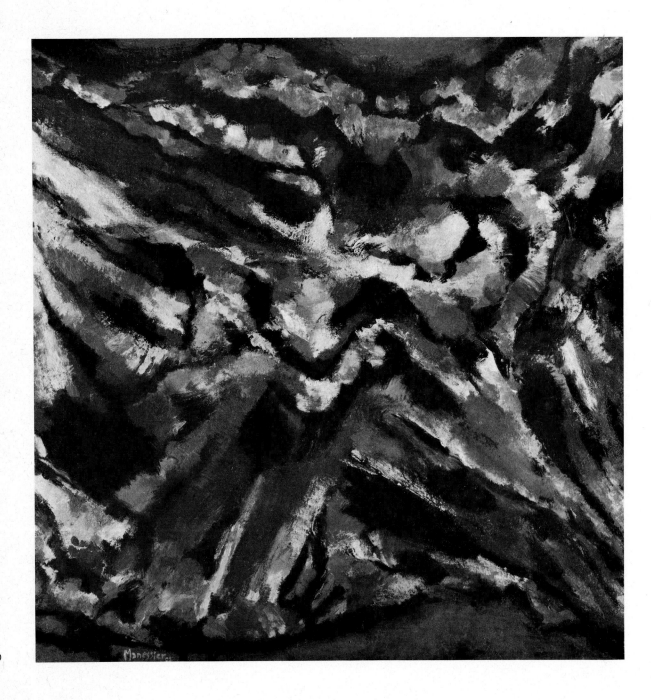

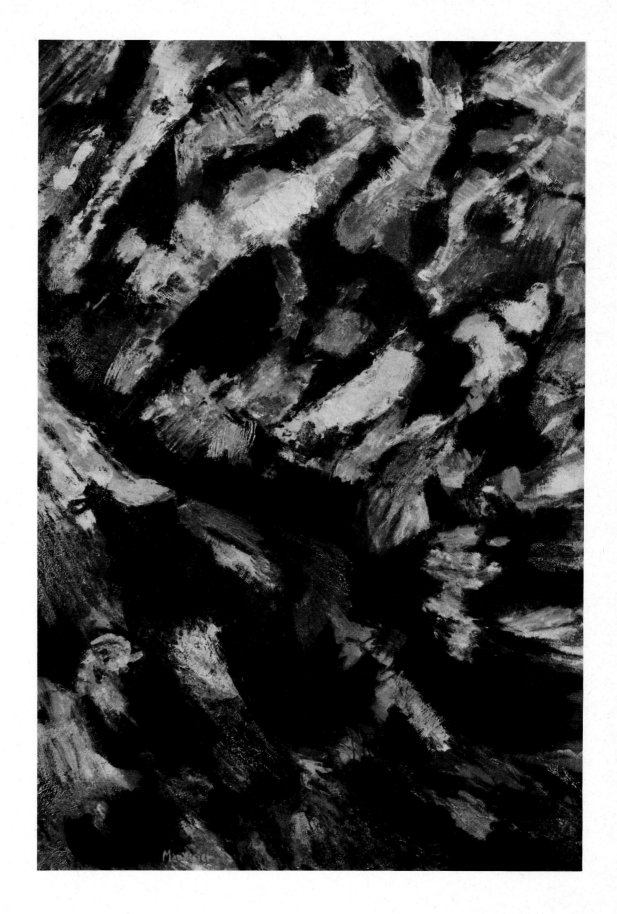

109 Vane at Ifach
1965
195 × 130 cm
Private collection

110 Winter blandness
1966
100 × 100 cm
Private collection

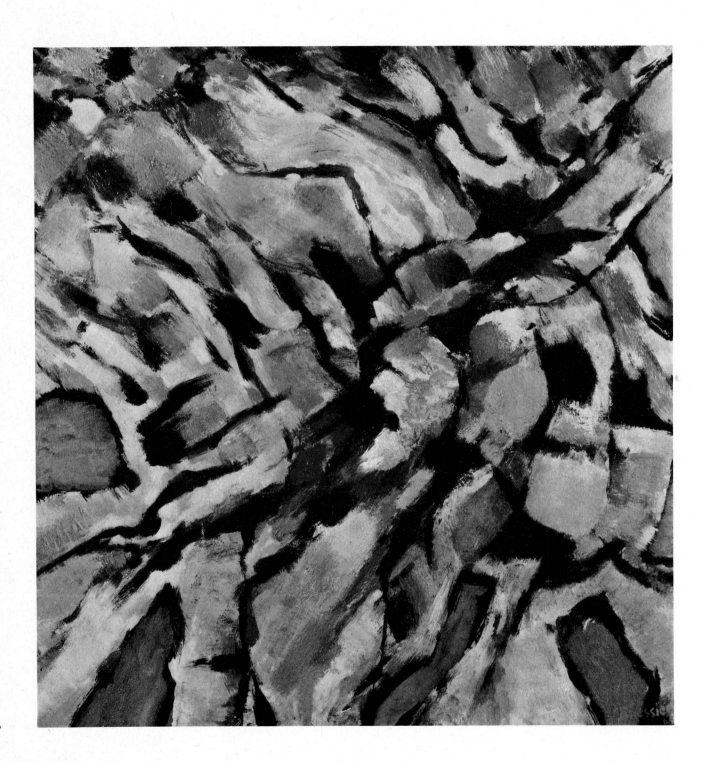

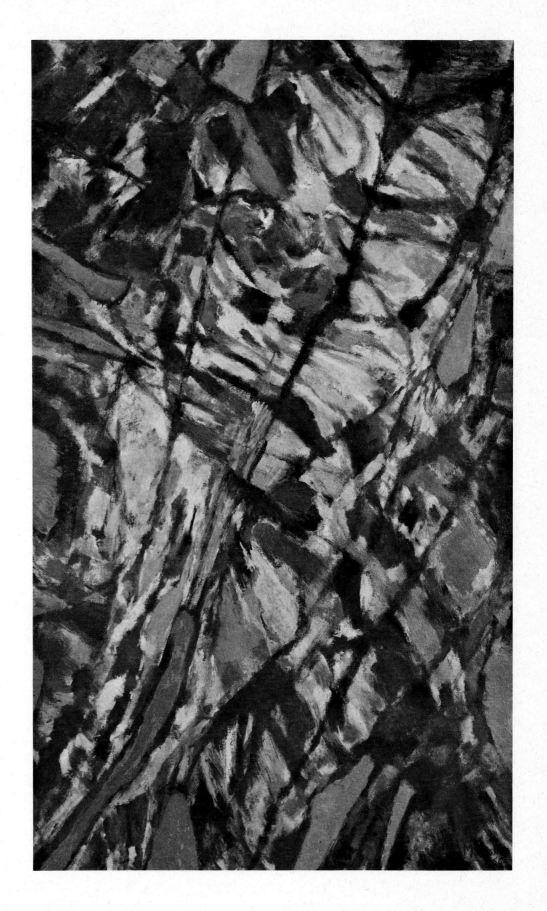

111 Thirsty Earth
1966
250 × 150 cm
Private collection

112 The Blizzard
1968
50 × 100 cm
Private collection

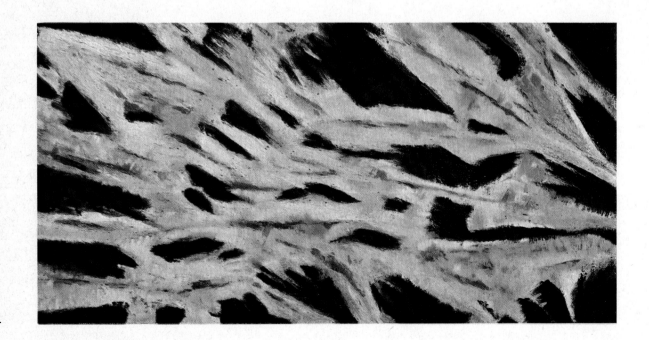

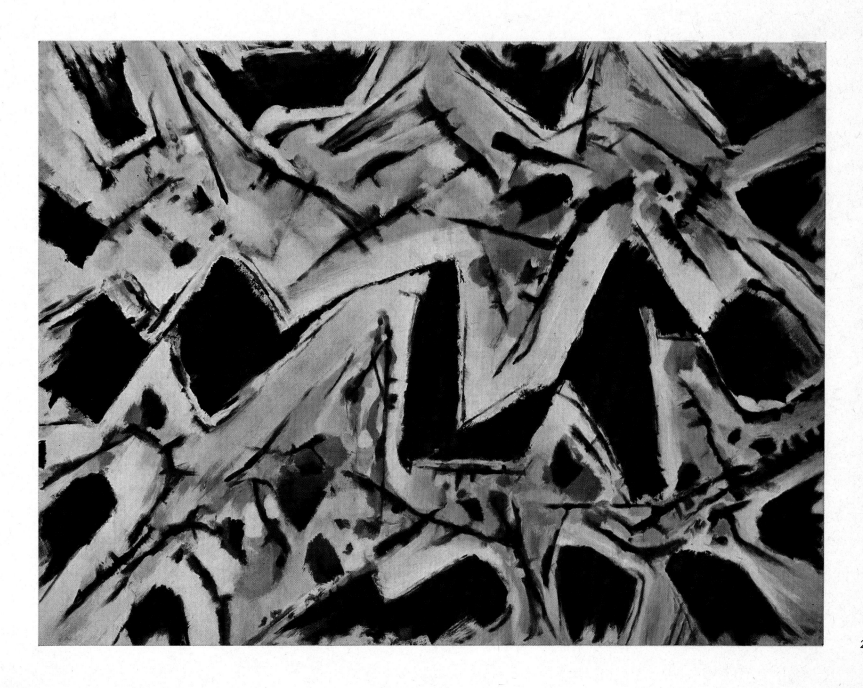

114 Eskimo Landscape
1968
162 × 162 cm
Galerie de France, Paris

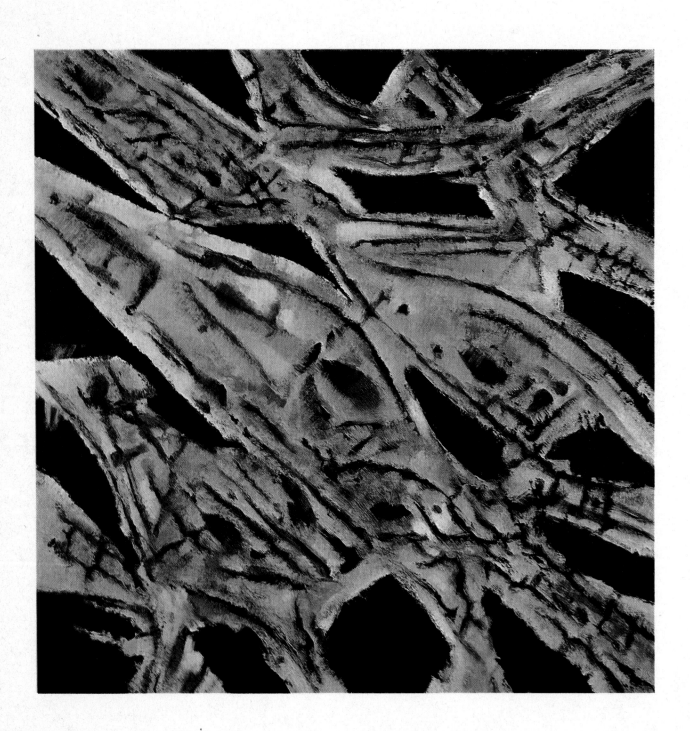

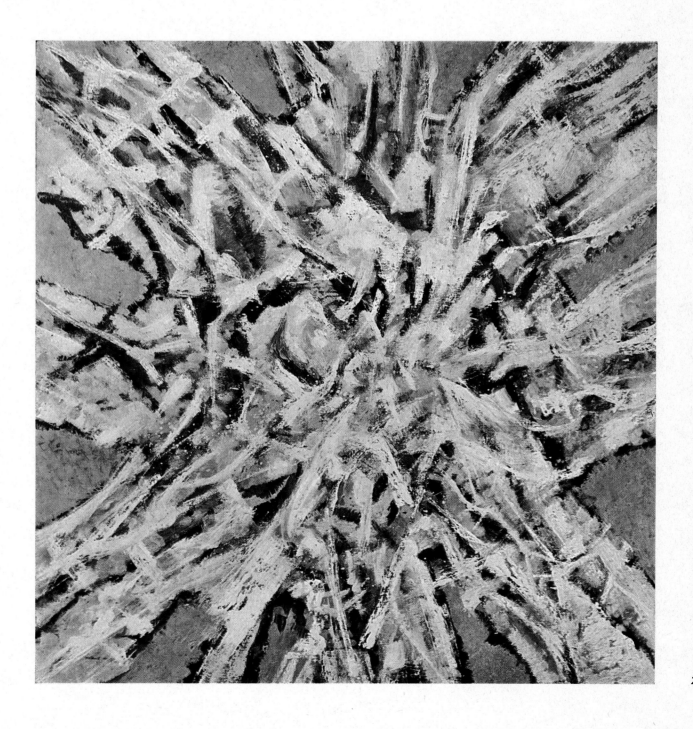

227

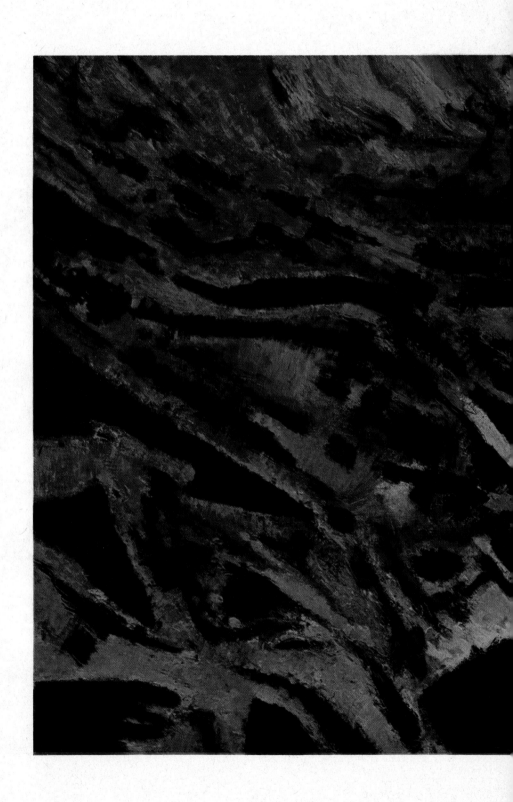

116-117 Fishes' sanctuary
1969
200 × 400 cm
Galerie de France, Paris

228

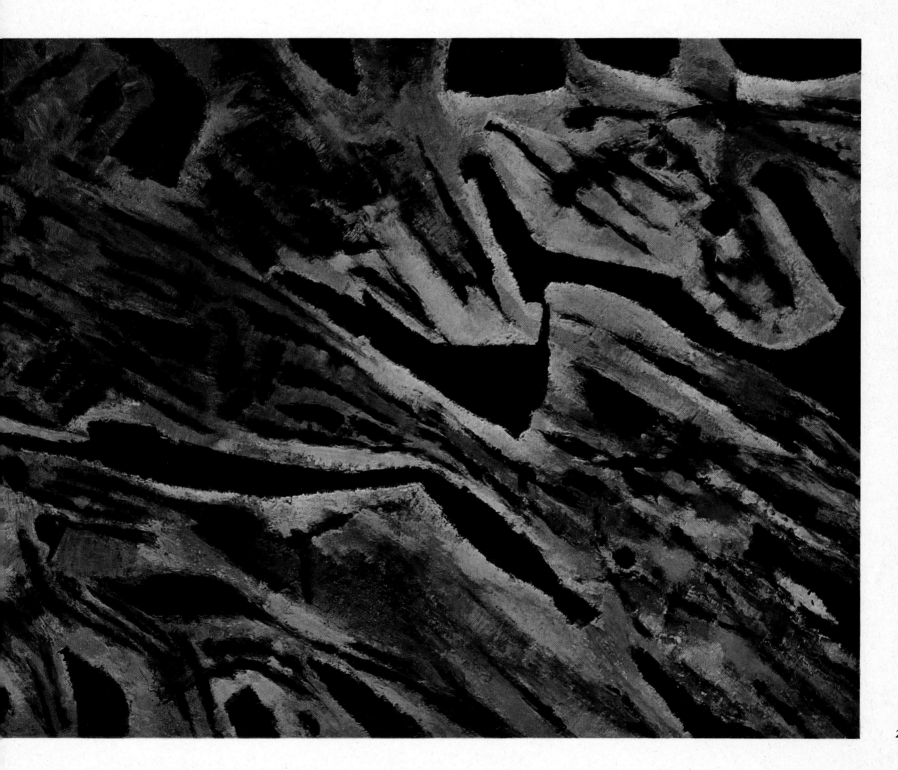

118 Harbour in the evening
1969
130 × 195 cm
Galerie de France, Paris

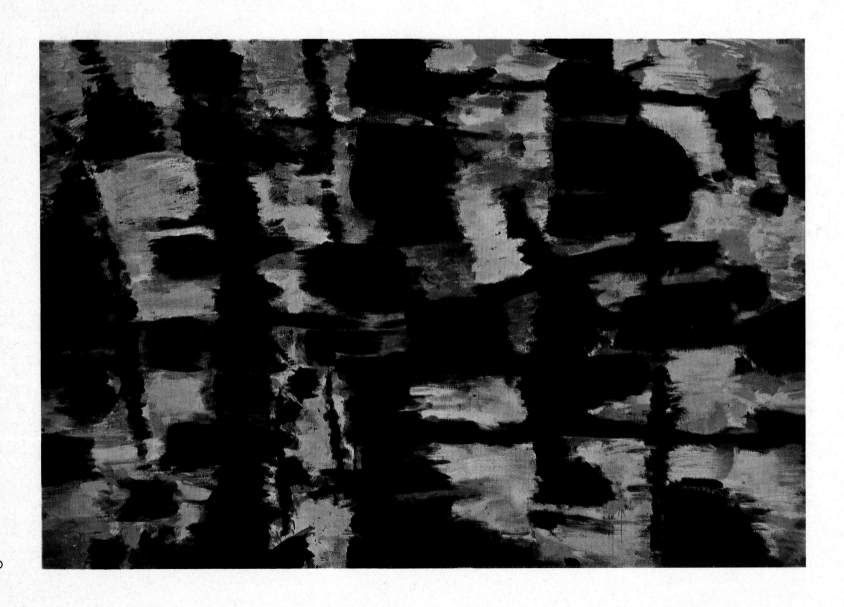

119 Flood tide in the Somme Bay
1969
130 × 195 cm
Galerie de France, Paris

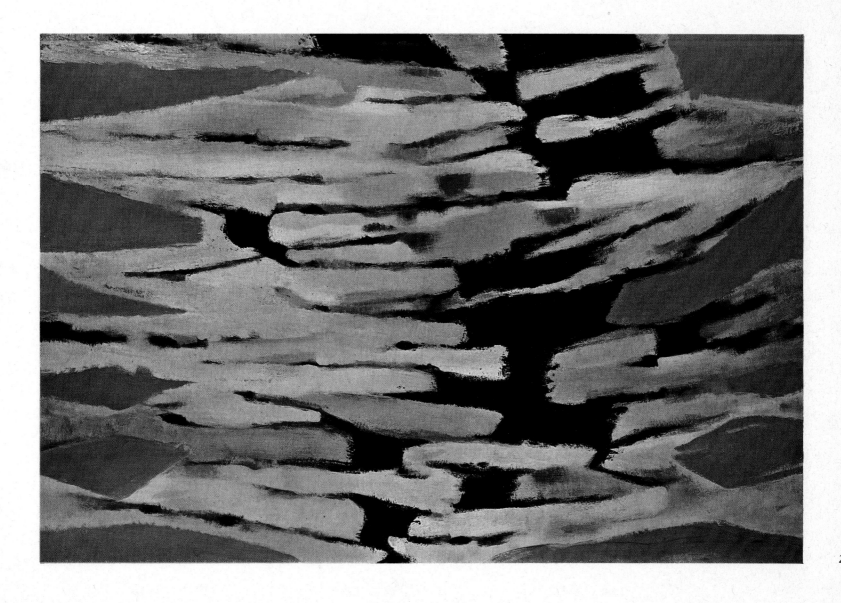

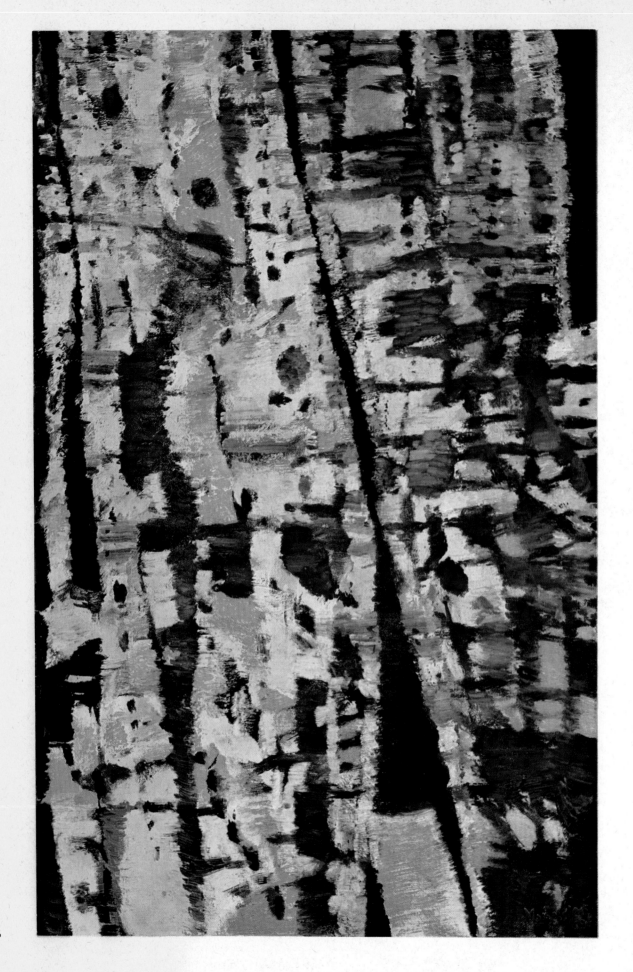

120 Homage to Corot
1969
100 × 65 cm
Private collection

APPENDICES

LIFE CHRONOLOGY

1911 Born on 5 December in Saint-Ouen near Abbeville.

1923 Starts painting in Le Crotoy.

1929 Leaves for Paris to study architecture at the Ecole des Beaux-Arts. Copies Rembrandt, Tintoretto and Renoir in the Louvre and makes free compositions after Cézanne and Rubens.

1932 First journey to Holland.

1933 Paints with Le Moal in Aiguallières.

1935 Meets Roger Bissière at the Académie Ranson.

1935–8 Lives at 117 rue Notre-Dame-des-Champs, Paris 6e.

1936 March, death of Manessier's father.

1936–7 In Amiens, liquidating his father's business.

1937 Works on monumental decorations for the Paris World Exhibition.

1938 Marries Thérèse Simonnet in October. Settles at 4 rue Franquet, Paris 15e, where he remains until 1939.

1939 Called up for military service as technical draughtsman in the Ministry of War in Paris. In July moves to 203, rue de Vaugirard, Paris 15e.

1940 His son Jean Baptiste born in Cahors on 3 August.

1940–1 October 1940–May 1941, lives in Benauge in the province of Lot.

1942–4 Active in the association *Jeune France* in Paris.

1942–6 Lives in Le Bignon, near Mortagne in the province of Perche.

1943 Visits La Grande Trappe de Soligny.

1945 His daughter Christine born in Paris on 13 April.

1948–9 Spends summers in Le Crotoy.

1953–5 Spends summers in Le Crotoy.

1955–6 Winter in Holland.

1956 February, Manessier buys the property in Emancé.

1958–9 Visits Provence.

1959 November, visits the actor Charles Laughton in Stratford-on-Avon.

1962 Spring, visits Madrid.

1963 August, visits Valencia and the *Ermita de Luchente*.

1965 May, visits Valencia and the *Ermita de Luchente*.

1965–6 December–January in the *Ermita de Luchente*.

1966 September–December, visits Spain again.

1967 Travels to Canada.

1969 Second journey to Canada.

1969 Visits the *Ermita de Luchente*.

AWARDS

1953 SÃO PAULO, First Prize for Painting at the Biennale.

1954 VIENNA, First Prize at the Exhibition of Sacred Art.

1955 PITTSBURGH, Carnegie Institute, International Grand Prix for Contemporary Painting.

 VALENCIA (Venezuela), International Painting Prize.

1958 VENICE, The International Institute of Liturgical Art Prize at the Biennale.

 GRENCHEN (Switzerland), First Prize for original engravings at the Triennale.

1962 VENICE, International Grand Prix for Painting at the Biennale.

 VENICE, The International Institute of Liturgical Art Prize at the Biennale.

EXHIBITIONS

One Man Exhibitions

1949 PARIS, Galerie Billiet Caputo.

 PARIS, Galerie Jeanne Bucher, Lithographs on the Theme of Easter (lithographies sur le thème de Pâques).

1951 BRUSSELS, Galerie Apollo.

1952 PARIS, Galerie de France (December).

1953 TURIN, Gallery Lattes.

 NEW YORK, Galerie Pierre Matisse.

1955 STOCKHOLM, Galerie Blanche, with Le Moal.

 COPENHAGEN, Institut Français, with Le Moal.

 TOURCOING, Museum of Tourcoing.

 BRUSSELS, Palais des Beaux-Arts.

 EINDHOVEN (Holland), Museum of Eindhoven.

1956 PARIS, Galerie de France.

1958 PARIS, Galerie de France, water colours.

 HANOVER, Kestner Gesellschaft.

1959 PARIS, Galerie de France, paintings and washes.

 ZURICH, Kunsthaus.

 THE HAGUE, Dienst Voor Schone Kunsten.

 ESSEN, Folkwang Museum.

1961 AMIENS, Musée d'Amiens.

1962 AIX-EN-PROVENCE, Galerie Tony Spinazzola, drawings, engravings, 12 lithographs illustrating *The Spiritual Canticles of St John of the Cross (Les Cantiques spirituels de Saint Jean de la Croix)*.

1964 WASHINGTON, The Phillips Collection.

 NOTRE DAME (Indiana, U.S.A.), University of Notre Dame.

1964-5 GRAZ (Austria), Forum Stadtpark, engravings.

1965 CAEN, Maison de la Culture.

 OSLO, Kunstnernes Hus.

 LUND (Sweden), Lunds Konsthall.

1966 PARIS, Galerie de France.

 BONN, Galerie Wunsche, washes.

 BREMEN, Galerie Emmy Widmann, paintings and water colours.

1967 BONN, Galerie Wunsche, paintings and water colours.

1968 AMIENS, Maison de la Culture, retrospective exhibition.

 RENNES, Maison de la Culture, retrospective exhibition.

 THONON-LES-BAINS, Maison de la Culture, retrospective exhibition.

 MONTPELLIER, Musée Fabre, paintings washes, engravings, retrospective exhibition.

 BOURGES, Maison de la Culture, retrospective exhibition.

 TOULOUSE, Centre Culturel, retrospective exhibition.

1969 METZ, Musées Metz, works 1935-68, retrospective exhibition.

 LUXEMBOURG, Musée d'Art et d'Histoire, retrospective exhibition.

234 TRIER, Städtisches Museum, retrospective exhibition.

1970	BREMEN, Kunsthalle, retrospective exhibition.
	KOBLENZ, Mittelrhein Museum, retrospective exhibition.
	DIJON, Musée de Dijon, works 1935–68, retrospective exhibition.
	BELLELAY, Abbey Church, paintings, tapestries, water colours and drawings.
	SOCHAUX, Maison des Arts et des Loisirs, paintings, tapestries, water colours and drawings.
	PARIS, Galerie de France, works 1967–9.
1971	ESCH-SUR-ALZETTE (Luxembourg), Galerie d'Art, paintings, washes, lithographs and water colours.
	MULHOUSE, Société des Arts de Mulhouse, paintings, washes, lithographs and water colours.

Group exhibitions

1937	PARIS, Galerie Breteau, *Témoignage*.
1938	PARIS, Galerie Breteau, *Matières et Formes*.
1941	PARIS, Galerie Braun, *Jeunes Peintres de Tradition Française*.
1942	PARIS, Galerie Berri Raspail, *Sous le Signe de l'Esprit*.
1943	PARIS, Galerie de France, *Douze Peintres d'Aujourd'hui*.
1944	PARIS, Galerie de France, with Le Moal and Singier.
1945	BRUSSELS, Palais des Beaux-Arts, *La Jeune Peinture Française*.
1946	PARIS, Galerie René Drouin, with Le Moal and Singier.
1947	PARIS, Galerie Maeght.
1948–9	FRANKFURT, STUTTGART, CONSTANCE.
1949	LUXEMBOURG, Museum of Luxembourg, *La Nouvelle Peinture Française*.
	TORONTO.
	DUBLIN.
	SÃO PAULO, Museum of Modern Art.
	PARIS, Galerie de France, water colours.
1950	STOCKHOLM and GOTHENBERG, *French Painting*.
	SOUTH AFRICA, *French Art*.
1951	PITTSBURGH, Carnegie Institute.
	LONDON, Royal Academy of Arts.
	BASLE, Kunsthalle.
	TURIN, *Painters of Today, France-Italy*.
1953	TURIN, *Painters of Today, France-Italy*.
1954	NEW YORK, Guggenheim Foundation, *Younger European Painters*.
	TURIN, *Painters of Today, France-Italy*.
1954–5	TEL-AVIV, Museum of Tel-Aviv.
1955	VIENNA, Exhibition of Sacred Art.
	PITTSBURGH, Carnegie Institute.
	NEW YORK, Museum of Modern Art, *New Decade* (also in other American towns).
	SPAIN, *French Modern Painting*.
	KASSEL, *Documenta*.
	VALENCIA (Venezuela).
	LJUBLJANA, *International Exhibition of Engravings*.
1956	PARIS, Galerie Charpentier, *Ecole de Paris*.
	MARSEILLE, *Festival de l'Art d'Avant-Garde*.
	MUNICH, *Ecole de Paris*.
	GENEVA, Galerie Motte, *Art Abstrait*.
1957	RENNES, *Réseau du Souvenir*.
	MILAN, Galerie dell'Ariete, *Painters of the Galerie de France*.
	TURIN, *Painters of Today France-Italy*.
	LISSONE (Italy).
1958	PARIS, Musée d'Art Moderne, *De l'Impressionisme à nos Jours*.
	VENICE, Biennale.
	PITTSBURGH, Carnegie Institute.

1958 BRUSSELS, Exposition Universelle Internationale, *French Pavilion*.
1959 PARIS, Galerie Creuzevault, *Dessins des Artistes de l'Ecole de Paris*.
 VIENNA and DORTMUND, *Exhibition of French Painting*.
 LJUBLJANA, *International Exhibition of Engravings*.
 KASSEL, *Documenta 2*.
1960 DIJON, *Exposition d'Art Moderne*.
 ISRAEL, *Exhibition of Contemporary French Art*.
 GOTHENBERG, *Exhibition of Contemporary French Art*.
 BREMEN, *Exhibition of Engravings*.
 TOKYO and KYOTO, *Exhibition of Contemporary French Decorative Art*.
 LOS ANGELES, *Parwood Investments*.
1961 PARIS, Exhibition at U.N.E.S.C.O. organized by the Société Phonographique Philips.
 MARSEILLE, Musée Cantini, *L'Estampe Française Contemporaine*.
 NANTES, Galerie Argos.
 LE HAVRE, Musée du Havre, stained glass windows and tapestries.
 MOSCOW, *Exhibition of French Art*.
 HELSINKI, Atheneum.
 LOS ANGELES, Felix Landau Gallery.
 PITTSBURGH, Carnegie Institute.
 MUNICH, Haus der Kunst.
 EINDHOVEN, Stedelijk Van Abbe Museum, *Post War European Art*.
1962 CHARTRES, *Les Maîtres de la Couleur*.
 LONDON, Tate Gallery, *School of Paris*.
 LONDON, Redfern Gallery.
 VENICE, Biennale.
 ROME, *Exhibition of Contemporary Sacred Art*.
 ADELAIDE (Australia), Festival of Art.
 ESCH-SUR-ALZETTE (Luxembourg), Municipal Gallery, engravings.
1963 REIMS, Musée de Reims.
 LONDON, Redfern Gallery.
 CANADA, *Exhibition of Contemporary French Art*.
 YUGOSLAVIA, *Exhibition of Contemporary French Art*.
 BERLIN, Akademie der Künste.
 COLOGNE, Galerie Orangerie-Verlag.
 VIENNA, Galerie Im Griechenbeisl.
 SALISBURY, Rhodes National Gallery.
 JOHANNESBURG, Municipal Museum.
 CAPE TOWN, National Museum.
 TOKYO, *International Exhibition of Painting*, organized by the Mainichi Newspaper.
 BERLIN, Akademie der Künste, *Symbols and Myths*.
 TURIN, Galleria la Bussola.
 LONDON, *The Dun International Exhibition*.
 ATHENS, Galerie 8, washes and lithographs.
1964 ROUEN, Galerie L'Armitière.
 CAEN, Maison de la Culture.
 LONDON, Tate Gallery, *54/64 Painting and Sculpture of a Decade*.
 KASSEL, *Documenta 3*.
 CARACAS, Fundacion Eugenio Mendoza.
 PITTSBURGH, Carnegie Institute.
 BASLE, Galerie Handschin.
1964–5 LEXINGTON, University of Kentucky.
1965 PARIS, Librairie Galerie La Pochade, etchings and lithographs.
 LE MANS, *Premier Festival du Mans*, organized by the Centre National de Diffusion Culturelle.

SAINT-ETIENNE, Musée d'Art et d'Industrie (continuation of the Festival du Mans).

MONTPELLIER, Musée Fabre (continuation of the Festival du Mans).

ESCH-SUR-ALZETTE, Municipal Gallery, engravings.

LISBON, Gulbenkian Foundation, *A Century of French Painting, 1850–1950.*

TOKYO, *Eighth International Exhibition of Contemporary Painting* (also other towns in Japan).

DETROIT, Hudson Gallery, *International 1965.*

LONDON, Redfern Gallery.

VERVIERS, Musée des Beaux-Arts, *Les Collections privées d'Art Contemporain du Grand-Duché de Luxembourg.*

1965–6 SOUTH AMERICA, *Exhibition of Contemporary French Painting.*

1966 PARIS, Imprimerie Draeger, *Panorama 1886–1966.*

PARIS, Galeries Lafayette, *Peintres d'Aujourd'hui.*

SAINT-PAUL-DE-VENCE, Fondation Maeght, *Exposition 1945–1955.*

PUTEAUX, Biennale.

NANTES, Musée des Beaux-Arts, *Rencontre d'Octobre 1966.*

BORDEAUX, Galerie Dalléas, *Le Cabinet de l'Amateur d'Art.*

BRUSSELS, Palais des Beaux-Arts, *Vingt Peintres Français.*

LUXEMBOURG, Musée, *Vingt-Quatre Peintres Français 1946–1966.*

COPENHAGEN, Museum.

SKOPLJE, Museum.

BASLE, Galerie Beyeler, *Aspekte 1944–1965.*

1966–7 SLOVENJ GRADEC (Slovenia) Art Gallery, *International Exhibition of Peace, Humanism and Friendship.*

1967 PARIS, Galerie Bongers, *Vingt Jeunes Peintres de Tradition Française, 1941–1967.*

PARIS, T.E.P., *Tendances Contemporaines.*

SAINT-GERMAIN-EN-LAYE, *Chefs-d'Œuvre des Collections Privées.*

GRENOBLE, Galerie Harmonies, engravings.

SAINT-MAUR, Museum, lithographs.

SAINT-PAUL-DE-VENCE, Fondation Maeght, *Dix Ans d'Art Vivant, 1955–1965.*

NICE, Musée des Ponchettes, *Comprendre la Peinture du XXe Siècle.*

ESCH-SUR-ALZETTE, Municipal Gallery, engravings (Exhibition of Engravings organized by the Club Mediterranée on the liner Louis Lumière, South American Cruise).

MONTREAL, Expo 67, French Section and the Pavilion of European Communities.

LAUSANNE, Third International Biennale of Tapestry.

PRAGUE, BRATISLAVA, OSTRAVA, *Contemporary French Art.*

DARMSTADT, Stadt Museum, *Second International Exhibition of Drawing.*

BERLIN and HAMBURG, *Tendencies of Present Day Painting.*

1968 CHARTRES, *Les Maîtres Contemporains du Vitrail.*

LE CANNET, Town Hall, *Centenaire de Bonnard.*

SAINT-PAUL-DE-VENCE, Fondation Maeght, *L'Art Vivant 1965–1968.*

WASHINGTON, National Gallery, *Painting in France Today.*

NEW YORK, Metropolitan Museum of Art, *Painting in France.*

BOSTON, Museum of Fine Arts, *Painting in France.*

CHICAGO, Art Institute, *Painting in France.*

SAN FRANCISCO, Museum of the Legion of Honour, *Painting in France.*

MONTREAL, Museum of Contemporary Art, *Painting in France.*

ROSENHEIM, Municipal Gallery, *Original Works of Contemporary French Graphic Art.*

MONTREAL, Gallery of Montreal, *Maîtres d'Ici et d'Ailleurs.*

NANTERRE, Maison de la Culture, *Peinture Vivante.*

GENNEVILLIERS, Centre Culturel, *Expression au Présent.*

RIJEKA, Museum of Modern Art, *International Exhibition of Drawing.*

BOLBEC, *8e Salon d'Automne des Peintres Bolbécais* (Honorary Guest Artist: Manessier).

1968–9 CENTRAL EUROPE, *Montreal 2.*

BREST, Galerie J. F. Bideau, *Dix Peintres de l'Ecole Française XXe Siècle.*

1969 LAUSANNE, Fourth International Biennale of Tapestry.

1969 VITRY-SUR-SEINE, Town Hall, *Noir et Blanc*.

 VILLENEUVE-SUR-LOT, Biennale, *Bissière et ses Amis*.

 AVIGNON, Festival d'Avignon, International Exhibition of Contemporary Art: *L'Œil écoute*.

 SAINT-PAUL-DE-VENCE, Fondation Maeght, *Peintres Illustrateurs – Le Livre Illustré Moderne depuis Manet*.

 LONDON, Royal Academy of Arts, *French Painting Since 1900*.

1970 MONTPELLIER, Musée Fabre, Exhibition of Tapestries (Ateliers Plasse Le Caisne).

 GENTHOFTE, Genthofte Art-Friends, *Salon des Peintres de Paris*.

 HEROUVILLE-SAINT-CLAIR, Centre Social Culturel, *Tapisseries et Céramiques Contemporaines*.

 ESCH-SUR-ALZETTE, Municipal Art Gallery, engravings.

 LAMALOU-LES-BAINS, *12e Salon de Peinture*.

 COLOGNE, *Maturity of the Great Artists*.

 TOKYO et NAGOYA, Exhibition organized by the Mitsukoshi Stores, paintings, drawings, lithographs.

1971 PARIS, Foundation Mercédès Benz, *Formes en Puissance*, 26 contemporary masters.

 LILLE, Galerie Christine Leurent, prints.

Salons

1933–5 PARIS, Salon des Indépendants.

1939 PARIS, 2nd Salon des Jeunes Artistes.

1941–2 PARIS, Salon des Tuileries.

1942–9 PARIS, Salon d'Automne.

Since 1943 PARIS, Salon de Mai (founder member).

1944 PARIS, Salon de la Libération, Musée National d'Art Moderne.

1955 LYON, Salon d'Automne.

1959 LYON, Salon du Sud-Est, *Hommage à Marcel Michaud*.

1962 DIJON, Salon Confrontation.

1967 ASNIÈRES, Salon d'Asnières.

MONUMENTAL WORKS

I. Stained glass windows

1948–50 CHURCH OF BRESEUX (Doubs). 6 windows, 3,05 m × 1,25 m, and a bull's eye, 1,25 m in diameter. Glass and lead. Ateliers François Lorin.

1952 ALL SAINTS CHURCH, BASLE. Window for the side altar, 1,20 m × 1,20 m. Glass and lead. Architect Hermann Baur. Ateliers François Lorin.

1953 CHURCH OF SAINT-PIERRE DE TRINQUETAILLE, ARLES. 2 windows, 5,90 m × 2 m and 5,30 m × 2 m, for the choir and the gallery. Glass and lead. Architect Pierre Vago. Ateliers François Lorin.

1957 CHAPEL OF SAINTE-THÉRÈSE DE L'ENFANT JÉSUS ET DE LA SAINTE FACE, HEM (Nord). Walls of slabs of glass, 4,35 m × 15,70 m and 2,60 m × 15,70 m, and a semi-circular baptistry 2,10 m × 5 m. Architect Hermann Baur. Ateliers Jean Barillet, sculptures by Dodeigne, tapestry by Rouault.

1958 CHAPEL OF NOTRE-DAME DE LA PAIX, LE POULDU (Finistère). 3 windows, 4,80 m × 2,60 m and 2 m for the Choir. In collaboration with Le Moal. Reconstruction by the architect Pierre Brunerie. Glass and lead. Ateliers Jean Barillet.

1959 MÜNSTERKIRCHE, ESSEN. 8 windows, 1,30 m × 0,75 m for the crypt. Glass and lead. Ateliers François Lorin.

1964 ST GEREON CHURCH, COLOGNE. 12 windows, 1,50 m × 0,75 m and 1,08 m × 0,55 m for the crypt. Glass and lead. Ateliers François Lorin.

1965–9 CATHOLIC CHURCH IN MOUTIER (Switzerland). Window, 1,22 m × 44 m and 2 lancettes for the nave. Slabs of glass. Architect Hermann Bauer. Ateliers Jean Barillet.

 16 panels, 2,75 m × 0,60 m for the baptistry. Slabs of glass. Ateliers Jean Barillet.

 Window, 1,22 m × 37,75 m for the choir. Slabs of glass. Ateliers Jean Barillet.

 Altar, furniture, tapestry and font by H. G. Adam.

1966–9 PROTESTANT CHURCH, UNSERER LIEBEN FRAUEN, BREMEN. Window, 10,50 m × 4,50 m for the choir. Glass and lead. Ateliers François Lorin.

 Rose window, 4,50 m in diameter, for the gallery. Glass and lead. Ateliers François Lorin.

 2 windows, 8,20 m × 2,80 m and 7,40 m × 2,75 m, for the nave. Glass and lead. Ateliers François Lorin.

3 windows, 7,50 m × 3 m for the nave. Glass and lead. Ateliers François Lorin.

1967 CHAPEL OF THE CARMELITE CONVENT, VERDUN. Window 3,50 m × 2 m for the choir. Glass and lead. Ateliers François Lorin.

1968–9 CONVENT OF THE SŒURS DE L'ASSOMPTION, rue Violet, Paris. 34 windows, 3,65 m × 1,50 m, 2,68 m × 0,67 m, 1,85 m and 0,57 m, and rose windows 1,50 m in diameter. Glass and lead. Ateliers François Lorin.

II. Tapestries

1947 *The Construction of the Ark (La Construction de l'Arche)*, Atelier at Feltin (Aubusson).

1949 *Christ at the Pillar (Christ à la Colonne)*, for the oratory of the Dominicans of Saulchoir (Seine-et-Oise), in collaboration with the sculptor Henri Laurens.

1949 *Forest in January (Forêt en Janvier)*. Atelier at Feltin (Aubusson). Property of the city of Paris.

1952 *Evening Litanies (Litanies du Soir)*, 7 m × 2,56 m, woven at the Gobelins. Property of the State.

1953 One Chasuble for Ordination for a Carmelite Friar. Atelier Plasse Le Caisne.

1955 One Chasuble for Ordination for a Carmelite Friar. Atelier Plasse Le Caisne.

1957 One Benediction Cape for His Eminence Monsigneur Lienart of the Chapel of Sainte-Thérèse, Hem (Nord). Atelier Plasse Le Caisne.

1958–9 Five Chasubles for the Chapel of Sainte-Thérèse, Hem (Nord); white, mauve, black, red, green. Atelier Plasse Le Caisne.

1960 *The Breakwater of Crotoy (L'Estacade du Crotoy)*, 14 m × 14 m. Atelier Plasse Le Caisne. Acquired by the Direction Générale des Arts et Lettres.

1962 A tapestry after a painting in black and blue, 5 m × 5 m. Atelier Plasse Le Caisne. Acquired by the Direction Générale des Arts et Lettres.

1963 *Gregorian Chant (Chant Grégorien)*, c. 35 m × 35 m, for the music foyer of the R.T.F. Atelier Plasse Le Caisne.

1965 *Underwater Space (L'Espace Sous-Marin)*, c. 50 m × 50 m, for the Council Room of the autonomous harbour at Le Havre.

1966 *The Night (La Nuit)*, 3 m × 4,10 m. Atelier Plasse Le Caisne. Private collection.

1967 *Before Dawn (Avant L'Aube)*, 2 m × 3,90 m. Atelier Plasse Le Caisne. Private collection.

Tapestry on the theme of marriage for the Wedding Room, in the new Town Hall of Grenoble. 3,40 m × 11,25 m. Atelier Plasse Le Caisne.

Joy (La Joie), 1 m × 0,50 m. Atelier Plasse Le Caisne for a Boeing (Air France).

Signs (Signes), 3 m × 0,80 m. Atelier Plasse Le Caisne. Private collection.

1968 *Halleluia (Alléluia)*, 3,40 m × 3,40 m. Atelier Plasse Le Caisne for private collection.

1969 *The Secret Lake (Lac Secret)*, 4,85 m × 7,60 m. Atelier Plasse Le Caisne for the National Arts Centre in Ottawa (Canada).

Tapestry, 2,70 m × 14,25 m. Atelier Plasse Le Caisne for the Hall of the S.C.I.C., Maine-Montparnasse, Paris.

Gregorian Chant 2 (Chant Grégorien 2), 4,55 m × 7,60 m. Atelier Plasse Le Caisne for the Music Foyer of O.R.T.F. (new version).

The Large Bouquet (Le Grand Bouquet), 3,20 m × 2,20 m. Atelier Plasse Le Caisne. Private collection.

ILLUSTRATED BOOKS

1949 *Lithographs on the Theme of Easter (Lithographies sur le thème de Pâques)*, edited by the Galerie Jeanne Bucher, Paris.

1958 Twelve original lithographs illustrating *The Spiritual Canticles of St John of the Cross (Les Cantiques spirituels de Saint Jean de la Croix)*. Edition des Sept, Paris.

1962 *Presentation of the Beauce to the Notre-Dame Church of Chartres by Charles Péguy (Présentation de la Beauce à Notre-Dame de Chartres de Charles Péguy)*, Société des Bibliophiles de France. Handwritten poem, original lithographs. Edition de l'Union Française des Bibliophiles, Paris.

1971 Illustrations for Camille Bourniquel's *Sentier d'Hermès*. Collection *Ecritures*, Calanis, Paris.

OTHER WORKS

1937 Collaborates with Felix Aublet and Robert Delaunay at the World Exhibition of Paris, Pavilion of the French Railways and Transport.

1945 Costumes and *décor* for *Marie-Anne Victoire*, by Jacques Tournier, Studio des Champs-Elysées, directed by Maurice Jacquemont.

1954 *Play in Snow (Jeux dans la Neige)*, 6,80 m × 2,60 m. Painting for the Lycée Climatique of Argelès (Hautes-Pyrénées). Architect André Remondet.

1957 Mosaic, 4,75 m × 3,50 m, for the porch of the Chapel of Sainte Thérèse de l'Enfant Jésus et de la Sainte Face, Hem (Nord). Architect Hermann Baur. Atelier Jean Barillet.

1955–8 Twenty-five enamels produced by Dom Jacques Dupeux. Ateliers of the abbey of Liguée (Vienne).

1960 340 costumes and eighteen *décors* for *The Decameron* by Boccaccio. International Festival of Ballet at Nervi (Italy). Choreography by Leonid Massine.

1961 Ciborium, 1,40 m × 1,40 m. Oil painting on panel for the altar at the monastery of the Carmelite Friars, Villa de la Réunion, Paris 16e.

1963 Costumes for *Galileo Galilei* by Bertolt Brecht. Théâtre National Populaire, Paris. *Décors* and construction by Jean-Baptiste Manessier.

1969 Double-fronted Crucifix for altar, 1 m × 1 m. Catholic Church at Moutier (Switzerland), in collaboration with A. Schaffner (silversmith, Basle) and M. Bergerson (enameller, Zurich).

1970 Mosaic, 2,40 m × 5,30 m, for the screen of the Chapel of the C.N.P.L., rue Vavin, Paris. Atelier Silvestri.

PAINTINGS AND GRAPHIC WORKS IN MUSEUMS AND PUBLIC COLLECTIONS

SOUTH AFRICA

JOHANNESBURG Museum of Johannesburg.

GERMANY

BERLIN Nationalgalerie, *Février près d'Harlem, 1956*.
BREMEN Kunsthalle, *Turris Davidica,* 1952; *Requiem,* 1957.
COLOGNE Wallraf-Richartz-Museum, *Le Feu,* 1957.
DUSSELDORF Kunstsammlung Nordrhein-Westfalen, *La Nuit de Gethsémani,* 1952.
ESSEN Folkwang Museum, *La Couronne d'Epines,* 1951; *Per Amica Silentiae Lunae,* 1954.
HAMBURG Hamburger Kunsthalle, *Fête en Zélande,* 1955.
HANOVER Niedersächsische Landesgalerie, *Jardins de Pâques,* 1952.
MANNHEIM Städtische Kunsthalle, *Port,* 1956.
STUTTGART Staatsgalerie Stuttgart, *Requiem pour Novembre 1956,* 1957.

BELGIUM

BRUSSELS Musées Royaux des Beaux-Arts de Belgique, *Seigneur, frapperons-nous de l'Epée,* 1954.

BRAZIL

RIO DE JANEIRO Museu de Arte Moderna, *Litanies Vespérales,* 1951.
SÃO PAULO Museu de Arte Moderna, lithographs.

CANADA

OTTAWA National Gallery of Canada, *La Sève,* 1964.

ENGLAND

LONDON Tate Gallery, — 12°, 1956.

FINLAND

HELSINKI Kunstmuseum Atheneum, *Le Long du Sentier,* 1960.

FRANCE

PARIS Ministère des Affaires Culturelles, *Le Buisson Ardent,* 1960. Musée National d'Art Moderne, *Combat de Coqs,* 1944; *Le Port Bleu,* 1948; *Espace Matinal,* 1949; *La Couronne d'Epines,* 1950;

Ensoleillé dans la Dune, 1951; *Résurrection*, 1961; *Les Ténèbres*, 1962; *L'Empreinte* (triptych), 1963. 3 panels and predella, 11 drawings; washes in indian ink, 1959. Musée d'Art Moderne de la Ville de Paris, *Nuit au Mas*, 1959.

AMIENS	Musée de Picardie, *Pietà*, 1946.
DIJON	Musée des Beaux-Arts, *Près d'Harlem*, 1955.
GRENOBLE	Musée de Peinture et de Sculpture, *Paysage espagnol*, 1963.
LE HAVRE	Musée du Havre, *Apaisé*, 1954.
LYON	Musée des Beaux-Arts, *Aube sur la Garrigue*, 1959.
METZ	Musée de Metz, *Hommage à Goya*, 1964.
NANTES	Musée des Beaux-Arts, *Salve Regina*, 1945.
ROUEN	Musée des Beaux-Arts et de Céramique, *Dans l'Espace Crépusculaire*, 1960.

HOLLAND
EINDHOVEN	Stedilijk van Abbe Museum, *Barrabas*, 1952; *Nuit d'Eté*, 1956.
ROTTERDAM	Museum Boymans Van Beuningen, *Port Nocturne*, 1950; *Offrande du Soir*, 1954.

ITALY
TURIN	Museo Civico, *Longwy la Nuit*, 1951.
VENICE	Galleria Internazionale d'Arte Moderna, *Alléluia 2*, 1962.

GRAND DUCHY OF LUXEMBOURG
LUXEMBOURG	Musée d'Histoire et d'Art, *Epiphanie*, 1961.

NORWAY
OSLO	Nasjonalgalleriet, *Hiver*, 1950; *Pastel et Lavis*, 1950. Sonja Henie-Niels Onstad Foundations, *Composition*, 1953; *Alléluia des Champs*, 1955; *La Nuit à Saint-Jean-de-Luz*, 1955; *Le Bouquet*, 1955.

SWEDEN
MALMÖ	Malmö Museum, lithographs.
STOCKHOLM	Moderna Museet, *La Nuit du Jeudi Saint*, 1955.

SWITZERLAND
BASLE	Kunstmuseum Basle, *Nocturne*, 1950; *Composition*, 1953.
LA CHAUX-DE-FONDS	Musée des Beaux-Arts, *La Passion de Notre Seigneur Jésus-Christ*, 1952.
ZURICH	Kunsthaus Zurich, *Tumulte*, 1962.

U.S.A.
FORT WORTH	Amon Carter Museum of Western Art, *Croix, ma Joie*, 1963.
NEW YORK	The Solomon R. Guggenheim Museum, *Etude pour Jeux dans la Neige*, 1961; Museum of Modern Art, *Figure de Pitié* (Gift of Mr and Mrs Zadok), 1944–5; *Mouvements nocturnes* (New York Collection), 1948; *Evocation de la mise au tombeau* (Cornelius J. Sullivan Fund), 1048; *Pour la Fête du Christ Roi* (Aldrich Rockefeller Fund), 1952; six lithographs.
NOTRE DAME	University of Notre Dame, Indiana, *Etude pour le Jardin des Oliviers*, 1963.
PITTSBURGH	Carnegie Institute, *Couronne d'Epines*, 1954.
RIDGEFIELD	Larry Aldrich Museum of Contemporary Art, *Le Torrent I*, 1959.
WASHINGTON	Duncan Phillips collection, *Du Fond des Ténèbres*, 1963.

YUGOSLAVIA
SKOPLJE	Museum of Contemporary Art, wash and drawings, 1959.

SELECT BIBLIOGRAPHY

Books
Bernard Dorival, *Les Etapes de la Peinture Française Contemporaine*, vol. III, 'Depuis le Cubisme, 1911–1944', Gallimard, Paris 1946.
Jean Cayrol, *Manessier*, Le Musée de Poche, Paris 1955, second edition with new illustrations, 1966.
Robert Collin, 'La Peinture Moderne' in *Les Clés de L'Art Moderne*, La Table Ronde, Paris 1955.
Patrick Heron, *The Changing Forms of Art*, Routledge & Kegan Paul, London 1955.
Werner Haftmann, *Painting in the Twentieth Century*, 2 vols., Lund Humphries, London 1960, original German editions 1954–5 and 1957.
Marcel Brion, *Art Abstrait*, Ed. Albin Michel, Paris 1956.
Jean Bouret, *L'Art Abstrait, ses Origines, ses Luttes, sa Présence*, Le Club Français du Livre, Paris 1957.
Marcel Brion, 'France (School of Paris)' in *Art since 1945*, ed. Will Grohmann, Thames & Hudson, London 1958 (also American, German and Italian editions).
Heinz Kohn, *Neue Meister der Letzten Fünfzig Jahre aus dem Museum Folkwang zu Essen*, Verlag E. A. Seeman, Cologne 1958.
Michel Seuphor, *Dictionary of Abstract Painting*, Methuen, London 1958, original in French and also German edition.
Pierre Courthion, *Art Indépendant*, Ed. Albin Michel, Paris, 1958.
Frank Avray Wilson, *Art into Life*, Centaur Press, London 1958.
G. Poensgen and L. Zahn, *Abstrakte Kunst, Eine Weltsprache*, Woldemar Klein, Baden-Baden 1958.
Lavis de Haute-Provence, Preface by Alfred Manessier, ed. Galerie de France, Paris 1959.
Jean Cassou, *Panorama des Arts Plastiques Contemporains*, Librairie Gallimard, Paris 1960.
Georges Charbonnier, 'Entretien avec Alfred Manessier', in *Le Monologue du Peintre*, René Julliard, Paris 1960.
Nello Ponente, *Peinture Moderne, Tendances Contemporaines*, Skira, Paris 1960.
Raymond Nacenta, *School of Paris, The Painters and the Artistic Climate of Paris, since 1910*, Oldbourne Press, London 1960, also American, French, German and Italian editions.
Gillo Dorfles, *Ultime tendenze nell'arte d'oggi*, Feltrinelli Editore, Milan 1961.
Michel Seuphor, *Abstract Painting, 50 years of Accomplishment from Kandinsky to the Present*, Prentice-Hall International London 1962, original in French, also American editions.
G. E. Kidder Smith, *The New Churches of Europe*, The Architectural Press, London 1964.
Art of our Time, ed. Will Grohmann, Thames & Hudson 1966, also American and German editions.
Edward B. Hemming, *Fifty Years of Modern Art, 1916–66*, The Cleveland Museum of Art, U.S.A. 1966.
Depuis 45, L'Art de Notre Temps, vol. I, La Connaissance, Brussels 1969.
H. H. Arnason, *The History of Modern Art, Painting, Sculpture, Architecture*, Thames & Hudson, London 1969.

Articles
Ole Henrik Moe, 'Manessier', in *Kunsten Idag*, No. 2, Oslo 1952.
'Allerheiligen Kirche in Basel', in *Werk*, Heft 12, Winterthur, December 1954.
Bernard Dorival, 'Manessier, Artisan Religieux' in *L'Œil*, No. 16, Paris 1955.
'Manessier: Un Nouveau Peintre Français vient d'obtenir le Prix Carnegie', in *Connaissance des Arts*, No. 50, Paris 1956.
'L'Art Sacré', in *Le Vitrail*, Nos. 5–6, Paris, 1956.
Dom Samuel Stehman, 'La Chapelle d'Hem', in *Art d'Eglise*, No. 104, Bruges 1958.
'L'Art Sacré', in *Nova et Vetera*, Nos. 11–12, Paris 1959.
Denys Chevalier, 'Alfred Manessier', in *Die Kunst und das Schöne Heim*, Heft II, Munich 1959.
A. M. Cocognac, 'Manessier Cultive son Jardin', in *Signes du Temps*, Paris 1960.
'L'Art Sacré', in *Les Rencontres Mystérieuses*, Nos. 11–12, Paris 1960.
Camille Bourniquel, 'Alfred Manessier peintre mystique', in *XXe Siècle*, No. 15, Paris 1960.
Guiseppe Marchiori, 'Spiritualité de Manessier', in *XXe Siècle*, No. 20, Paris 1962.
Jean Clay, 'Alfred Manessier, Ma Vérité de Peintre', in *Réalités*, No. 202, Paris 1962.
Alfred Manessier, 'Georges Braque', in *L'Art Sacré*, Nos. 1–2, Paris 1963.
J. Guichard Meili, *Galerie des Arts*, No. 19, Paris 1964.
'L'Art Sacré, la Peinture Contemporaine', I, in *A la Recherche de l'Espace et de la Forme*, Nos. 7–8, Paris 1964.
'Manessier expose à Paris après Sept Ans de Silence', in *Connaissance des Arts*, No. 174, Paris 1966.

'Pour Alfred Manessier, l'Art c'est avant tout la Conquête de la Liberté', in *Heures Claires*, No. 33, Paris 1966.

'La Commedia Umana dal Decameron di G. Boccaccio.' Costumes and *décors* by Alfred Manessier, *Ente Manifestazioni Genovesi V. Festival Internazionale del Balletto*, Teatro dei Parchi di Nervi, July 1966.

Michel-Georges Bernard, 'Nature et Peinture dans l'Œuvre d'Alfred Manessier', in *Les Temps Modernes*, No. 247, Paris 1966.

Curt Schweicher, 'Alfred Manessier, eine Epoche Neuer Kirchenkunst', in *Das Münster*, 22nd year, issue No. 5, Munich 1969.

Léone de la Grandville, 'Manessier entre Deux Voyages', in *Plaisir de France*, Paris 1970.

Catalogues

Camille Bourniquel, *Trois Peintres* (Jean Le Moal, Alfred Manessier, Gustave Singier), Galerie René Drouin, Paris 1946.

Camille Bourniquel, Preface to Catalogue of the Stedelijk van Abbe Museum, Eindhoven 1955.

Ell de Wilde, 'Manessier', Preface to the Catalogue *1955–1956 La Hollande*, Ed. Galerie de France, Paris 1956.

Werner Schmalenbach, 'Alfred Manessier', Preface to *Katalog* No. 3, Kestner Gesellschaft, Hanover 1958–9.

Jean Clay, 'Excerpts from an Interview with Manessier', Catalogue of the Alfred Manessier Loan exhibition, The Phillips collection, Washington 1964.

Jacques Lassaigne and Don Alfonso Roig, Prefaces to the Catalogue of Manessier's paintings from Spain, Galerie de France, Paris 1966.

Bernard Dorival, Preface to the Catalogue of the Manessier Retrospective Exhibition (works from 1935 to 1968) at the Museum of Metz, 1969.

Bernard Dorival, 'Alfred Manessier', Preface to the Catalogue of the Exhibition at the Abbey Church of Bellelay 1970.

Jean-Paul Pellaton, Extracts from the text of the book *Les Vitraux du Jura*, in the Catalogue of the Exhibition at the Abbey Church of Bellelay, 1970.

Michel-Georges Bernard, 'Nature et Peinture dans l'Œuvre d'Alfred Manessier' (another version of the same article appeared in *Les Temps Modernes*, 247, 1966), Preface to the Catalogue of the Galerie de France, 1970.

Léone de la Grandville, 'Entretien avec Alfred Manessier' in the Catalogue of the Galerie de France, 1970.